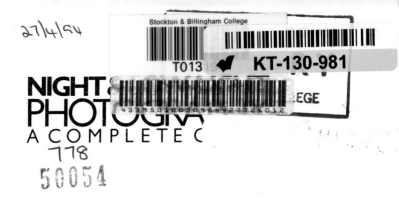

NIGHT
PHOTOGRA
A COMPLETE C

Incinerator fire at night.
Cameras with automatic
off-the-film metering are
exceptionally useful for
pictures like this one, since
they meter the scene as it
changes, closing the shutter
only when enough light has
actually reached the film.

NIGHT & LOW-LIGHT PHOTOGRAPHY
A COMPLETE GUIDE

Bob Gibbons and Peter Wilson

BLANDFORD

Series editor: Jonathan Grimwood

Blandford Press
An imprint of Cassell
Artillery House, Artillery Row, London SW1P 1RT

First published in the UK 1987
This paperback edition first published 1989

Distributed in the United States by
Sterling Publishing Co, Inc,
2 Park Avenue, New York, NY 10016

Distributed in Australia by
Capricorn Link (Australia) Pty Ltd
PO Box 665, Lane Cove, NSW 2066

ISBN 0-7137-2127-8

British Library Cataloguing in Publication Data

Gibbons, Bob
Night and low-light photography: a
complete guide.
1. Photography, Available light
I. Title II. Wilson, Peter
778.7 TR147

Typeset by Asco Typesetting Ltd., Hong Kong
Printed in Great Britain by Purnell Book Production Ltd, Paulton, Nr. Bristol, Avon

Contents

The possibilities of this wide-angle shot of a railway line were obvious enough, but the bright floodlight, top right, shining straight towards the camera, produced exposure difficulties. The use of a graduated neutral density filter helped to solve the problem by reducing the exposure at the extreme top.

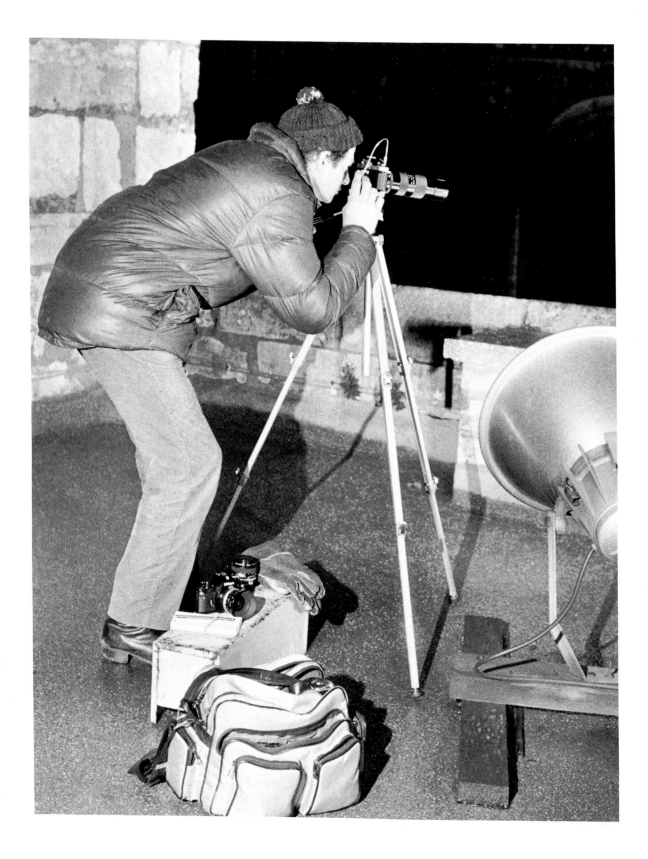

1 Essential Equipment for Night and Low-light Photography

Although few people will buy many major items of equipment solely for low-light photography unless they are planning to concentrate on this aspect of photography, it is nevertheless true that many cameras and lenses have features that make them suitable for low-light photography, whilst others do not. On the other hand, there are many smaller items of equipment – filters, flash, camera supports etc. – that the photographer may buy solely to help with low-light work, and there are some specialised pieces of equipment designed especially for this type of photography. This chapter is intended as a guide to what is available, what is useful, satisfactory, or downright useless, and how best to choose basic equipment with low-light work in mind.

CAMERAS

General considerations

An early consideration when buying a camera is the size of film that it takes – the format. It is unlikely that one would buy a particular format just for night work, but there are factors involved that might help to influence a decision. Generally speaking, the larger the film size, the greater the definition and the more impressive the results, but against that has to be weighed the greater weight and cost of equipment that takes larger film sizes. The smallest film sizes, 110 and disc, are very cheap and the cameras are light, but definition is poor and few of the features that help the low-light worker are available. Unless you prefer these cameras for other reasons, we suggest that something larger is used.

35 mm cameras (with a negative size of 36×24 mm ($1\frac{1}{2} \times 1$ inch)) are the most widely-used and widely-available types, and the range of ancillary equipment for them is enormous. They represent the best compromise of size, weight and bulk, and price for most people, with the added bonus that there is a huge range to choose from and almost any item of extra equipment can be bought for them. There is a very wide range of 35 mm film available (see Chapter 2), and the quality obtainable is good enough for virtually all publishing and projecting purposes. A few publishers, especially calendar and greeting-card manufacturers, prefer larger formats to work from, but these are relatively few in number.

Of the camera formats larger than 35 mm, the so-called 'medium-format' cameras, using 120 or 220 roll-film, are the most popular. Depending on

Some of the essential equipment for night photography in use: a good tripod, a cable release, a capacious bag, and warm clothing and gloves.

the design, these produce negatives of 7×6 cms, 6×6 cms ($2\frac{1}{4}$ inch 'square') or 6×4.5 cms, and a few can be modified to produce more than one size, including inserts to produce 35 mm sized negatives. These cameras are widely-used professionally, and they produce large, clear negatives or slides which can look very impressive. They tend to be a few years behind 35 mm cameras in terms of the technology available for them; for instance through-the-lens flash metering (see page 21) is only just being built in, some 10 years after it first became available for 35 mm cameras, and large aperture lenses, of the type particularly suited to low-light work, are very expensive. One useful feature, though, is the opportunity that most provide to change films, without rewinding, midway through a film. This is particularly useful if you wish to switch to a fast film for nightwork one evening but still have half of a normal slow film in the camera, or if you wish to change from a natural light-balanced film to an artificial-light film. With other cameras, you can always carefully rewind a film (see Chapter 10), or have two bodies, but there are often more than two types of film you would like to use, and rewinding is slower and more wasteful than simply changing backs as you can with 'medium-format' cameras.

Beyond the roll-film cameras, there are still larger cameras, taking plates and producing negatives as large as 10×8 inches. These are highly specialised cameras, almost exclusively for professional use, and we will not consider them in any detail. Many of them have a range of 'movements', such as tilting backs and lenses, which allow complete control of perspective distortion in architectural photography, but most photographers will probably find it more convenient to buy tilt-and-shift lenses (see page 64) for their existing cameras if they are especially keen on photographing buildings. We will assume for the purpose of this book that most readers will use 35 mm or 120 medium-format cameras, and the techniques and range of equipment discussed are geared to these.

VIEWING SYSTEMS: SINGLE-LENS REFLEX (SLR) OR VIEWFINDER CAMERAS?

Within the world of 35 mm cameras, and to a lesser extent of other film sizes, there is an important difference between cameras where the picture is viewed by the photographer through the lens that will take the picture, by means of a hinged mirror, and cameras that have a lens for taking the picture and a viewfinder that is separate from this. The former are called single-lens reflex cameras (SLR for short) and they have several huge advantages, though, as we shall see, there are a few disadvantages as well. The advantages are that you can compose the picture precisely, take light meter readings of the exact scene you wish to photograph through the lens, and compensate readily for filters, close-up lenses and so on. These possibilities also make it much more worthwhile changing lenses, e.g. to a telephoto lens, on these cameras since the viewing system allows you to see exactly what you take whichever lens or accessory you have on the

front. Virtually all SLRs have interchangeable lenses, giving you access to a huge range of possibilities, whereas very few non-SLRs do, because of the difficulties of composing the picture, metering, and so on. Most serious photographers have at least one SLR in their equipment range, and the advantages are obvious. SLRs benefit from a greater development than other cameras: they tend to have more sophisticated metering, for example, and a wider range of equipment is available for them.

The viewing system does, however, have the inherent disadvantage of a mirror and pentaprism to find room for, and the need for more complex, larger lenses, since they are further away from the film. If you compare the standard lens on a single-lens reflex, which is about $1\frac{1}{2}$ inches deep with a diameter of about $2\frac{1}{2}$ inches, with the tiny piece of glass serving a similar function on a viewfinder camera, you can appreciate the difference. This means that non-SLRs can be much smaller and more pocketable (though not all are), which can be useful. A second advantage is that the shutter mechanism does not involve a large mirror flipping out of the way and returning, so non-SLRs are much quieter and more vibration-free, which can be a help in low-light work. A third advantage of non-SLRs is that it is much easier to incorporate automatic focusing, and many compact cameras have auto-focusing, often quite cheaply – while few SLRs do, and it is never cheap. The value of this feature in low-light work is discussed below.

If you intend to use only one camera, then an SLR is the best, despite the drawbacks, since your photographic horizons can expand in any direction with it. But since some compacts are very cheap it can be quite feasible to have both cameras, and benefit from the advantages of each.

CAMERA METERING SYSTEMS

Most cameras manufactured nowadays have built-in light meters, usually coupled with the shutter speed and aperture controls of the camera. In SLR cameras, the metering is almost invariably designed to operate through the taking lens (TTL metering), which allows you to take an exact meter reading of what you are photographing. Whatever lens you use, this clearly facilitates most aspects of low-light work, just as it does with most other branches of photography. TTL metering has become the norm, and virtually any new SLR will have it, but there are a few extra features now available which are worth considering. Most meters take light readings that are an average of the whole screen, but usually biased towards the centre and base of the field of view. This is fine for more general scenes, but in many low-light situations the lighting is complex and does not follow the average pattern. (Incidentally, it is helpful to know the approximate pattern of bias in your camera's meter reading pattern. How to work this out, if the information is not already available in your camera's handbook, is described in Chapter 3.)

One recent development (or rather redevelopment of an old idea), is the

facility for spot-metering, i.e. taking a meter reading from a very limited area of the picture. Despite its obvious value in difficult lighting situations, this went out of fashion some years ago, to return in a more sophisticated form in the electronic age. Several cameras now offer the facility of spot reading, and this is most complex in those cameras that allow you to take a series of spot readings of different parts of the scene, and then average them for you to give the most accurate exposure for your needs. It takes some experience to know the parts to take the spot readings from, but apart from that, spot-metering is a tremendous boon under any difficult circumstances including low-light situations. At the time of writing, the best cameras in this respect are the Olympus OM4, which has the facility built in, and the Minolta 9000 to which it can be added via an optional extra databack.

The other development of ordinary through-the-lens metering that can help us here is that of through-the-lens *flash* metering. This is a remarkable achievement in which sensors can read and monitor the amount of light actually reaching the film *during* the exposure (which may only be measurable in thousandths of a second), and then instantly switch off the flashguns being used so that exactly the right amount of light for correct exposure reaches the film. Because the light is measured by the amount reflected from the film, this method of exposure is known as off-the-film (OTF) metering. It has tremendous benefits for night and low-light photography, not only by making ordinary or multiple flash shots more accurate but also by greatly simplifying all sorts of long night-time exposures: since the light is always being measured, even during an exposure of up to two minutes, you can fire flashguns at your subject, set off fireworks, direct torchbeams onto an object, or whatever you like, secure in the knowledge that the meter is accumulating all this information and it will close the shutter when the film is correctly exposed. Normally, since every such situation is different, you cannot work by calibrating your flashgun set-up, and have to fall back on a series of 'bracketed' exposures on either side of what you think is correct, with all the wasted time and money that this involves; OTF exposure virtually eliminates this problem, and is also great fun to use. It now appears on an increasing number of good cameras, having begun many years ago with the Olympus OM2, and is worth investigating. The techniques of making use of it to the full are discussed in Chapter 3 and elsewhere as the subject arises.

AUTOMATIC OR MANUAL METERING?

The camera user or prospective purchaser will almost certainly have noticed that, in recent years, many cameras, including SLRs, have been labelled 'automatic metering', or just 'auto', or display even finer details such as 'aperture priority automatic' or 'shutter priority automatic'. What do these terms mean, and are they of any significance to the low-light photographer?

Lake in France, in late evening light. This was taken with a wide-angle 24–48 zoom lens, set at 24 mm. Wide-angle lenses are one of the most useful items in the low-light photographer's armoury.

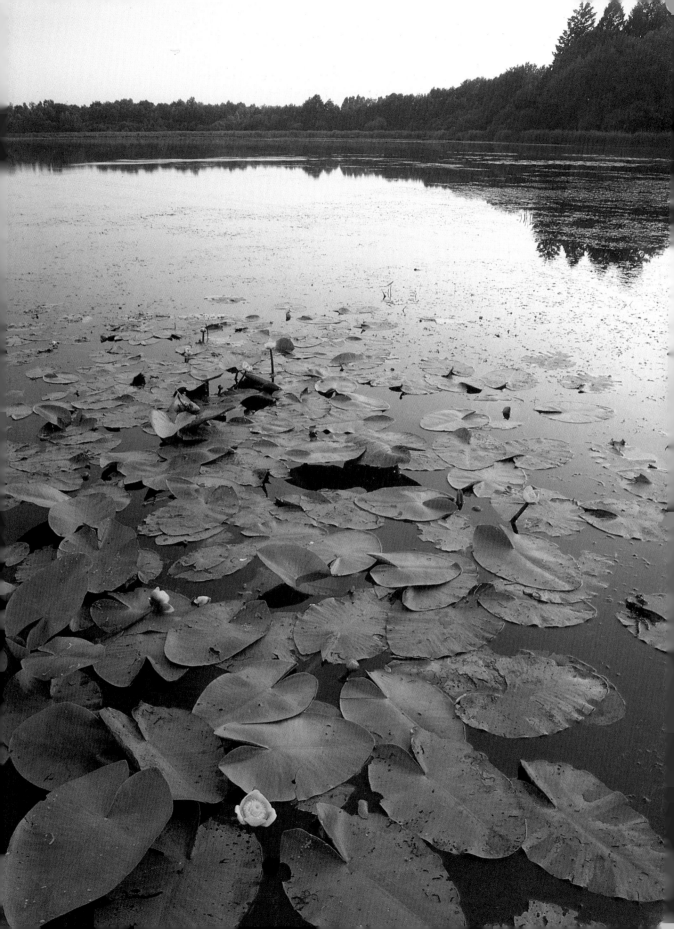

There was, and still is, considerable resistance amongst photographers to automatic metering on the grounds that it takes away creativity or flexibility. We believe this is erroneous and a waste of a good opportunity. What a good automatic camera does is allow you to set, for example, the shutter speed that you require, and then it will automatically give you the correct aperture (subject to the limitations of the meter, as always) for the photograph you are taking. Some cameras work by setting the aperture automatically after you have chosen the shutter speed you require (known as 'shutter priority automatics', e.g. the Canon AE1), while others work by setting the shutter speed automatically according to the aperture you have chosen (known as 'aperture priority automatics': most automatic SLRs work on this principle, including the Olympus OM4 and Pentax). An increasing number can do either, according to the position of a switch, and they are usually known as 'multi-mode automatics', (e.g. Canon A1, Pentax Super A, Nikon FA and Canon T70).

All cameras except the cheapest have some means of over-riding the automatic exposure mechanism, allowing manual control of both shutter speed and aperture, as well as some means of compensating for unusual situations by up to 2 stops either way while still on automatic. As long as you avoid the 'auto only' types, which are usually the cheapest, then these automatic cameras give you everything that manual metering provides, plus the benefits of automatic metering. If set on 'auto', you have the speed of use and instant reaction to changing circumstances that only an automatic can give you, yet you can compensate for difficult subjects, such as a light face against a dark shadow (by giving perhaps $1\frac{1}{2}$ stops' compensation) and still retain automatic metering. If you prefer, or if you need more than 2 stops of compensation, you can switch to wholly manual metering and do as you please. Most users of manually metered cameras will line up the needle to the correct position in the viewfinder and expose at the indicated aperture – an automatic camera simply does this operation for you, but more quickly. Beware, however, of 'programmed automatic' cameras which set both aperture and shutter speed for you and allow you no control – these should be avoided, for our purposes.

There are two less obvious advantages of an automatic metering system. Firstly, in either type, the setting that the camera makes is completely stepless and so the exposure can be exactly right for the circumstances; for example, in an aperture priority camera, you may have set the aperture to f5.6 and the meter will determine that 1/104 second will give the exactly correct exposure; on a manual camera you would have to use 1/125 second. Secondly, and especially welcome to night and low-light photographers, though only found in the better aperture priority systems, is the ability to give exposures of up to 2 minutes automatically. In, for example, a twilight or night picture, such exposures are not unusual but are extremely difficult to gauge with a manual meter – if, indeed, you can see the needle at all.

We both use automatic cameras regularly and leave them set on 'auto-

matic' for almost everything, compensating if judged necessary, and we get consistently accurate exposures. The only point to remember, especially if you travel abroad to exotic locations, is that most automatics are totally dependent on battery power for all functions, including the shutter mechanism, although some provide a single mechanical shutter speed of about 1/100 second to allow limited photography if the battery fails and a very few, such as the Pentax LX, give a complete range of manual speeds. The obvious answer is to carry spare batteries, but one can easily forget, and it is surprising how often the spare fails to operate, especially in difficult circumstances when you most need it. Some manually metered cameras have mechanical shutters, so only the meter will fail if the battery fails.

Before leaving the subject of automatic metering systems, we should endeavour to answer the question of whether aperture priority or shutter priority automatics are most suitable. There will always be many other considerations involved in choosing a camera, and this one should properly be well down the list, but, as a guideline, the shutter priority camera will probably best suit the photographer who concentrates on available-light action pictures, while for most other low-light work an aperture priority, with its long-exposure capability, better control of depth of field and so on, will be preferable.

AUTOFOCUSING

One of the biggest developments in recent years in camera technology has been the widespread introduction of automatic focusing. A few years ago, a number of SLR makers tried various ways of making cameras focus automatically but none was really satisfactory and most models disappeared without trace, with only the Olympus OM30 lingering on as the best of a rather poor bunch. The mechanics and electronics of autofocusing in compact non-SLR cameras, however, is much easier and this method of focusing suits them better. As a result autofocusing (AF for short) can be obtained on a wide range of viewfinder cameras which are not necessarily expensive. Most of them work by focusing in zones rather than focusing precisely in metres and centimetres, and the cheaper they are the fewer zones they focus in. Some focus in as few as three zones, which gives scope for shots not being focused accurately, whilst good cameras use about ten to twelve zones. With the wide angle lenses usually used on these cameras, this will ensure accurate focusing under any circumstances.

Autofocusing in SLRs has returned to prominence since the introduction of the Minolta 7000 and subsequently the remarkable 9000. The first generation of AF SLRs had cumbersome lenses each with a battery-driven mechanism in it; the second generation (at least, the better ones) have the mechanics and most of the electronics located in the camera, and the lenses are similar in size to normal lenses, though normal lenses cannot perform the same function as yet. The speed of action of the autofocusing, espe-

cially on the Minolta 9000, is faster than the photographer focusing manually. Incidentally, there is now an 'independent' autofocus lens, the Vivitar AF 200 mm, which can convert most SLRs to autofocus use, but it is not cheap. Alternatively, the OM30 with its AF 35–70 zoom is an excellent combination, almost up to 'second-generation' standard while the new Nikon autofocus SLRs can even use older lenses via an 'autofocus' converter.

All these innovations clearly have implications for the low-light photographer though the autofocusing system is not yet as useful as it could be. Most SLR systems rely on contrast differences within the subject, just as the human eye tends to, so the AF systems find it difficult to focus in low light or low-contrast situations, just as our eyes do (though the Olympus system works at 1/60th second at f2.8 with 1600 ASA film on some subjects). Minolta have partially solved the problem by incorporating an infra-red emitter and receiver in their 'dedicated' flashguns, which automatically comes into play when the flash is used (and can operate even in total darkness!), but it is not suitable for off-camera flash work, nor for difficult low-light conditions where you do not want to use flash. Most non-SLR autofocus systems rely on infra-red emitters all the time, so they can be used in very low-light conditions (useful at parties). It is wise to ensure that there is a focusing area shown in the viewfinder – i.e. a line around the area that the camera uses to focus on – so that you know if the system is likely to be misled by an off-centre subject. A 'focus-lock' system is very useful for enabling you to lock the focus onto any object and then alter the composition afterwards, and it is handy if this is cancellable in case you decide not to take the picture after all.

Despite its limitations, autofocusing does have advantages in many situations and it may help to get low-light pictures that you would otherwise have failed to get, especially in action situations.

OTHER FACTORS INVOLVED IN CHOOSING A CAMERA

In addition to the factors outlined above, there are other important considerations to bear in mind if you intend to do low-light or flash work, apart from obvious personal ones such as cost.

Film speed

It is important that the camera's meter can cope with a wide range of film speeds, to allow you to use fast films, uprated if necessary (see Chapter 2). For a compact/viewfinder camera, a maximum film speed of 1000 ASA is useful, but an SLR owner should expect to have the capacity for using 3200 ASA film. If your camera has automatic 'DX-coding' (i.e. it sets the filmspeed itself) then you need to have a manual override to allow for uprating or manipulation.

Viewfinder

A viewfinder display that can be illuminated internally for short periods

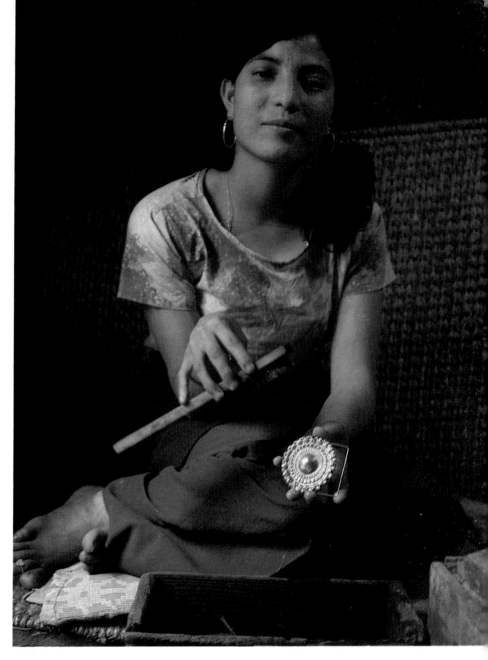

Nepalese woman with silverware. The light level in this Kathmandu workshop was too low for normal hand-held work, and it was judged that flash would have spoiled the atmosphere. This was taken using a 2 second exposure, with the camera mounted on that essential piece of equipment – a tripod.

is useful; many are lit by daylight only, and you do not always have a torch available when you need one.

Interchangeable focusing screens

In SLRs, the lens is focused on a screen via the mirror to imitate the effect of focusing on the film when the mirror is moved. The screens provided with the camera normally have a central circle with some extra focusing aids, especially a split-image rangefinder and microprism dots, but these are unsuitable for use in photomicrography, astrophotography (see Chapter 7), or when using telephoto lenses or macro lenses. For cameras with interchangeable screens, the maker's handbook will indicate which screen

is suitable for which purpose: there are usually specific ones available for each type of use. If you intend to cover many of these specialist forms of photography, it is worth looking out for this feature, which is usually found in the better quality SLRs aimed at the professional and top amateur bracket. Some makers offer a 'Lasermatte' screen which is excellent for focusing in low light because of its bright image.

Mirror lock-up

The provision of a mirror lock-up, whilst only found in a few cameras nowadays, is useful for reducing vibrations in longer exposures, preventing the vibration from the moving mirror from having an effect. A delayed action timer (intended to allow the photographer time to get into the picture) will often release the mirror well before the shutter opens, thus giving the same beneficial effect, though it is not convenient where you wish to time the moment of your exposure accurately.

High flash synchronisation speed

A high flash synchronisation speed is very useful. Most cameras only allow a flash to be used at 1/60th second or slower, and this can cause double-images or camera shake to be apparent in some circumstances where the natural light registers as well as the light from the flash. The problem occurs most often when using fill-in flash (see Chapter 3), but can be solved by having a higher flash synchronisation speed. For some reason only a few manufacturers have made any real effort to solve this problem, most notably Nikon and Minolta who have raised the speed to 1/250th second, while many manufacturers of otherwise excellent cameras have retained 1/60th second. At the time of writing, Olympus have recently produced a new camera and flash combination allowing synchronisation at all speeds, and this may eventually become the norm. A higher speed is a useful thing to look for, though it should not govern your choice of camera.

'B' and 'T' settings

It is useful to have 'B' or 'T' settings on the camera shutter speed dial. Either of these two settings, 'bulb' and 'time', allows exposures to be as long as you like, which is essential for some night photography. 'B' works by keeping the shutter open as long as the release button is depressed, whilst 'T' means that the shutter is opened as the button is pressed and it remains open until it is pressed again. The 2–3 minute exposure capability of some aperture-priority automatics is a reasonable alternative, while a few databacks allow precisely-timed exposures of up to about 2 hours.

Back-up system

A good back-up system for your camera is vital. As your interests develop, it is almost inevitable that you will want to expand your system, and some manufacturers cater for this better than others. Although a huge

range of independently-made lenses are available for most cameras, some more specialist items are available only from the camera manufacturers, and in this respect it is best to stick to a 'system' camera from Nikon, Minolta, Olympus, Pentax or Canon, which will also guarantee you good quality.

LENSES

The choice of lenses is as important as the choice of camera for low-light photography, and it is more likely that you will buy a lens specifically for low-light work.

General considerations

Aperture Other things being equal, go for lenses with a large maximum aperture; for example, a 135 mm lens with a maximum aperture of f2.8 will be more use than one with f3.5. Besides giving more light for photography, they also make viewing and focusing easier.

Lens quality It is better to choose a simple high quality lens than a complex all-purpose lens that purports to do everything. You will frequently use your lenses at their maximum aperture, where their quality is tested to the utmost; and you may often need to hand-hold them at slowish shutter speeds, when the weight and bulk of, say, a 70–210 mm zoom compared to a tiny 105 mm portrait lens will be more difficult to handle. Flare from point light sources is very prevalent in night photography, but is minimised in well-designed high quality multicoated lenses, and in this respect camera manufacturer's lenses tend to be better than even the best of the independent makers', whatever their other virtues may be.

Lenses for low-light photography

The scope of the photographic field covered in this book is so huge that almost any type of lens will find a use at some time. This is a brief review of the types available and features to look for.

Standard lenses For a 35 mm camera, this is usually about 50 mm (though it may go to 40 mm or even less on non-reflex cameras), and it is the lens that the camera is supplied with. Most SLRs are offered with a 50 mm f1.8 lens, but there is usually an f1.4 or even f1.2 lens available. These larger aperture lenses are more costly, and larger, but are invaluable for low-light work, and it is unlikely that you will buy this much light-gathering capacity in any other focal length. In the past, standard lenses with a maximum aperture as large as f0.9 have been made, but f1.2 is about the largest currently available. f1.2 and f1.4 lenses give exceptionally bright, clear focusing images.

Wide-angle lenses These give a field of view wider than a standard lens. They are most frequently used to allow more to be compressed into the picture when working in a confined space, but they have the added

advantage that they are easier to hand-hold at slow shutter-speeds than standard or telephoto lenses. 28 mm wide-angle lenses give a very marked wide-angle effect, useful for interiors and general wide-angle work, and they are available with large maximum apertures. 'Aspherical' lenses are designed to minimise flare in night-time situations, but they are very expensive.

Telephoto lenses These cover a narrower field of view than the standard lens, and therefore appear to magnify distant objects, as binoculars do. They are more difficult to hand-hold, and tend to have smaller maximum apertures (e.g. f4 or f5.6) than standard or wide-angle lenses, so their use is more limited. A short telephoto of between 80 mm and 135 mm is an invaluable lens for pleasing portraits, general purpose work, candids and many other aspects of low-light work, and a very wide range of good lenses is available. A 100 mm f2.8 lens, or something similar, is very easy to use for most low-light work, and it is available quite cheaply.

Larger telephotos, of about 200 mm upwards, have their uses but you will need very fast film or a solid support, since they will require hand-held exposures of at least 1/250th second (see Chapter 3). There is a welcome trend towards using very high quality low-dispersion glass, together with internal focusing, to construct exceptionally good quality, large aperture telephoto lenses e.g. 600 mm f4 or 300 mm f2.8. These are aimed at professional sports and news photographers and are too expensive for most amateurs to contemplate, but Tamron have introduced an interchangeable-mount 180 mm f2.5 IFLD (internal-focusing, low-dispersion) lens, and it looks as though prices may come down as the technology advances and competition increases. Needless to say, these lenses are ideal for low-light photography, if you can afford them.

Mirror lenses are a form of telephoto lens employing mirrors instead of lenses, giving a 'folded' light path and a much shorter, usually lighter, lens. Opinions differ as to whether the resultant lens is actually easier to hold than a conventional long telephoto lens – in either event, sharp results in low-light conditions are unlikely without a tripod. Mirror lenses suffer from the lack of a diaphragm to stop the lens down beyond the maximum aperture (although such lenses are just beginning to appear), and they may make an unpleasant pattern out of any out-of-focus highlights, though at times this multiple 'ring-doughnut' effect can be used to good advantage.

Zoom lenses These may fall into any category of focal length, or even, increasingly, cover several. Although very popular for general photography, they have few advantages for low-light work since you are always carrying around more glass than you are using for any one shot, and their maximum aperture is usually smaller than that of equivalent 'prime' (i.e. single focal-length) lenses. Nevertheless, a great deal of research effort has been put into zoom lenses, and their quality has improved dramatically. The 70–210 zoom lens, for example, is now available in a size that is smaller than the 200 mm lens of only a few years

ago, with excellent optical quality. They also have their uses in 'special effects' (see Chapter 10) in addition to their more conventional usage for precise framing and composition.

CAMERA SUPPORTS

For anyone considering doing much low-light work, and especially night-time photography, a good tripod is an essential prerequisite, and will open up new fields of photographic possibilities. For some low-light work, and flash photography, a support is not essential, and may even be a positive hindrance, but for most work a good support is essential. Tripods are not the only form of support, though they are usually the best, and it is worth also considering some of the alternatives.

Tripods These are literally the mainstay of the night and low-light photographer and no one specialising in these fields should do without one. There seem to be hundreds of models to choose from, but they can be rapidly narrowed down by the following requirements:

a) A good rigid tripod is necessary under all normal conditions – try it out with a telephoto lens on the camera, if you can, and see if it vibrates. A shaky tripod is worse than useless!
b) The tripod must have a good 'head' which is adjustable in three directions. A *small* ball-and-socket head is useless as it will not hold a camera with a heavy lens on, though many people favour a *large* ball-and-socket (such as the professional Gitzo ball-and-socket head) to the more conventional 'pan-and-tilt' head usually fitted: the pan-and-tilt is better if you need to move the camera in one plane only, but a ball-and-socket is more manoeuvrable.
c) Models that allow the legs to be splayed for low-level angles and greater stability are very useful.

Useful accessories for tripods include a spirit level, especially for landscapes and seascapes, arms on which to fit flashguns, and a cable-release that threads through the handle of the pan-and-tilt head.

Tripods to avoid include 'table-top' tripods, which are fine for table-tops, but useless on uneven ground since they are not adjustable and they fall over. We have, however, found the small adjustable-leg tripods, such as Velbon HE-3 mini, useful at times, and they may be just right for pressing against a wall to photograph, say, an evening scene, or to steady a telephoto. They can also be very useful for supporting flashguns or other accessories, both outdoors and in the studio.

Monopods These are single telescopic tubes with some form of camera support at the top, e.g. a ball-and-socket head. They are much less rigid than a tripod and do not allow long exposures, but they can reduce camera movement and are very useful for semi-action photography, such as candid low-light street scenes, where a tripod can be cumbersome. It is best to look for one that has strongly locking legs (some types give way if

you lean hard on them) and a head that can be moved in different ways. They are generally much lighter and more portable than tripods, though they certainly cannot replace them.

Rifle-grips These are useful devices which comprise an adjustable 'stock' with a shoulder-butt at the near end and a hand-grip at the far end. The camera fits on an adjustable plate to allow it to be used close to the eye and the shutter is fired, via a long cable-release, from a trigger on the hand-grip. The combination of steadying the set-up against the shoulder and releasing the shutter with a cable-release makes for a very smooth operation, and it can add to your ability to avoid camera shake by about 2 steps of the shutter speed (e.g. from 1/250 to 1/60 second) in some circumstances. Rifle-grips are highly mobile supports and we have found them most useful for active photography with relatively long focal length lenses. When choosing one, avoid the very cheapest makes, which tend to be flimsy; you may find it worth looking for one which gives the option of an electronic release as well as cable-release, especially if you plan to use motordrive (some motordrive/autowinders are not triggered by an ordinary cable-release). You can also make your own fairly easily from wood or metal, with the aid of a long cable-release.

Other supports Although a good solid tripod is the basis of many a good photograph, there is no doubt that there are times and situations when it is impractical to use one. In these instances, some of the many alternative camera supports are useful.

The bean bag is a fascinatingly useful and versatile support, readily made at home or available commercially. It consists of a strong bag filled with dried beans, polystyrene or similar material and sewn up. The best shape for the bag is rectangular rather than square, so that it can be stood on end for a higher viewpoint. If working close to ground level, the bag is placed on the ground and the camera manipulated so that it is steady in the position that you want; in most cases it will remain there without further support, allowing exposures as long as you like, if a cable-release is used; in other cases, some extra support is needed, but you can still get away with, say, 1/8 second exposure. If working from the car, a good solid bean bag can readily support a camera with telephoto lens placed on the roof (but turn off the engine!) or even – rather less well – on a wound-down window. Many other objects present themselves – walls, bollards and so on – and the bean bag makes an invaluable addition to a gadget bag.

Most other supports comprise a ball-and-socket head attached to some form of support. A G-clamp with a head on can be clamped to fence posts, car windows and so on, though it is rarely solid enough to use a long lens and the support is hardly ever where you want it! A magnapod attaches to any metal surface by a powerful magnet, so it too can be used on a car.

If nothing else is available, it is surprising how useful a folded-up coat, a gadget bag or rucksack, or even a fence-post can be. Something is usually better than nothing!

Before leaving the subject of supports, one further item should be

mentioned. To get the best out of any support, a cable-release is invaluable to prevent any vibration arising from you touching the camera. A reasonably long one is best, and a collar lock is essential to allow long exposures using 'B'. You will find that you keep it longer if you colour it brightly with tape or paint.

FLASHGUNS AND FLASH ACCESSORIES

Use of flashguns is an important part of photography in low light, but the range is now so enormous, and so many are unsuitable, that some guidance is necessary. It may help, perhaps, to first define a few terms:

Electronic flash Nowadays, any flash unit that you buy will be electronic, unless you specifically seek out something else, and the days of flashbulbs are almost gone. Most electronic flashes are powered by batteries, which usually last for about 50–100 'flashes', and the light comes from a gas-filled tube through which a high voltage current is passed. The great advantage of electronic flash over bulb flash, other than the fact that you can get so many 'flashes' without having to change the bulb, is the fact that the duration of the 'flash' itself is extremely short – usually 1/1000 second or less – and so it provides a sure way of 'freezing' movement.

An automatic electronic flashgun has a light sensor and additional circuitry which allows it to 'read' the light coming back from the subject and switch itself off when enough light has been emitted correctly to expose the subject at a pre-determined aperture. This system is very clever, but not entirely satisfactory since it is not generally accurate out-of-doors or in close-up work – although macro-sensors are available for some models, and these overcome some problems.

Through-the-lens flash systems In this type of system, the amount of light actually reaching the film from the flashgun is metered and the camera switches off the flash when enough light has reached the film. This has tremendous advantages, particularly accuracy and versatility, since it can be used with any lens, extension or filter combination, or bounced, diffused or used with multiple flash, and at any aperture. With some makes it can even be used to give accurate fill-in flash metering. We have also found that with the excellent Olympus system one can 'paint' the subject with light from a series of 'open' flashes (see below) during a long exposure, and simply carry on until enough light has been provided. The versatility of these systems is endless and, with the best, up to nine flashguns can be used at once in any combination of positions as long as they are all connected to the camera.

'Open' flash Better flashguns have an 'open flash' or 'test' button which allows you to fire the flashgun separately from the camera. This means, amongst other things, that you can flash at any time during a long exposure and as many times as the flash will allow during a very long

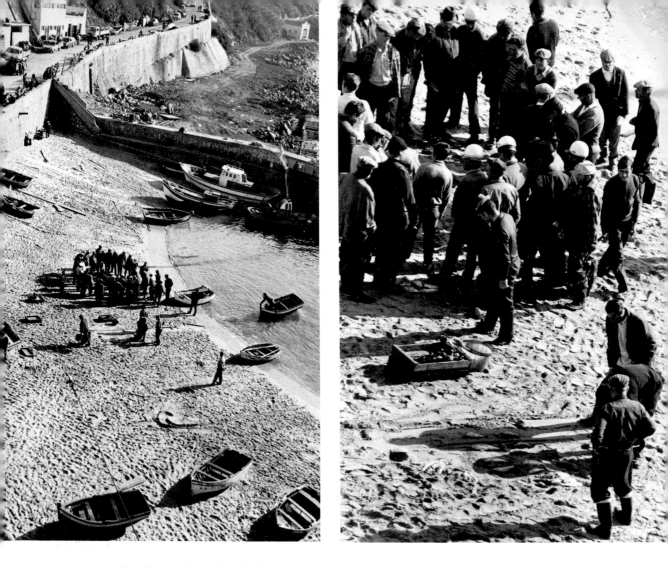

exposure to build up a complex lighting pattern. This is invaluable for many low-light pictures (see Chapter 3).

'Dedicated' flashguns These are flashguns designed to work only with a particular camera or range of cameras, and when fitted they automatically set various functions such as the correct synchronisation speed, view-finder information, and so on. Independent makes (e.g. Sunpak) are now available with interchangeable 'feet' to allow dedicated operation on any popular camera.

Guide numbers The guide number of a flashgun (GN for short) is an indication of its power. It is calculated by multiplying the aperture you would need for correct exposure by the flash-to-subject distance. Because this varies with the film speed you are using, as well as the way you measure the distance (feet or metres), manufacturers usually have standardised guide numbers quoted for 100 ASA film, with the distance measured in metres. So if you have a flashgun with a guide number of 32 (ASA/ISO 100, metres), it would allow an aperture of f16 to be used at a distance of 2 metres ($2 \times 16 = 32$). In practice most guide numbers are rather optimis-

Two pictures, taken in the same evening light, to show the effect of different lenses on form and composition. The first was taken with a standard lens, while the second was taken from the same viewpoint with a long telephoto lens to isolate the group of fishermen from the scene.

tic, perhaps because they are measured in a bright reflective room, but all seem equally inaccurate so you can still compare different flashguns.

It is worth remembering the way in which guide numbers are calculated as this greatly facilitates fill-in flash and other calculations (see Chapter 3).

Which flashgun?

As a general rule you will need a fairly powerful flashgun, preferably either with reduced power settings or with an automatic sensor to allow variable power. If you buy an automatic 'gun, ensure that it can be used manually, and for any flashgun ensure that it can be fired independently by a test button. Some flashguns do not provide a lead, and can only be used on the camera hot-shoe, but there is an accessory available to overcome this problem if you wish to use the flash off the camera (as we hope you will after reading this book!).

The new 'System' flashguns (e.g. the Sunpak Auto 622 Pro system) are excellent. They provide a range of interchangeable light sources, such as ring-flash, bare bulb, bounced flash etc., with the same power pack and electronics. A few flashguns, such as the National PE-388 SW allow easy fill-in flash, which can be an advantage although it is not a difficult technique to master (see Chapter 3). If your camera provides TTL flash metering, it is well worth buying the correct flashguns to make use of this – usually the manufacturer's own flashguns, although some interchangeable dedicated 'guns will work.

Flash accessories

Slave units These are small triggering sensors that fit onto a flash lead to trigger the flashgun when light from another flash falls on it. They are much more convenient than leads in multiple flash set-ups, especially over long distances. A few flashguns have built-in sensors.

Zoom heads Some flashguns have built-in, while others offer as accessories, a variable optical magnifier which allows the light beam to be narrowed and therefore strengthened for use on more distant subjects. Since many flashguns emit light in a wide enough arc to cover the field of view of a 28 mm lens, then narrowing down a beam to cover the field of view of, say, a 100 mm lens greatly increases its power. At the same time, these heads usually have the effect of producing a greater reflector area which helps to soften the light and avoid hard-edged shadows.

Some flashguns also offer a range of filters to colour the light from the flash, or reduce its strength; overall we have found them to be useful accessories.

Power sources Portable flashguns are normally powered simply by penlight batteries. A mains connector is useful for studio use, while a separate rechargeable pack of batteries, sometimes available as an optional extra, is useful if you need to change batteries in a hurry. If you use flashguns a good deal, we would recommend using rechargeable batteries in place of normal ones to cut costs considerably. There is also an interesting alter-

native, called the Quantum battery, which replaces batteries with a very stable, high-powered, rechargeable waistpack.

OTHER USEFUL ACCESSORIES FOR LOW-LIGHT WORK

Besides lenses, flashguns, and camera supports, there is a wide range of accessories that will assist the process of obtaining good low-light pictures. It is unlikely that anyone will use all of them, but it is useful to know what is available. Some specialist items are briefly referred to here, but looked at in more detail in their respective chapters. Filters for low-light work are considered in chapter 2.

Light meters and flash meters

Although your camera's built-in meter will work for almost any situation, there are times when a separate light meter is an advantage. Cameras with more complex metering systems, featuring multiple-spot metering and through-the-lens flash metering, will solve most of the problems, but simpler systems are easily defeated by low-light and flash photography.

Light meters or exposure metres normally measure and indicate the amount of light reaching them from any continuous source, but not from electronic flash. Flashmeters are designed to read the exposure for a flash-lit situation or a mixed flash and daylight picture. They vary greatly in complexity and accuracy, but are only of use in *repeatable* situations, where you can fire the set-up as you will use it, meter the exposure, and then set this on the camera for the real thing. This may limit their use, though even in some forms of wildlife photography you can use a 'dummy' and check the likely exposure in advance of your subject's appearance.

Standard exposure meters come in various forms, at a huge range of prices. Western Euromaster meters, though rather dated, still tend to be the standard for others, but there is a great choice available. Selenium meters work by emitting a variable measurable current when light falls on them (like Solar panels), while Cds and other types are battery powered and measure a variable resistance. Cds meters are generally more sensitive in low-light situations, and therefore better for our purpose, though the cheaper types may have a 'memory' lasting a few minutes, giving false readings if you move from bright light to dull light. Cds meters tend to be more robust, but Selenium meters can be helped by the addition of a locking needle.

The main points to look for include:

1) Reliability, including robust construction and locking needle: this usually means the costlier models of the better-known brands.
2) Ease of use; remember that you may be using the meter in very dull light, so controls should be simple to handle. A lockable reading is invaluable since you can take the reading and *then* check it by

torchlight. Direct action is better than the older types where you need to read the needle and then transfer the reading.

3) Availability of attachments, particularly telephoto or spot-meter attachments, which are most useful for low-light work. An incident light facility is less useful for this type of work, though many people favour it for general work. Some form of angle-narrowing attachment is very useful to simulate telephoto lens coverage, or to take a reading selectively from one part of the picture.

Meters by Weston, Gossen, Calculite and Minolta are all excellent value. Flashmeters have come down considerably in price in recent years, and there is now a great range available. For the type of work covered in this book, some useful features to look for include:

1) Flexibility, to use the meter in various positions
2) A hot shoe on the meter, allowing you to fire a small flash to trigger your main flashes via slaves – this makes it easier to use the meter from the camera position without long leads to each flashgun
3) The meter should be sensitive enough to work from a small flashgun – many are designed primarily for higher power studio units with a longer duration of flash, and may not be accurate with the fast flash speed of modern small units
4) The option of high and low sensitivity scales
5) Reliability, and repeatability of results

Some flashmeters now cope with ordinary daylight exposure and fill-in flash, too, which can be useful. When using flashmeters, be very careful to ensure that your flashguns are fully charged both when metering and when taking the picture: the 'ready-light' comes on before the flash is fully charged, so allow a few more seconds to give you reliable results.

Lens hoods – or shades

A lens hood is invaluable for night work. It may be tempting to think that it is unnecessary in low-light photography, but all light sources at night – street lights, passing cars, etc. – will cause flare which will detract from the quality of your image. The longer the exposure used, the worse the flare will be. A good lens hood, geared as closely as possible to the lens you are using, will greatly reduce flare, and is especially important if you are using filters. Incidentally, a rubber eye-cup over your viewfinder helps with your viewing of the viewfinder image, especially if you wear glasses.

Image intensifiers

It is possible to buy image intensifiers, e.g. the Modulux, giving an illumination gain of about $\frac{1}{4}$ million times, for use in photography. Their use is limited for natural-looking photographs, but they will frequently produce useable photographs when there is no other way. They are expensive, of course, but can be hired as required.

Reflectors

Reflectors are simply pieces of material that will reflect light, and they can be commercially-made or improvised from readily-available materials like card, polystyrene, or silvered survival blankets. There are innumerable occasions when a reflector will put light where it is needed or balance the exposure of a contrasty subject, and it is well worth having one with you all the time. For close-up work, a piece of white card with foil on one side will be adequate, but for general work a larger reflector is needed. The range of folding Lastolite reflectors is very convenient, allowing a large circular reflector (white, silver or gold) to be packed into a gadget bag, or one of the large silvered survival bags (intended as heat reflectors) will do equally well.

Triggering devices

There are now a number of camera-triggering devices commercially available that will allow the camera shutter to be fired when an object cuts a beam. Since most of them work as well in darkness as in the light, their advantages are obvious. They are available in various forms from Kennett Engineering, Mazof, and others, and are particularly useful for night-time natural history work (see Chapter 5).

Specialist adaptors

There are specialised adaptors available for using cameras with microscopes, telescopes, monoculars etc. and some of these are looked at in more detail in the appropriate chapters. Incidentally, you can also buy adaptors that allow you to use telephoto lenses as good quality telescopes, and Tamron make one especially for use with their lenses.

Camera waterproofing systems

Since you may frequently face poor weather conditions in the quest for good low-light pictures, it is useful to be aware of the range of Ewa waterproof capes or fitted camera covers that allow photography to continue in wet weather, and even underwater.

Miscellaneous items

A number of non-photographic items will frequently come in useful, particularly for night work, and these are looked at in more detail later. They include a notebook and pencil to record your exposure details and other information; a torch for seeing camera or notebook, finding the dropped lenscap, focusing, and even lighting up the subject for special effects; a portable, battery-operated, hairdryer for wintertime night work to prevent condensation forming on the lens and viewfinder; and warm clothes and gloves are invaluable!

2 Films, Filters and Processing

Working at night and in low light, you will be faced with a wide range of qualities of light, many of which are outside the range for which the commonest films are primarily designed. You are likely to use very long exposures, strongly coloured evening or early morning light, artificial light from tungsten, neon, fluorescent or other sources, or a mixture of these, and ordinary films are simply not intended to cope with these situations. There are, however, an enormous number of films available to cope with most lights, and there are also filters that will allow you to eliminate colour casts and improve your results, as well as producing special effects. Since you can also manipulate your results considerably by the way you process, or get someone else to process, your films, that is covered here too.

Film quality has improved dramatically in the last few years. Names that were associated with rather poor films are now synonymous with really excellent materials, and the established names have all improved the quality of their products. In fact, the ultimate quality of the very best films such as Kodachrome 25 or Pan-F film has changed little, but a whole range of faster films has been introduced and these are beginning to compare favourably with the established standards. For the low-light worker, this has made life easier, and has opened up new possibilities for low-light action shots that were quite impossible a few years ago.

Before looking at the range of films available, and what use they are, it may be helpful to explain a few terms. The *speed* of the film (as distinct from shutter speed) is of vital importance to the low-light worker. It is a measure of how sensitive the film is to light: the more sensitive it is, the less exposure you need for a given result. Film speed is measured on a standard scale, nowadays usually quoted as an ASA or ISO number (which are the same) or a DIN number (which is different). The higher the figure, the faster the speed is, and it follows a geometric scale such that 200 ASA film is twice as fast as 100 ASA film, and 800 ASA is twice as fast as 400 ASA. In practical terms, if you double the film speed you are using, then you need half the exposure, e.g. 1/60th second at f8 instead of 1/30th second at f8. To take a more extreme example, if, in a particular low-light situation, you found that the meter reading would be 1/8th second at f1.8 with 50 ASA film, this would become 1/250th at f1.8 with 1600 ASA film. It is obvious which would be easier to make use of with a hand-held camera, or with a moving subject.

Naturally enough, there are advantages and disadvantages to each type

of film. As an almost universal rule, the faster the film is, the less detail it records, and the grainier and less sharp it is. Faster films also tend to show less contrast, and with colour films, the colours are usually less accurate. There are many low-light situations when you can do nothing but use a fast film, but if you are working with a tripod, or using extra artificial light such as flash, then a slower film will provide the sharpness and impact lacking from a faster one. Good situations for using slower film include photographing floodlit buildings or sunset and dawn pictures.

Some types of film can be uprated to be used at higher speeds than their normal rating. All black and white films can be uprated, and so can all colour slide films that are processed with E6 (or the equivalent CR56 or AP44) chemicals, such as Ektachrome, Fujichrome professional and Agfa-chrome professional. Most will stand uprating by 2 stops if necessary (e.g. 100 to 400 ASA), but they lose quality with each stop they are uprated. In order to uprate a film, you need to set the meter accordingly at the start of the film and keep it there, simply treating the film as a faster one, and then make sure you tell your processor what you have done (or process it yourself accordingly).

Most films are designed to give their best performance in well-lit situations, especially on sunny summer days. Not only do colours respond less accurately in low light, but also the simple law that governs the exposure of the film breaks down. Normally, if you halve the time of the shutter speed (e.g. from 1/125th second to 1/250th second) you need to double the size of the aperture (e.g. from f11 to f8) to keep the amount of light reaching the film, i.e. the exposure, constant. At longer exposures, though, the film becomes relatively less sensitive, and going from, say, 1 second to 2 seconds does not have quite the expected effect. This inherent

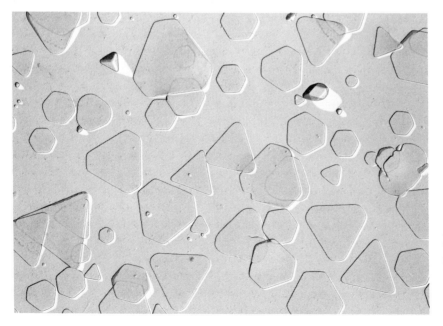

A scanning electron micrograph of the new Kodak 'T-grain' emulsion, enlarged almost 2000 times. The regular thin platelets give an increase in speed and sensitivity for the film without a corresponding increase in granularity or unevenness. Photo courtesy of Kodak Ltd.

characteristic of films is called *reciprocity failure*. Films vary in their degree of tolerance; for Kodachrome 64 for example, Kodak recommend + 1 stop extra exposure at a shutter speed of 1 second, and do not recommend use at all beyond this (though we find this to be irrelevant as long as you are not too concerned about precise colour balance in the results). Ektachrome 400 would require an extra $2\frac{1}{2}$ stops at 100 second exposure, while Ektachrome 100 is not recommended at all for use beyond one second. Colour print film, e.g. Kodacolor or Fujicolar and black and white film, are both recommended for use at long exposures, with colour correction as necessary (see page 32), provided correction of 2–3 stops at 100 seconds' exposure is given. Negative films, like black and white films or colour negative (print) films, are more tolerant than slide films since there is scope for correction in the printing stage, though it is always best to aim for correct exposure in the first place.

TYPES OF FILM AVAILABLE

Black and white film (Monochrome)

Black and white film is readily available in speeds between 25 ASA and 400 ASA. For really sharp contrast results, the slow films such as Kodak Panatomic-X, Agfapan 25 and Ilford Pan F are perfect, but they can only be used in low light with a firm camera support. They are the best films for sizeable enlargements and exhibition prints, but there is no point in going for a slow film if conditions mean that there may be camera shake or subject movement.

Ilford FP4, Kodak plus-X and Agfapan 100 are all excellent all-purpose films. They are fine for everyday use, sharp enough for most enlargements, yet they can be uprated to meet more demanding low-light conditions if necessary, without much loss of quality. 400 ASA films, such as HP5, Agfapan 400 and Tri-X are also readily available and widely used. They show a little less contrast and sharpness than their slower counterparts, but if exposed normally will give very good results. Black and white 400 ASA films are most frequently uprated, and sports or news photographers working in low-light action situations will regularly use them uprated as far as 3200 ASA. It is rare for speeds beyond this to be used, and the higher speed ratings are most suited to low contrast subjects, or when you are unable to take sharp pictures by any other means. The fastest widely available 'ordinary' black and white film (although see below) is Kodak recording film 2475 (1000 ASA) for 35mm users, and Kodak Royal-X Pan film (1250 ASA) for 120 roll-film users. These are inherently grainier and softer than slower films, but very useable, and they can be 'pushed' 1–2 stops further to give 4000 ASA where absolutely essential (if your camera can accept it!). Sharper monochrome film is being introduced.

A relatively recent development in the field of black and white films is the appearance of chromogenic or dye-image films, Ilford XPI and Agfa Vario-XL. These use a quite different process to normal monochrome

films, and have different characteristics, though the end results are very similar. Instead of the normal silver process, they use colour negative film chemistry and are processed either in the manufacturer's special developer (e.g. Ilford XP1 chemicals) or the C41-type colour process with very slight loss of quality. The great difference in their use, compared to normal films, is that their effective film speed is variable at will. Although their nominal film speed is 400 ASA, both makes can be used over the range 50–1600 ASA on the same film if necessary, without adjustment or changes in development, though results are better if they are used at one film speed and processed accordingly. This means that you can take photographs at almost any setting, without problems arising! They can also be uprated during development to give about 3200 ASA especially if working in low contrast conditions. Many people prefer the results from chromogenic films anyway, and their ease of use is unsurpassed, particularly for low-light and night photography. They have not become as popular as expected, perhaps because of the higher cost of processing, but they are well worth trying. Of the two, the Ilford film is generally reckoned to be the better, and we have found it to be excellent.

Colour negative film for prints

This is probably the most widely used film amongst amateur photographers, since prints are much more readily shown to relatives and friends. They are not as suited to publication as colour transparency films (see below) and their definition is less good, but they are very tolerant of under- or overexposure and their popularity is understandable. The quality of colour negative films has advanced distinctly in recent years; the slower films have become much sharper with more accurate colours, and at the same time many faster films have been introduced. 400 ASA films are now virtually standard, several 1000 ASA films are available, and there are even two 1600 ASA films (Fuji and Konica). The latter films are especially suited to low-light work, and in addition, are more tolerant of incorrect exposure, particularly overexposure, compared to transparency films – partly because of the opportunity for correction at the printing stage.

There are so many colour negative films available that we cannot review them all. They fall roughly into the slow higher-definition films, all of about 100 ASA; the medium-speed 400 ASA group; and the 1000–1600 ASA group. They may be treated in exactly the same way as different monochrome films, using slow films only for static subjects with a well-supported camera, and the fastest films for the most difficult circumstances where nothing else will do.

Virtually all colour negative films are manufactured to give their best results in daylight or with electronic flash, and negative films that are balanced for use in tungsten lighting can only be obtained with difficulty (e.g. Eastman 5293 film). However, the faster films, such as Kodacolour VR 1000 are tolerant of a wide range of different light sources without special care, and filters can be used for correction (see below).

Colour transparency (slide) or reversal films

Colour transparency films are most popular with professionals, lecturers, authors and advanced amateurs, because they directly produce slides for projection, and are most suited to work for publication in colour. They are very fine-grained, with clear accurate colour for reproduction. Most makes are geared to daylight/electronic flash lighting, but manufacturers usually also offer a tungsten-balanced film for use in artificial light of the appropriate type. Daylight film used under different lighting conditions will give mixed results – it is usually fine for situations like fairgrounds or street scenes where there arc many light sources and colours do not need to be precise; but for accurate colour rendition tungsten film should be used if working solely in artificial light indoors. Filters may also be used to correct colour casts and the techniques of matching film to your light sources are described in more detail on page 32.

The slowest transparency films (25–50 ASA) are very fine-grained, with exceptionally accurate colours. If circumstances permit, these are worth using in low light to provide strikingly sharp pictures, but they are ruled out of all hand-held or action situations by their extreme slowness. There is a huge range of films available around 100 ASA – e.g. Ektachrome 100, Fujichrome 100, Agfachrome 100 and so on, and most of them are very good all-purpose films. Most can be uprated as required by 1–2 stops, but it is not usually worth going beyond 1 stop extra except in emergency, since there are faster films available anyway.

Films are available from most manufacturers at 200 or 400 ASA which combine reasonably good colour and definition with higher speed, and are suitable for many low-light applications. Most can be uprated satis-factorily. Beyond this, there are 1000 ASA slide films available from Agfa and 3M, and an 800/1600 ASA Ektachrome film from Kodak, suitable for use at either speed, or at 3200 ASA if necessary. The quality and definition of the faster films is certainly lower – though if you compare them with, say, the GAF 500 film of 10 years ago, you realise how much film quality has advanced – but they are very usable, and in many cases are the only option. We have recently tried the new 400 ASA and 1600 ASA Fuji professional films, and found them to be excellent, even when uprated by 1 stop.

Artificial-light films, balanced for about 3200°k tungsten lighting (see Chapter 3) are available from Kodak, Fuji, Agfa and 3M. Most have speeds of about 50 ASA, but there are faster versions available from Kodak (Ektachrome 160 ASA) and 3M (640 ASA), which may be useful in lower light situations.

Infra-red films

Special films for recording infra-red light are available in both colour and black and white. This field of photography, and its fascinating results, is described in Chapter 10. At present only Kodak make widely-available infra-red recording films, and these are Ektachrome Infrared film 2236

(roughly 100 ASA, colour transparency film) and Kodak high speed Infrared film 2481 (variable speed, black and white film). The colour version is referred to as producing false-colour images, since these bear little relationship to our visual perception of colour. Processing of the colour film is by E4 processing (see Chapter 10 for UK laboratories dealing with this), while the black and white film is recommended for development in Kodak D-76 or HC-110.

FILTERS FOR LOW-LIGHT PHOTOGRAPHY

Filters have played an increasingly large part in photography in the last few years particularly since the introduction of the Cokin-style square 'effects' filters. Many of these are not specially relevant to low-light photography, but there are a number of filters that do significantly affect results in our field. There are a range of correction filters which aim to correct the colour balance if the type of light is wrong, or to compensate for the failure of the film colours to respond evenly during long exposures; and there are a number of filters designed primarily for general purpose work which can play a part in low-light work, plus a few specialist filters that will be mentioned here, but will be described more fully in the relevant chapters. Most types of filter can be bought as simple circular pieces of glass, which may be multi-coated, that screw into the front of the lens being used; or in square acrylic for one or other of the 'effects filter' systems; and some can be bought as gelatin sheets that fit in a holder.

Filters for colour compensation and correction

The colour composition of natural light varies according to the time of day and the atmospheric conditions, and the colour composition of artificial light sources differs from that of natural light. Our eyes and brains tend to adjust to most changes in colour composition, but films are not able to do so, and are designed to work best in particular types of colour composition. Colour composition can be measured, and is normally expressed in terms of Kelvin degrees, a measure of temperature, such that the lower the number (or colour temperature) the more red and orange there is in the light; and the higher the number, the more blue and white there is in the light.

To get correct colour balance, (though this is partly a subjective matter), you need to match your film with your light source, e.g. daylight film is balanced for light at about 5500–6000°K, while tungsten film is balanced for 3200°K. Often, however, you may not have the correct film for the moment, or such a film may not exist, and this is where conversion filters come in. A very wide range of such filters exist, with the widest range made by Kodak. For precise colour balancing, however, the filtration is so precise and varies according to both the film and the exact type of light source, that there is not space to offer all available combinations. The most

commonly used ones are:

1) Type 80B (Blue) for exposing daylight colour films by Type A (photolamp 3400°K) light
2) Type 85 (Amber) for exposing Type A film in daylight
3) Type 85B (Amber) for exposing tungsten films (very similar to Type A films) in daylight

In addition there are a range of filters for correcting minor shifts in colour temperature (the Wratten 81 and 82 series) and others for using, for example, daylight film in fluorescent lighting (e.g. Hoya's FL-W or FL-day, or various Kodak filters), but unfortunately different types and makes of fluorescent lighting need different colour correction, so the idea is not very practical unless you really *have* to get correct colours.

To compensate for the small colour shift caused, e.g., during long exposures, you can use a colour compensating filter, designated CC followed by a number; e.g., when exposing Kodachrome 64 or Kodacolor 100 at about 1 second, the use of filter CC10R is recommended (plus 1 stop extra exposure); while when using Ektachrome 400 at exposures of 1–2 minutes, filter CC10c is recommended, with 2–3 stops extra exposure. In important once-only shooting sessions it is possible to check test transparencies on a light box by overlaying correction filters until you obtain the colour you want, and then to shoot again with a filter of half that strength; for example, use a CC10R if a CC20R looks right on the light box.

To summarise: it is possible, with a little trial and error, to compensate for light or film characteristics and get the colour balance of your choice. One useful mildly coloured filter is the skylight type 1A filter, which is very pale pink, and which is useful for reducing the bluish cast on some films exposed in the shade on sunny days, or occasionally with electronic flash. Its effect otherwise is no more than that of an ultra-violet filter, and it can be left on as a lens protection.

Other filters

Polarising filters find many uses in general photography, for improving sky rendition, removing reflections from water, clarifying the tones of foliage, etc. In low-light work, they are useful for photographing polished wood, pictures mounted behind glass, and through windows. In each case they reduce the glare from the reflections and consequently improve definition – but remember that you lose about $1\frac{1}{2}$ stops of light in the process. Polarising filters can also be used for interesting effects out of doors, and can be combined with colour filters.

Square graduated filters in grey (which cause no colour shift on the picture) or light brown (e.g. tobacco or sepia) may be useful where the sky is much brighter than your subject. They can be used to reduce this exposure difference, making a better picture. Similarly, if there is a bright light source in the upper half of a night-time picture (e.g. the moon, or a street

light), you can effectively increase detail in the rest of the scene by reducing the intensity of this source, (see below, also, under Neutral Density filters).

Neutral density filters are grey filters that *reduce* the amount of light reaching the film without upsetting the colour balance at all. They come in various strengths e.g. ND2, ND4, and progressively reduce the light in one stop increments. It may seem odd to mention them in a book on low-light photography, but they do have their uses. Square neutral density filters can be held over *part* of the photograph to reduce the exposure for that part, e.g. the moon, a street light, a bright sky, to bring it closer to the exposure value of the remainder of the scene. In extreme cases where there is a very bright light and a very dark subject (which often happens on moonlit nights), you can use a black card, or even your hand, to achieve the same effect during part of a long exposure. You can also use them to turn a longish exposure into a really long one, giving more opportunity for using extra flashguns, reflectors, etc.

Special effects filters such as 'starburst' etc. can liven up some night scenes, and they are discussed in Chapter 10. There are also filters that are suitable for use with infra-red film to enhance its effects, e.g. 12 or 15 (both deep yellow) or 87 (black); these are discussed in Chapter 10.

Incidentally, if you regularly use screw-in filters, you will find a cheap *filter wrench* is an extremely useful accessory.

Boy at funfair sideshow. With very low-light, but active, subjects, you are obliged to work at the limits of your film and equipment, and accept that the results may not be technically perfect. This was taken at f2.8 with a 100 mm lens, at 1/30th second, using Ektachrome rated at 1600 ASA.

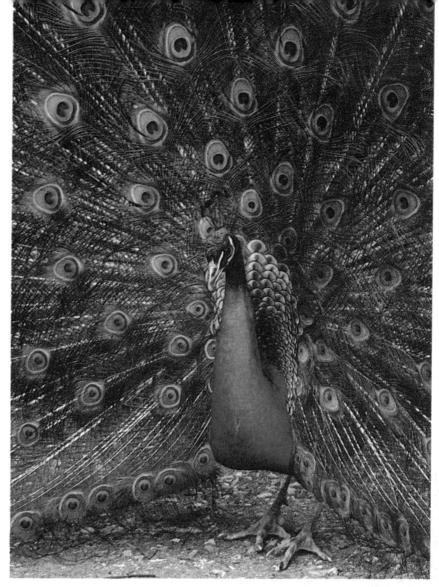

Male peacock displaying. The quality of colour and detail available from today's high speed films is remarkably high. Here, the very low light necessitated the use of a fast film, in this case Fujichrome professional 1600 rated at 3200 ASA, with very satisfactory results. The effect is less good where light-coloured areas show the grain, but this is not a problem here.

PROCESSING FOR LOW-LIGHT WORK

It is not the purpose of this book to go into minutiae about the processing of film but rather to point you in the right direction by giving you the background to film development, suggesting a few possibilities to try, and giving you some advice on how to make the most of your negatives. We start by discussing processing black and white negatives taken under low-light conditions and making a finished print from them, and then go on to discuss processing colour films for increased speed.

Processing Black and White film

Here, as throughout the book, most of the comments apply to 35mm film, though with only slight modifications the basic techniques apply to all formats. Amateurs normally develop film in small, light-proof plastic tanks with the film wound on a plastic or stainless steel spiral. These small

tanks typically hold 300 ml of solution to develop the film. The basic process is to load the film on the spiral in the dark, put the film in the light-proof tank, tighten the lid and switch on the light. All processing then takes place in the light. A 'developer' is poured in for a specified time which is governed by the developer's activity and temperature. This developer considerably enhances the effect of light on the light-sensitive silver salts and converts them to silver oxides. The process is seldom continued for long, but curtailed at a pre-determined time that gives the best reversed representation in greys from black to white. After development the film is washed by pouring water through the lid, which is funnel shaped and light baffled. A solution called 'fixer' is then poured in, which removes all the silver salts not affected by the developer; the film is then washed thoroughly to remove all the chemicals. This process represents the bare bones of the story; other things happen during processing such as the removal of anti-reflection dyes and hardening of the emulsion, but they need not concern us here.

It is the action of the developer which is most important here, particularly its ability to increase the effective speed of the film. With any developer, the effect it has of increasing the speed of a film is controlled by increasing a) the concentration of developing agents and b) the length of time and temperature at which it is used. However, it is not usually quite as straightforward as this, since some developing agents produce only contrasty results, and others produce 'soft' low contrast results and most are used in a combination to give a correct or normal negative at a 'normal' time and temperature. There are many negative developers available to suit all types of film and conditions, including some very good general purpose negative developers which are sufficiently versatile in terms of dilution and development times to be used as both normal developers and developers for film exposed under low-light conditions. Any deviation from the normal recommended development time for a particular developer/film combination will be at the cost of either increasing or decreasing grain, definitions and contrast. Increased grain and contrast usually go hand in hand with increased developer activity or increased time in the developer.

Different developers and film combinations have different sets of compromises and since there are so many permutations, enthusiasts can be sure of finding one to suit their particular requirements. However it is not usual to use the extremes of low contrast speed-reducing fine-grain developers with low contrast high speed films.

You will gather from the above that it is possible to exert a fair amount of control over your negatives, and tailor your developing technique to your subject. Make sure you fine-tune your taking and developing technique to suit the subject, in the following manner: for low contrast low-light situations greatly increase development time – at least half as much again (with normal light levels and a flatly lit scene one would also increase the speed of the film by $\frac{1}{2}$ stop at the time of taking). For high

contrast low-light scenes give slightly more exposure and decrease the development time.

The gross uprating of films where almost everything else is sacrificed to produce a high contrast image in extremely low-light conditions is used routinely for some medical and scientific applications. One medical technique involves photographing the interior of the eye with a normal black and white film (FP4) chosen for its special response in one area of the colour spectrum, and uprating this film from 125 ASA to 1250 ASA by using a developer at twice the normal concentration at 5°C above normal developing temperatures, for twice the normal time. A print showing this technique used in hospitals for fundus flourescein angiography is shown here. The technique clearly shows the tiny bloodvessels on the image-receiving layer of the eye and is used to diagnose causes of loss of vision.

There is one film which in our opinion stands out above all the others for its ability to be up-rated and produce results under adverse conditions – this is Ilford HP 5. We have used this film and its predecessors for over 25 years with the same brand of developer – May and Bakers Promicrol – and herein lies the secret of success. Using the same developer/film combinations for so long has given us the consistently predictable results we need – we know just what to expect when using this film/developer combination for normal work and for push processing. We have learnt exactly how far we can uprate a film and judge closely its likely effects. We do not particularly advocate you use this simple system but we do advocate that you standardise a system and keep to it, as there is very little to be gained from using a whole range of developers and films.

It is not within the scope of this book to delve deeply into darkroom practice but rather to point you along the right paths to establish your own techniques to suit your style of photography. Briefly our system for HP 5 film is to dilute the standard Promicrol 1 litre stock solution with an equal part of water i.e. a 1 : 1 dilution, and develop for twice the recommended time at 20°C. This uprates the film by a factor of 2 from 400 to 800 ASA. For 1600 ASA we develop for half as long again i.e. if the basic developing time was 10 minutes for 800 ASA, we develop for 15 minutes for 1600 ASA. Promicrol is also excellent for Ilford's other two films, Pan F and FP4 which we use for our general photography using a similar uprating technique.

This system works very well for us, though other successful photographers we know use Ilford HP 5 and other Ilford films with Ilford's microphen developer. A sports photographer we know who takes a lot of pictures under floodlit conditions uses HP 5 with Paterson Acuspeed developer. In Fleet Street, the press photographers seem to favour Kodak Tri-X developed in D 76 or a similar developer, but all without exception agree: find a combination which suits you and stick to it. Do not chop and change or you will never get consistent predictable results. Keep to the same film/developer combination, and you will soon begin to adjust your taking strategy to keep within its known limitations.

An unusual picture of an eye. The patient had been injected with fluorescent dye to detect whether there was any leakage from the arteries and veins; the film used was FP4, which responds well to this dye, uprated to 1250 ASA and developed for twice as long as usual in concentrated developer at a higher than normal temperature.

Processing the low-light print or enlargements

Having got a good negative it is best to be able to print or enlarge it satisfactorily. Making an enlargement from a negative involves the same development and fixing process as used for the negative but with different kinds of developer specially formulated for enlarging papers, and whilst the fixer may be the same, it is used at a different dilution, and without additives such as hardeners used to protect the negative. Paper development is done to completion, not cut short as in negative development, and again there are a number of developers to choose from. Our advice is to find one and stick to it, though we have found that the paper manufacturers' own are invariably among the best.

At the enlarging stage one can again control contrast, not this time by increasing or decreasing exposure and development times, but by selecting paper grades which will give hard or soft results. A grade one paper will give a soft, low contrast with many shades of grey, and a grade five paper will give high contrast and few shades of grey between black and white. Grade 3 is considered to be normal contrast. We would recommend the multigrade type of paper where the contrast is governed by the use of a series (1–5) of yellow and magenta filters by which means all grades of contrast are available on one sheet of paper at the same time. This means that just part of a scene can be changed to a higher or lower contrast rather than the whole scene, as happens with conventional enlarging papers.

Alleyway in a French town, at night. Modern films, in this case Ektachrome 100, handle a range of light sources well though results are not always quite as the eye sees. This picture is a typical night shot, with different types of artificial light, and the blue of the twilight at the top.

There are two types of printing or enlarging paper – resin-coated and fibre-based. The latter takes longer to develop, typically two to three minutes, longer to fix properly (5–10 minutes) and longer to wash (15–30 minutes). With resin-coated papers the whole process can be completed in 5 minutes and, additionally, when air dried, they stay flat. They do have a few disadvantages in that they are slightly more difficult to mount with heat, the tone according to some people is not quite as good as it is in fibre-based papers, and there is not quite the range of surfaces available. Surfaces of printing papers can be glossy, pearl, fine lustre, matt or silk. We use only two types of surface – glossy for commercial work and fine lustre for exhibition and display.

To make an enlargement or print, you place a clean negative in an enlarger, and, using a special lens which has the same apertures as the taking lens but no shutter, you project an image onto the base board. The light of the enlarger is switched off, a sheet of enlarging paper placed on the board and an exposure made by switching on the enlarging light for a predetermined time. The time is estimated by making test strips – an important step towards producing the finished print, since the test strips will show what various parts of the projected image will require different exposure times. We have very rarely found a negative that could be printed straight without any 'dodging-in' (the term used for the process of giving more or less exposure to various areas of the print). One gives more light or a longer exposure (called 'burning in') to areas that would print too light; this needs to be done where the negative area is dark. Conversely one

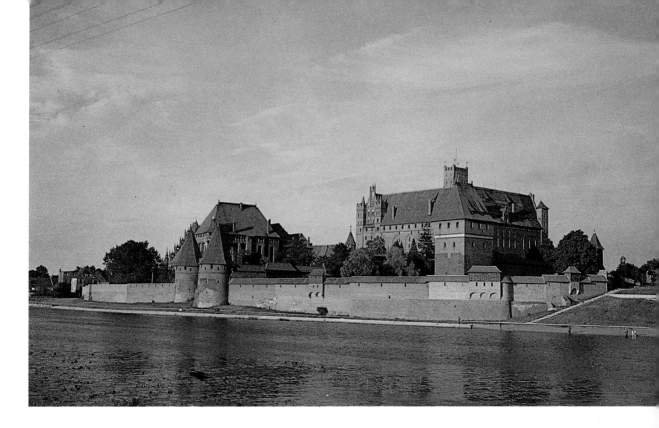

East European castle, evening light. Evening light is very likely to record on film differently to the way it was perceived at the time. Different films react differently, and in this case the red brickwork has been considerably warmed in colour, though it is by no means unattractive.

gives less exposure or 'holds back' areas where the negative is too light or thin, and would otherwise produce too dark an area on the print. 'Dodging-in' is done either with the hands, or with bits of card stuck onto wires. Often these shapes are specially made to fit various areas of the print. We suggest you practice the art of dodging because it is only in this way that the finest prints can be made: enlarging papers cannot reproduce as many greys as there are on the negative with one single overall exposure, which is why dodging is required. It not only helps to give a more correct representation of the negative but can be used deliberately to enhance various parts of the picture, and examples of each are shown here. A straight print of a group near a hamburger stall at a fairground gave a very unsatisfactory print. The film had been very carefully exposed and there was detail in the shadow areas furthest away from the counter and also in the interior of the stall. A single short 10 second exposure of the printing paper would only give detail in the area furthest from the stall's light, and none in the stall's interior, whilst a longer one of 20 seconds gave us more detail in the interior of the stall and made the shadow area too dark. This latter print looked the better of the two and is shown here but it could be further improved with dodging. We found the correct exposure for each of the three main areas of the print from the test strips, and during a 40 second exposure moved a hand across light coming from the enlarger so that parts of the print had 10 seconds' 20 seconds' and 40 seconds' printing time. The hand was moved across, obscuring part of the picture after 10 seconds, and kept moving in a shaking way at the boundary of the next area and so on with the 20 second and 40 second exposures. The

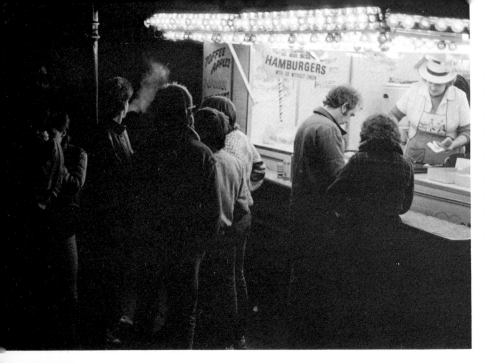

These are two pictures of a crowd at a fairground stall; the first was printed directly from the negative, using 20 seconds overall, while the second was printed differentially as shown in the diagram to improve the detail in those people furthest from the stall. The picture also clearly shows the way in which light from a source falls off rapidly, according to the inverse square of the distance.

diagram shows where this was done, and you will probably agree that the finished print looks very much better (see Fig 1). The idea behind the late evening shot of the mountains looking across the estuary at Port Madoc was quite different as here we did not want to give a correct representation of the scene, but rather to interpret the mood as we saw it. The negative prints very well straight but there is too much light reflected off the water, and whilst there is detail in the left hand patch of reed, the greys in this area look muddy, and the print looks just like an ordinary mountain view. With a straight 10 second exposure the distant snow-covered mountain looks too white and lacks any fine detail from rocks, stone walls and trees. Fig 2 will shown how this was improved to make a rather striking landscape picture: only the central area received the basic 10 second exposure.

Pictures taken under low-light conditions probably need more dodging than other types because of the excessive range of contrast often found. Whilst dodging, one must keep the hand or card rather nearer the enlarging lens than the baseboard, giving a blurred edge to the shadow so there is a gradation between the areas being 'burnt in' and 'held back'. Sometimes it is necessary to have the boundary between two areas a little more distinct – this often happens when one is burning in the sky whilst holding back the landscape across a distant horizon line. The boundary is made more distinct by lowering the card or hand to give a sharper edge but the edge is still kept moving with a little shaking movement.

We have gone to some lengths to describe in rather general terms the enlarging process, since this is the key to successful black and white low-light photographs. Making colour prints is much more complicated, involving the use of filters to correct colour casts in the scene, negative or slide depending on the process, and between batches of colour printing paper. The effects of colour-correcting filters vary with exposure time and dodging can therefore produce local colour casts, but about one third variation in exposure either side of the overall correct one can usually be tolerated. In black and white, however, the variations can be between 10 and 100 seconds or more. There are two basic methods of producing colour prints: one which uses a negative which has reversed colours from which it is difficult to judge what the final print will look like; and one which prints from a transparency. Using the latter, one knows almost exactly what to expect but this process produces very contrasty results. Recent work, however, has shown that by using a modified two-bath development technique contrast can be controlled to within normal limits, and even varied between soft and hard.

Processing Colour transparency films for increased speed

Colour transparency films using the E 6 process are routinely uprated to two or four times their original rating without any major problems. However there are one or two things to bear in mind. If you use a commercial processing station you must tell them by how much you have

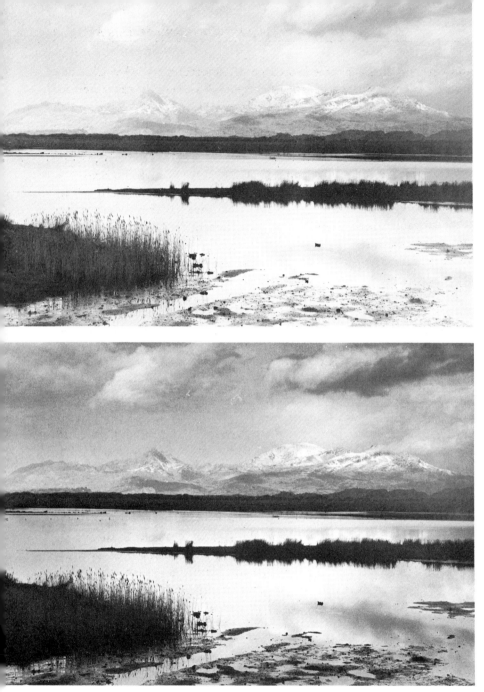

Two pictures of a Welsh
estuary taken in low light,
printed from the same
negative to show the effect of
differential printing times.

uprated the film so that they can process it accordingly, and you may be expected to pay extra for the service, though some do it free. Films not using the E 6 process such as Kodachrome 25 and 64 cannot be home processed or uprated. The E 6 process for Ektachrome-type films is easily done at home in the small tanks used for black and white negative processing.

Processing kits are available from the film manufacturers and also much more cheaply from independent suppliers. To uprate a transparency film, one usually increases the time in the first developer by about 1/4 or 1/3 for each stop the film was uprated, e.g. one independent kit gives a normal development as 7 minutes, and an uprating by 1 stop (e.g. 100 to 200 ASA) as a time of 9 minutes, or $12\frac{1}{2}$ minutes for a 2 stop increase.

Developing kits will only develop about six films, but if you uprate films then you should not expect to get this number out of the solutions for consistent results. With some makes, we have also found that after a fast film has been processed at uprated times, a slight colour cast is produced which can be minimised by increasing the time in the colour developer. Instructions packed with kits are comprehensive and you should have no difficulty in using them. By far the most common problem is maintaining the critical limits of the rather high processing temperature of 38°C to within 1/3rd of a degree.

Since slide films can be obtained in ratings of 100, 200, 400, 800 and 1600 ASA there is little point in pushing a 100 ASA film to 400 ASA. Normally little or no loss of quality can be detected in going up by 1 stop from 100 to 200 ASA, but beyond that some slight loss of quality begins to appear; blacks become less dense and even greenish if pushed too far, and the whole colour balance changes, typically toward magenta or yellowish depending on the film and developing kits used. There is always an increase in grain which becomes more noticeable the more one uprates. Because of these factors we recommend you follow our system and use 100 ASA films for much of your normal photography, uprating it to 200 ASA if needed. If an even greater speed increase is needed, use a 400 ASA film, or an 800 ASA film and uprate this if necessary.

3 Techniques

Working in low light or with flash does involve a few techniques that are not widely used in general photography: shutter speeds are slower, lens apertures arc wider, weather may be bad, and there may be great difficulty in metering for exposure, for example. Problems like these are common to several branches of low-light photography, so they are grouped together here for convenience. Specific problems encountered in specialised situations are discussed in more detail in the relevant chapter.

HANDLING THE CAMERA

Steadiness is vital if you are to achieve sharp pictures with longer exposures. If you are not using a camera support, you must adopt a stance that minimises your own movement; this varies for different people, but if you are standing it is usually best to stand with your weight spread evenly and your legs about 18 inches (0.5 m) apart. When holding the camera, keep your elbows tucked in close to your body, and if you are using a long lens (e.g. a telephoto or zoom) use your left hand to support the lens barrel (and focus), and your right hand to hold the camera body (and take the picture).

You will increase steadiness by kneeling/crouching down (at least, most people do – try it out and see), or by leaning against a wall or any other support. If you can support the camera on a wall, car, fence post or similar solid object this will give added steadiness, especially if you can cushion any rocking movement produced. The bean bag (see p. 20) is ideal in these circumstances. Whichever method you are using to steady yourself, keep checking the viewfinder to see how steady you are, and alter your technique if you are not succeeding.

When you come to release the shutter, press gently and evenly on the release to make sure that you are not moving the camera at the same time, and try to ensure that you are not breathing heavily. Some photographers recommend holding your breath at the moment of picture-taking, although this does not suit everyone.

Following these techniques, you can reasonably expect to hand-hold the camera at shutter speeds of 1/30th second with a standard lens on. Although people occasionally claim to be able to hold the camera steady at 1/15th or even slower speeds, you usually find that they do not examine their pictures closely enough to notice camera-shake. It depends what you use your pictures for, and how important sharpness is, but in general 1/30th second is the longest exposure to expect to hand-hold. A wide-

angle lens is less prone to show camera-shake, while a telephoto lens becomes more prone as the focal length increases. The usual limit for hand-held exposures involves taking the reciprocal of the focal length as a guide – for example, 1/125th second for a 135 mm lens, 1/500th second for a 500 mm lens, and so on, though you can lengthen these a little if you have a good support. It will be clear, however, that long lenses are not really suitable for use in low-light work without a tripod!

When deciding on shutter speed, remember that faster shutter speeds may be needed to stop action in the subject itself – there is no point in satisfactorily controlling camera shake with a speed of, say, 1/60th second

The effect of different light sources can be dramatic; the first picture of this carving inside a prehistoric tomb was taken using flash mounted on the camera; the second was taken using the 'grazed' lighting of a very obliquely-placed flashgun, which gives much more pronounced modelling of texture and form.

if the subject moves in this time and gives a blurred image. For much low-light hand-held work, the depth of field is not a vital consideration, which means that you can use as large an aperture as necessary, and it is a good general rule to go for as fast a shutter speed as possible in action situations. Where the movement is in one direction only – for example a passing car that you are photographing – then you can 'pan' (i.e. follow the car steadily as you expose the film) to reduce subject blur and increase background blur. In situations where movement is more general, you need to avoid close-ups unless you can use a high shutter speed, so that the movement is less noticeable. Using a wide-angle lens will have the same effect.

Focusing in low light can present problems, For simple cameras with zone-focusing or pan-focus lenses, there is little difference from daylight work, as long as you can see what you are doing. Similarly infra-red auto-focus systems will work satisfactorily, including that emitted by Minolta AF flashguns. Other auto-focus systems will probably fail as they rely on contrast detection and need higher light levels. If using an SLR, there will be a similar problem for you, trying to focus manually, as there may not be enough contrast and reference points to work from. The problem is compounded by the fact that the larger apertures required in these circumstances mean that there is very little depth-of-field, and focusing has to be much more accurate.

There are, however, various ways in which you can help overcome the focusing problem. Two important preliminary actions are firstly to check that your eyesight is correct or, if necessary, that you have the appropriate correction lens fitted to your viewfinder (a few cameras now have built-in variable correction lenses, for example the OM4, and the these should be set correctly in advance). It is surprising how many people find focusing difficult, even in good light, because of eyesight problems. Secondly, it is worth checking to see if your camera manufacturer provides a focusing screen suitable for low-light work; some do, and they are worth fitting.

These two points will help with, but will not always solve, your focusing problems. If there is really nothing that you can focus clearly on, then try to find a well-lit object at a similar distance and focus on that; if you have a torch (as you should have), and your subject is one which you can shine a light on, then this will make focusing much easier. If all else fails, then you will just have to guess or measure the distance, and set the lens accordingly. Wide angle lenses need less critical focusing, but of course they do not always give you the results you want. Equally, slight focusing errors will be less noticeable on very fast film than, say, on Kodachrome because the overall sharpness is lower.

Whatever you are endeavouring to do with camera, it pays to know the workings of your camera well before venturing out into the darkness. The best way to do this is to use it regularly, but failing that it is worth checking which direction the aperture, shutter and compensation dials work in, and where the button (if any) to illuminate the viewfinder

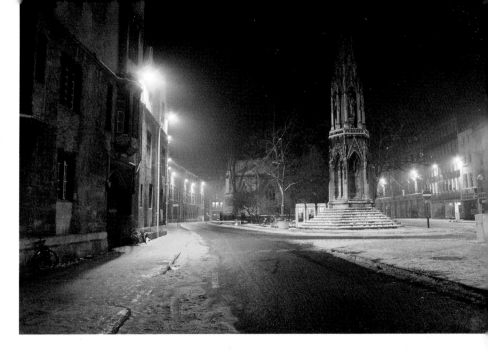

Oxford at night after snow. For this night shot, one extra stop exposure was given over the estimated exposure to clarify details, accepting some increase in flare from the light sources.

Looking up to a staircase and ceiling. For this long-exposure shot, a tripod was not necessary, since the camera could be placed on the ground and fired. The self-timer allowed the photographer to get out of the way.

information is. Also make sure that your lenses are scrupulously clean for low-light work. Because light sources are often actually in the picture, there is much more likelihood of flare or poor quality images, which is made worse by grease or dirt on the lens.

SETTING UP A TRIPOD

For any really long exposures, and for maximum sharpness and depth-of-field in static situations or when using telephoto lenses, a tripod is virtually essential. The basic erection of a tripod is reasonably self-evident, but there are a few pointers to follow for maximum stability. If setting to a lowish setting, use only the upper, thicker sections, avoiding using the thinner, less stable sections. If setting it to near maximum height you will find it easier to lengthen the lower sections and then adjust the upper sections. The legs should be splayed as widely as possible, and if you have a long lens on, this should have a leg rather than a gap below it, which will also enable you to look through the viewfinder more easily, with less chance of tripping over a leg. If possible, avoid extending the central column more than necessary – it reduces stability when extended. On uneven ground, try to set up the legs to get the platform horizontal, and the centre column vertical; this is easier than making adjustments with the top controls later, especially if you intend to rotate the head, since the camera will cease to remain level as you rotate it if the centre column is not vertical.

Before taking a picture, make sure that all controls or threads are tightened fully to prevent any movement. Finally, always use a cable release with a tripod to take the fullest advantage of its stability; failing this, use the camera's self-timer to trip the shutter since this isolates the camera from you at the time of the exposure, and often releases the mirror

in advance with SLRs. If you have a mirror lock-up facility, use it when you can, after making all the settings. If you have no cable-release or self-timer, steady the camera by gentle vertical downward pressure from one hand while you release the shutter with the other.

LONG EXPOSURE TECHNIQUES

Once you have a tripod, you are in a position to start using really long exposures, which are amongst the most exciting and revealing tools available to us. With the aid of a locking cable-release, you can keep the shutter open for as long as you like, to record very dim lights, the movement of stars through the night, a complete firework display, or more complex set-ups. To achieve this, set the camera shutter to the 'B' setting, which allows the shutter to stay open for as long as it is depressed, either by hand (which would probably cause camera shake) or by cable release, which is made much easier if the cable release locks in position. The shutter closes when pressure on the button is released. Some cameras, mainly older ones, have a useful 'T' (time) setting which opens the shutter when pressed once and closes it when pressed again. Some aperture-priority automatic cameras allow accurately metered exposures up to about 2 minutes on automatic, and this is particularly useful if the camera has off-the-film (OTF) metering as it will account for any changes in light during the exposure (see below).

Once you start to use long exposures, you begin to realise that they give you an immense amount of control over what goes onto the film: ultimately you are limited only by your own imagination. Various uses of long exposures are described in later chapters. The two basic techniques to discover are:

a) 'open' flash techniques in which you fire off one or more flashguns, usually via their 'test' or 'open flash' button, as many times as desired during the long exposure. The flashguns need not be linked to the camera in any way, and indeed it is much easier if they are not. Two main ways in which this technique can be used are to selectively 'floodlight' a scene (for example you could photograph your garden at night on 'B' setting from an upstairs window, and walk round individually 'spotlighting', say, rose-bushes) or building – this is particularly useful in cave photography or in poorly-lit buildings – or you can use it to freeze some point of action against a static background e.g. you can 'flash' in a sharp picture of some people viewing a night scene for which a long exposure was required. The possibilities are endless, and fascinating.

b) The second useful technique to discover is that of interrupting a long exposure, rather like taking multiple exposure pictures. You can prevent light from continuing to reach the film by replacing the lens cap, or putting black card or even your hand over the lens, and then either move the camera to another scene, or await some change in the view you are

photographing. The latter is especially useful in photographing fireworks, to avoid overexposing the general scene. You can also change the focal length of a zoom during exposure, for interesting and occasionally revealing effects.

Gauging exposure in low light

It has to be admitted that getting the exposure right in low-light photography is one of the most difficult features of this art. Not only are there the technical difficulties of exposures beyond the range of the meter, light sources in the photograph, and so on, but there are also the aesthetic considerations of achieving the desired appearance – you may frequently not get the result you want from an apparently correct meter reading.

It may help to first look briefly at how light meters work. The different types are described in Chapter 1, and the value of each is indicated. All work in essentially the same way in that they produce a reading representing an average of the light reflected from the scene they are surveying. Most SLR cameras now have through-the-lens (TTL) light meters which meter exactly the scene that the camera will take. To try to lend weight to the parts of the scene that, on average, the photographer is most likely to need correctly exposed, the meters have a varying pattern of sensitivity. They usually give most weight to the centre and parts of the lower half of the picture, and take less notice of the remainder. It helps to know how the meter in your camera is looking at the scene; if your camera handbook does not tell you, then you can easily work it out, as shown in the panel.

Working out your meter sensitivity pattern

If your instruction book does not tell you the sensitivity pattern of your meter, you can easily work it out as follows:

Take your camera with standard lens attached, and point it at a bare lighted bulb. With the meter on, set the shutter speed to give a reading of the smallest available aperture (e.g. f16) when the bulb is in the centre of the viewfinder. Then, with a pre-drawn sketch of the viewfinder ready, take a series of aperture readings, as shown, with the bulb in different positions in the viewfinder. You will end up with something like this:

			4					
			5.6					
			11					
	8		16		8			
5.6	8	11	16	22	16	11	8	5.6
			16					
	8		11		8			
			8					

You can then construct a sensitivity pattern by joining up readings of the same value, e.g.

Fig 3 A diagram to show the effect that using a wide-angle lens can have on cloud formations by dramatically increasing the perspective effect. In an otherwise dull evening scene this can sometimes give added interest to the composition, especially with the more extreme wide angles, beyond 28 mm.

A few camera meters and some hand-held ones allow you to take a spot-meter reading of a much smaller part of the scene. These allow a more precise estimation of the light values in the scene, and have considerable uses in low-light work, as we shall see.

The other characteristic of meters which is worth remembering is that they work by trying to expose every tone as one akin to light grey – this is the calibration that gives most useful overall results, but because it is a method that depends on average circumstances, the meter can easily be led astray. The result on the film of a meter reading for a pure black situation would, for example, look grey.

These metering limitations are normal, but they tend to be exacerbated in low-light situations and great care is needed. To illustrate the problems, it is easiest to look at a few typical examples. Suppose you are standing on a hill overlooking a town on a bay; it is completely dark but the lights of the town show as numerous pin-points of light, and a few slightly larger areas, together with some pale reflections in the water. The sky and the hills across the bay are black. If your light meter was sensitive enough to record the light accurately, it would indicate a long exposure, even with fast film, that would record all the ground and buildings within the town as mid-tones, all lit areas would be grossly overexposed, and the sky would be pale orange-grey. What you probably actually wanted was something quite different! If the full moon was in your picture, giving a bright light but not shedding much light on the scene, your problems would be compounded.

Another situation could be a snowy street-scene at night. The view you want is of a snowy alley, with the central section covered by hard-packed icy snow and the sides with whiter, softer snow. At the far end, in the picture, is a large streetlight, and between you and it are two well-lit shop windows and a number of dark shadowy alleyways and doors. The sky is black apart from a pale orange reflected glow from the lights of the town. Your meter will 'read' this scene and present you with an average figure which, if followed, may by chance give you the effect you desire but is more likely to give you something quite different.

Low-light interior. This was taken to show the effect of the light streaming through the slats patterned with an image of Lincoln Cathedral. The available light reading was taken from the carpet, allowing the light coming through the pattern to burn out, while fill-in flash balanced for the same aperture was used to light up the people; note the reflection of the flash in the picture on the wall.

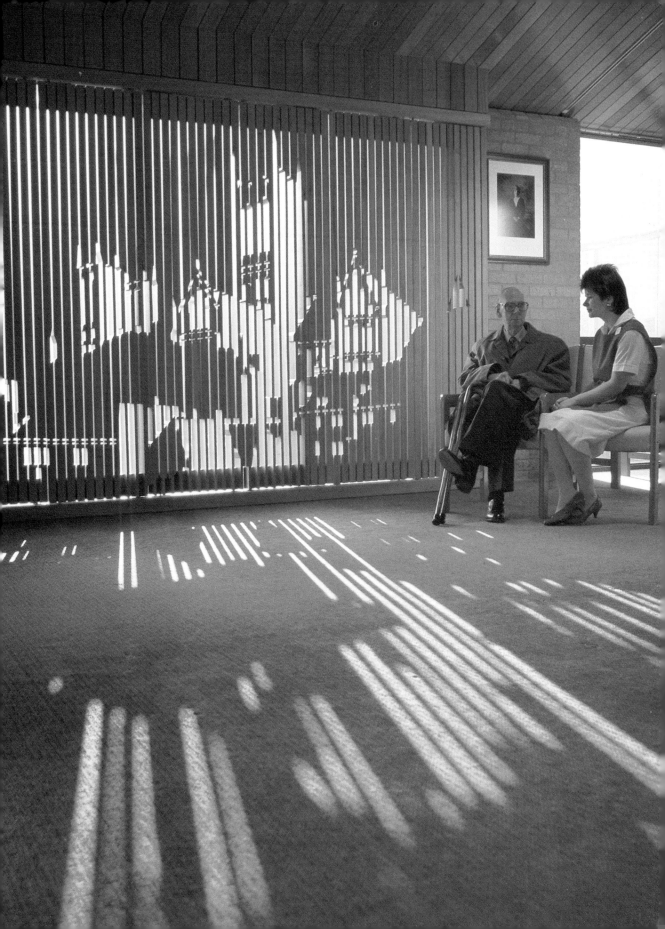

So, what can you do about it? Fortunately it is not quite as impossible as it seems. First, learn to look at scenes like these and analyse them in terms of the results you want. Which parts do you need to be correctly exposed? Which bits can you ignore altogether? For example, if there is a lot of black sky, or deep shadows in the picture that you want to remain black, then use the meter so that it ignores it – if the meter takes it into account, it will come out paler than you want *and* the rest of the picture will be overexposed, whereas if you ignore it, it is bound to be underexposed, and it matters little if it is one stop or four stops under – it will still look black! Similarly, a bright light source will look bright over quite a range of exposures, and if you try too hard to expose correctly for it, the rest of the picture will be too dark. In most cases therefore, look at the important mid-tones, and let the shadow and highlights look after themselves. To persuade the meter to ignore these extremes, you can angle the camera to include almost all the mid-tone areas and exclude the extremes, then use the resultant meter-reading when you return to your original composition. If you have a zoom, you can lengthen the focal length to exclude parts of the picture temporarily (e.g. the dark sky behind a floodlit building) to get a more precise reading, and the same effect is gained by using a spot meter accurately. If none of these are possible, you can usually move closer temporarily to take a reading, e.g. from the street itself in the example above, and either enter that into the 'memory', if working with an automatic, or note the reading and set the camera accordingly.

Some situations seem too complex at first to analyse in this way, but once you exclude the shadows and highlights, it is usually possible to work out something from the remainder. In a strongly two-toned subject like a sunset with a dark rocky foreground, you need to decide which is more important – detail in the rocks (and an overexposed sky) or a correctly-exposed sky and dark rocks – and then work accordingly.

In very dark situations, you may not only find it difficult to see something to take a reading from, but also that the scene is out of range of your meter. In these circumstances, you can put a light-coloured object in the field of view to pick up any light that is about and take a reading off that – then increase the exposure 2–3 stops or shutter-speed increments. Unless you are using the fastest possible film speed, you can make your meter more sensitive by turning it to the fastest film speed, say 3200 ASA, taking a reading at that, and then working back to what it should be, e.g. if the meter indicates 1 second at f2 for 3200 ASA film, and you had 200 ASA film you would need to halve the speed four times to reach 200 (1600 : 800 : 400 : 200) so you would need to double the exposure four times to 16 seconds (2 : 4 : 8 : 16 seconds) plus a bit extra for reciprocity failure, assuming, of course, that you have chosen the right place to meter from! With automatic cameras having a long exposure capability (usually up to 2 minutes), you can try setting the camera on automatic after making sure you are metering the right part of the scene and compensating as neces-

sary. You should time the length of exposure, though, and if it is at the maximum then try another manually-timed exposure at double that time. In any event, it is worth taking exposures on either side of whatever you have estimated – there are so many variables, that you can rarely be sure of getting it just right first time. If you have estimated 4 seconds at f4 then try 2 seconds and 8 seconds as well, or an even wider range if the photograph is unrepeatable. This is known as exposure bracketing, and everyone does it!

Finally, if you prefer, you can abandon your meter altogether and use tables based on other people's experience and successes. We provide one below as a basis for working from, though conditions are too unpredictable for it to give certain results. It is worth bearing in mind that monochrome, fast colour negative, and the faster slide films like Ektachrome 400 are most tolerant in difficult situations. If you are planning much night photography, copy this table and take it with you.

Recommendations for exposure for low-light subjects		
SUBJECT	FILM SPEED	
	100 ASA	800 ASA
Floodlit buildings	1 sec f4	1/4 sec f5.6
Fairs, amusement parks etc.	1/15 sec f2	1/60 sec f2.8
Shop windows, well-lit	1/30 sec f2.8	1/60 sec f5.6
Well-lit streets (less if wet)	1/30 sec f2	1/60 sec f4
Firework displays	'B' on f8	'B' on f22
	keeping shutter open for several bursts	
Lightning	'B' on f4/5.6	'B' on f11/16
	keeping shutter open for several flashes	
Fire-lit subjects	1/8 sec f2	1/15 sec f4
Full moon, direct pictures	1/125 sec f11	1/500 sec f16
	but more exposure if moon is obscured by haze or clouds	
Moonlit landscapes	1 min at f2.8	15 secs at f4
	but give less exposure if snowy, more if moon is not full or clear	
Home interiors	1/4 sec f2.8	1/15 sec f4
Well-lit stage shows	1/60 sec f2.8	1/125 sec f5.6
Average stage shows	1/30 sec f2	1/125 sec f2.8
Floodlit sports events	1/60 sec f2	1/125 sec f4
Traffic headlight streaks	30 secs f16	8 secs f22

USING FLASH

This book is not intended as a manual for the use of flash, and we do not propose to cover it in detail. There are, however, many occasions when flash can add greatly to the impact of a low-light picture, and other occasions when nothing else will do.

Portable flashguns are an exceptionally convenient source of light that can be carried anywhere and used from any direction, in as complex a set-up as you like. The duration of flash from most flashguns is very short, typically 1/1000th second or less, and so it allows you to 'freeze' movement totally, or to 'freeze' selected moving objects during a longer exposure. As a general rule, it is better to use the flashgun(s) off the camera; if placed centrally over the lens in the ubiquitous hot-shoe, you get flat lighting, unimaginative pictures, and 'red-eye' effect in people looking towards the camera. You also lose possibilities such as back-lighting or strong modelling in your subject.

For simplicity, you can mount the flashgun or guns on brackets attached to the camera to improve slightly your lighting quality, especially with close-ups. For more distant subjects or more marked effects, you need to have the flashes well away from the camera, fired via a long lead or slave units if you have several flashguns, or on open flash during long exposures. Flashguns can also be bounced either off their own reflector, available for some flashguns, or any convenient light surface, or off walls and ceiling if working indoors. This reduces the power of the flash, but gives much softer, more natural looking lighting than direct flash. Watch out for coloured surfaces which give a colour cast to the subject.

Gauging exposure using flash

This is not especially difficult, given a bit of thought and experience. The easiest types of exposure gauges to work with are the through-the-lens metered types, where all light from the flashguns is measured as it reaches the film, during exposure, and the flashes are automatically quenched when enough light has been given. It sounds perfect, though in practice normal metering difficulties apply and are in some ways more complicated. Suppose you are photographing a person in low light but it is not dark; the subject only fills $\frac{1}{3}$ of the frame, with the remainder as background. If metering for available light you might judge the person to be similar in tone to the background, but during the exposure with flash the person will be brightly lit and the background will appear dark in comparison. The meter will make some attempt to average the two, giving more light than is necessary to light just the person and the result is an overexposed person, and in all probability the background will still be black since there is little chance of a portable flash lighting up a distant background. If your whole subject area will be lit by the flash, there is probably no problem; if not, try to visualise what will happen during exposure, and compensate (usually for less exposure) accordingly.

The other problem with TTL metering is that most such flashguns have

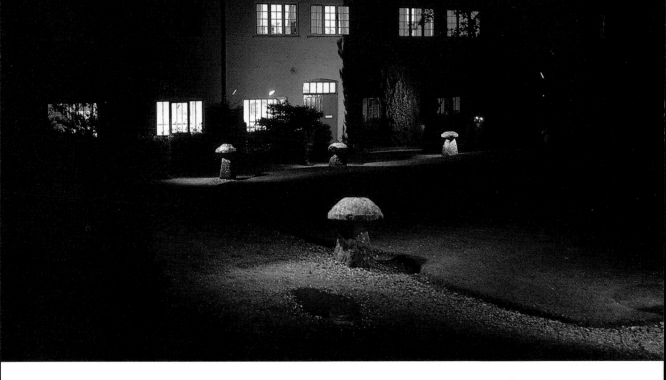

An ordinary long exposure at night of this house was added to by walking round the garden and giving each bollard one flash from the flashgun, on 'open' flash, followed by one to light up the house wall.

to be connected to the camera to work, and in the process they automatically set the shutter to 1/60th of a second – which rules out fill-in flash, or balanced daylight and flash, in most circumstances. Except for the few cameras that cope with these alternatives, you need to use your flashguns on manual for fill-in flash while for flash during long exposures, you can use automatic TTL metering by firing off open flashes, not connected to the camera. The camera cannot control the flashes but it will close the shutter when a correctly-exposed negative has been produced.

Automatic flashguns with a built-in sensor work in a similar way though they are less versatile. You need a sensor that remains pointing forwards when you bounce the flash, and if you wish to use the flashes off the camera then you need a detachable sensor to mount on the camera. You are usually limited to relatively few apertures with such flashguns, unlike TTL flash, but given its limitations the system generally works well.

For purely manual flashguns, or other flashguns used on manual, you need to calculate the exposure using the guide number given for the flashgun, together with the film speed and flash-to-subject distance. In practice, most flashguns give you a variable table from which to calculate the correct aperture. It is worth knowing what a guide number is, though, just in case you need to calculate anything. The guide number is the product of the distance in metres and the aperture for correct exposure, i.e. GN = distance × aperture. Consequently if you know that your guide number is 32, and that your subject is 4 metres away, the correct aperture would be 32/4 = f8. Most guide numbers are nowadays quoted for a distance in metres using 100 ASA film.

With all manual flash calculation, you have to bear in mind that most

The effects of different exposures at the time of taking the picture (rather than later, during processing) can be considerable. The first picture was taken exposing for the windmills and the ground, ignoring the sky – this gives a rather dull picture. The second picture was exposed as an average, in the knowledge that the effect of the brighter sky would make the windmills appear as starker silhouettes.

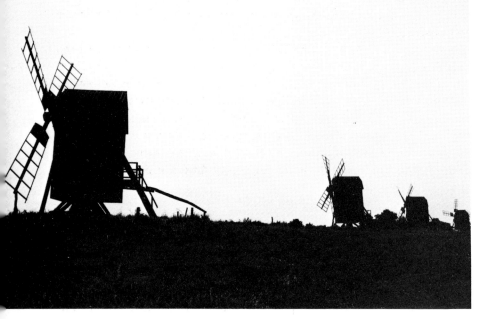

guide numbers are calculated for indoor use in reflective rooms. Outdoors, you lose the light reflecting from walls and ceilings, and guide numbers have to be treated as over-optimistic; add on about a stop extra exposure as a starting point, then more if experience suggests that you need it.

FILL-IN FLASH

Using flash to light up duller parts of your picture, whilst retaining the basic exposure for, and therefore the effect of, the ambient light, is a useful way of achieving high-quality professional-looking results. It is not difficult, and has been made more easy by the introduction of automatic flashguns. Opinions vary as to the exact balance between flash and

daylight that is required, but we find it about right to have the light from flash at about $\frac{1}{4}$ (i.e. 2 stops less than) that of the ambient light, or even a little less in subtle lighting.

The basic idea is to establish the exposure required for the scene by available light and then to add in flash at $\frac{1}{4}$ this exposure to light up parts of the scene that require extra light, for example the front of an opaque object backlit by the evening sun. First, establish the meter reading for the scene as lit by natural light, ensuring that your shutter speed is less than or equal to your flash synchronisation speed. A likely combination is, for example, 1/30th at f8. For the flash to produce the desired effect of $\frac{1}{4}$ light, it needs to be set to produce enough light on the scene to expose accurately at f4, while you keep the aperture at f8. To achieve this with an automatic flashgun, you have to 'fool' it (and this is very easy) in one of two ways – either inform it that your film speed is 2 stops faster than it really is (e.g. 400 ASA instead of 100 ASA) and it will 'think' it is correctly exposing the scene at f4; or inform it that the aperture you are setting on the camera is f4, but actually set f8, and again it will deliver $\frac{1}{4}$ the power for correct exposure.

With manual flash, it is slightly more difficult. First establish what the correct exposure would be, using the guide number and distance as described, or the panel on the flash. If your flash has variable power, simply set the power to $\frac{1}{4}$ of that required for correct exposure. If it has not, then you will have to *double* your flash-to-subject distance if you can, or reduce the power of your flash with layers of handkerchiefs, or by bouncing it off a card or similar object. With long exposures, you can use open flash for similar effects, balancing the two light sources in whichever way you wish.

USING REFLECTORS

Reflectors can be used in a similar, though usually more subtle and restricted, way to the fill-in flash. You can buy or make reflectors in almost any size, and they are very useful accessories for bouncing light onto a subject to fill in shadows or provide highlights. Naturally they are dependent on having enough light around to bounce with, but there usually is and the results can be very effective. The advantage is that you can see their effects before taking the picture, though on long exposures they have more effect than you might expect. White reflectors are very neutral and subtle, silver ones a little brighter and sharper, while gold ones will warm up the scene.

MAKING MULTIPLE EXPOSURES

We have looked at the ways of interrupting long exposures to give a sort of multiple exposure, but it may be useful to use more conventional multiple exposures when you wish to superimpose images from widely different

locations or times. Most cameras nowadays have built-in shutter locks to ensure that you wind on before the next exposure, thus preventing accidental double exposure, and only a few have a multiple-exposure (M E) button to defeat this mechanism. The procedure with ordinary cameras is as follows:

1) Gently turn the rewind crank in the direction of the arrow to take up any slack in the film.
2) Expose your first picture as required.
3) Press (or turn) the rewind release knob located on the base (or occasionally front or top) of the camera.
4) Then whilst holding this knob in *and* carefully keeping the rewind crank stationary by firm pressure, re-set the shutter by winding the film on as normal.

This procedure should make the camera ready for the next exposure, on the same piece of film. Registration of the two images may not be perfect, so do not try anything too precise to start with. It is easiest if you use objects against a dark background, positioned in different parts of the frame. In this case, exposure for each scene can be as indicated, but if you superimpose two fully-lit scenes, you will need to give each one a stop or so less than indicated, to prevent overexposure. It is also possible to double-expose a film in a different way, as explained in Chapter 10.

PROTECTING THE CAMERA IN POOR WEATHER

The range of low-light photographic possibilities is extended by the ability to take out the camera in rain, snow or freezing conditions. Apart from the obvious need for protective clothing for the photographer, you can also protect the camera and keep using it. A few cameras, such as the Nikonos and many cheaper ones are designed for wet weather or underwater use, and they can be used in the rain with impunity. It is more likely, however, that you will wish to protect an existing camera.

A good start is to have an umbrella, a UV filter, and a good lens hood. This combination will successfully keep rain off you and the camera in many circumstances. For better protection, you can either encase the camera in a polythene bag, with holes for the viewfinder and lens, sealed with rubber bands, or you can buy a photographer's 'rain cape' (e.g. the one made by Ewa) to give good working protection. Better still, for really bad conditions, especially if salt water is involved, are the Ewa underwater housings, allowing use of ordinary cameras in very wet or underwater conditions. There are models for allowing the use of autowinder, flash, telephoto lens, and some large format cameras.

Finally, a good waterproof gadget bag for carrying your equipment and films in, unless you do all your photography next to the car, will be found invaluable. We have found that the excellent Camera Care Systems bags are waterproof under all normal circumstances, as well as being very tough, and they have even been known to float!

4 Towns and Cities at Night

Towns and cities are some of the most intriguing places to photograph at night. Many features of towns and cities, such as public squares, fountains and parks, are beautifully designed and lend themselves to photography. Other features, whilst of no great artistic merit, have great character accurately reflecting the country's people and culture.

Almost subconsciously, one finds oneself dividing the time spent in photographing towns into two main categories. One is the general city-scape type of picture – which may be the view from the hotel window showing street lay-out, position of churches, skyscrapers, or city walls and ancient monuments. Also in this category is the view along the street or across the square or the river through the city. In the second category are the pictures of the intimate fabric of the town or city: the house front, statues, monuments, streets corners, inn signs, etc.

There is also a third category, of abstract pictures, which are especially easy to take in towns and whilst they will not usually accurately reflect any particular place will enrich your set of photographs and tax your photographic versatility.

THE CITY-SCAPE

Taking pictures in cities and towns is rather like taking a landscape whose emphasis is on the near and middle distances with all the interest concentrated in these two planes, in contrast to a conventional landscape where the emphasis is on a wider view, a grander scale and the recession of more planes. The general low-light city-scape is best photographed not in the absolute blackness of the night when only the street lights are twinkling like grounded stars, but rather in the twilight. This is the half hour or so just after the sun has set – the time when a clear sky will show as a dark blue or purple backdrop to office blocks or floodlit buildings. Winter time is the best for this type of shot – there are often clear cold sharp days and nights and the lights seem to have an extra sparkle. It is of course the lights on in buildings that make up the pattern and texture within the photograph and in winter the twilight hours will be in the late afternoon when work places will still be well-lit. Try to get shots from a high viewpoint across the city at this time. Pictures have more impact and design if you can look along the main road coming into a city rather than looking across it. A nearby main road junction seen from above is a great help especially if the cars are sharp enough to give some sort of scale to the scene.

In some cities there are high-rise buildings that have tourist viewpoints on the top; try to find these and take your tripod with you. If you load with very fast film of 800–1600 ASA, a tripod will not always be necessary, but we suggest you take one along so that you can choose to use a long exposure. There are occasions when long exposures to record traffic moving along the roads below will give photographs an extra impact and dimension. All you have to do is meter for a shutter speed of 10–15 secs at whatever aperture is needed to achieve this. In the semi-darkness, moving vehicles will be recorded only by their lights, which will make orange and red stripes down the length of the street; longer exposures can be given but if your picture has an intersection regulated by traffic lights you may get overexposure of the lights as the traffic waits to move. You can of course use this to advantage by starting the exposure with the traffic standing still and letting the exposure continue as the cars move away or you can just hold your hand or a piece of black card over the lens (do not touch or move the camera) for the time the traffic is either moving or standing still, depending on what effect you want. It pays to spend some time watching the traffic lights to get the timing right.

We mentioned at the beginning of this section that city-scapes looked very good with a dark blue or purple backdrop. The way to achieve this, once you have the right sky conditions, is carefully to meter the sky and the main areas of building, and to start taking pictures when the sky area needs twice the exposure needed for the buildings – taking the photograph at the meter reading for the building. What you are doing of course is underexposing the sky area.

If you are interested in floodlit buildings you will have to be ready to take pictures immediately the lights are switched on at dusk: it is surprising how bright floodlit buildings are compared to the evening sky. All towns and cities have a very distinctive and individual skyline, which is easy to depict if it is Manhattan or any of the English cathedral cities. Some other places may tax your ingenuity, though consulting a local guide book will usually solve the problem of what to include.

With all these pictures, we have assumed that the view will be from a high view point, either from a building within the city or from nearby high ground. Your collection of pictures, however, should include some taken of typical streets or city squares. The biggest problem with these sort of pictures is people: either there are too many of them hurrying through your picture area, or if they are included they move during the exposure. At worst they become interested in what you are doing and attempt a well-meaning but distracting conversation. You may want people in your picture and accordingly be using a fast film if your picture ideas include people showing movement as part of the design, but if you do not want the city dwellers or visitors in your pictures, we suggest two ways to avoid them. Taking pictures in low light gives you the opportunity to use very long exposures of one or more minutes – not forgetting to make the correction for reciprocity failure, of course (see Chapter 3). With expo-

The monument to Henry the Navigator in Lisbon, taken in very low-angled evening sun, to show the relief in the stonework. A 135 mm lens was used to isolate the main part of the statue.

sures as long as this a few pedestrians moving through your picture will not be recorded at all as long as they are not wearing brightly reflecting objects. The other suggestion we have is to go out and take pictures late at night when there are fewer people about; you will be surprised how deserted some towns and city centres are after 11 p.m., especially at weekends and in winter time. Winter can be one of the best seasons for photography in towns and cities, for at this time the trees in the parks and squares are without leaves and not only do they obscure less of the buildings but they can also be used as part of the composition – the arching filigree of branches and twigs filling an otherwise blank sky area. Trees can often be used to obscure unwanted objects like bright signs and lights.

Winter brings rain and snow, especially to northern towns and cities, and high altitude places, but do not put your camera away, as snow is a great asset, covering dark roofs and reflecting street lights into dark doorways. If you are using colour film you will almost certainly find it impossible to record the snow as white but do not worry – all those odd colours reflected in and off the snow help to liven up the scene. Rain, too, can be a great asset in town photography: wet pavements and roads will give hard reflections and add contrast to the often drab city-scape, especially if you move from the plush centre areas to the run-down quarters found in every town and city throughout the world. The exposure for these low-light snow and rain scenes is surprisingly simple – take a normal reading and use that (but see Chapter 3 for complications). If you do your own processing modification can be made, particularly with black-and-white films; otherwise just make compensations for long exposures as detailed in Chapter 3. The only things to be aware of, and to adjust the meter reading for, are extra bright lights or large dark areas that would cause under or overexposure of the area you are interested in – the best thing to do, if possible, is to go closer to the main subject to take the meter reading to exclude the light or dark areas and then return to the original view-point – though this is often impracticable. It may be better to swing the camera round and try to meter an area more evenly lit, or better still you could try using a spare camera and lens, as described (on page 64) in the section on photographing buildings.

Often the older areas of towns are most photogenic: they are sometimes lit with old street lamps or old ones thoughtfully converted to use modern lamps. The texture of cobbled streets makes a pleasant change from smooth tarmac, and light rain will give an extra shine to them.

Perhaps your photograph would be better with a figure in it and if you have not got an amenable companion with you who will stand exactly where you think best, you can always be your own model. All you have to do is to use the self-timer mechanism which usually gives about 10 secs delay – ample time for you to get into position. Using yourself or a companion in a picture is often a good idea to give scale and life to a long, tapering street scene and works best in your own country where hopefully you will be dressed like every one else – a tourist in palm beach

shorts will look most incongruous in an old Spanish town.

Whilst wandering along the streets, pause for a moment or two and look in the shop windows. The windows of some of the high class stores are often most attractively displayed and uncluttered – window dressing is an art form in itself and some displays make attractive pictures – there are problems with reflections in the plate glass from passing cars and street lights and you can try using a polarising filter to minimise or get rid of them. If you are using colour film the finished prints and slides can be quite surprising since the display lighting will often have been filtered to show the colours of the fabrics to the best advantage and not as you thought you saw them in the isolation of darkness.

The docks or waterfronts of maritime cities are excellent locations for low-light photography – the atmosphere is often enhanced by long shadows – and modern dockland has its attractions with large cranes and sleek cargo vessels. Good view-points are surprisingly difficult to find as dock basins are often square, with the ships tied up to concrete quays. We have often used a moderate telephoto 100–135 mm to take pictures across the dock pool. Apart from the cranes and boats there is much other photogenic paraphernalia laying about in docks – coils of rope, bollards, etc. all make good subjects. Docklands, whether old or new, are not the best places to be alone at night – always have a companion or two with you on such jaunts and do make sure someone knows where you are going and what time you are expected back.

Some of my favourite low light situations are the harbours of fishing villages – there are many fascinating possibilities from the stark ribs of a rotting fishing boat against an evening sky to the long shadows extending from a pile of lobster pots. Modern nylon fishing nets are no longer hung out to dry – but the post and frames that used to be used for this are often still in place and used in juxtaposition with either old warehouses or more modern fish sheds can make attractive pictures. Small fishing boats, though, still retain the local traditional designs even though they are no longer powered by oars or sails. The high-prowed Portuguese fishing boats drawn up on the beach awaiting launching into the Atlantic make superb pictures in evening light, throwing long shadows across a steeply sloping beach. Get up early, too, and see them towed into the sea for the day's fishing. There is much activity before launching – it is best to be prepared with a faster film than you need during the day – 200 ASA is often not too fast. A normal 100 ASA film uprated to 200 ASA (see section on uprating) means that you can use the same type of general purpose film to do two jobs but be careful to label clearly those you have uprated.

INDUSTRIAL AREAS AT NIGHT

Factories often look their best at night, especially if they are in full production with their lights full on. The most dramatic are undoubtedly oil refineries and steel works. Even with modern processing methods and attention to atmospheric pollution, there are often streams of emissions

Cranes at sunset. A tripod was used for maximum sharpness, with a telephoto lens to concentrate the composition on the main subject.

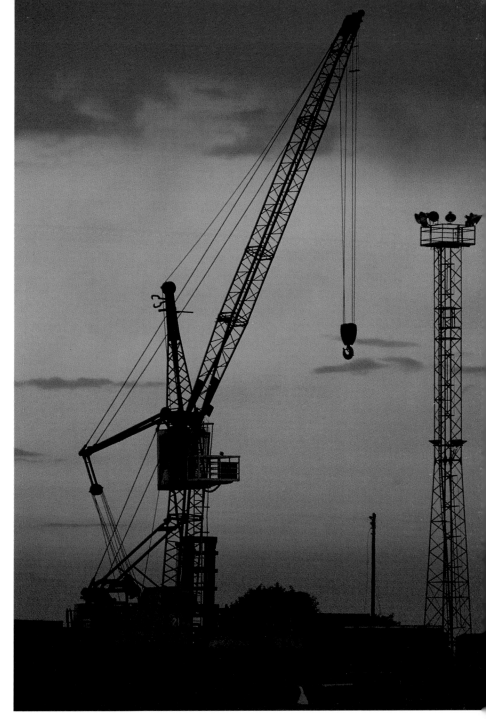

from cooling towers and factory chimneys. Oil refineries often have several flares burning off excess gases, and steel works, though not as dramatic as they used to be, are still capable of lighting up the night sky when the furnaces are tapped. Refineries are very well lit places and a distant view of the whole area will show the site studded with lights like a Christmas tree – while in a closer view, the sinuous shapes of the many shining aluminium-clad pipes create interesting picture opportunities.

Refineries are perhaps best photographed against a sky that is still partially lit after the sun has gone down. The purple/dark blue effect showing through all the pipe-works is most effective. Most factories combine well with a sunset sky. If you do get the chance to photograph a steel works at night watch for the tapping of the furnaces – it is a fairly regular process occurring at the same time each evening and often at regular intervals. A night with low cloud will give the best effect since the furnaces give off an intense glow which will be reflected from low cloud cover, while a light mist can also result in some interesting lighting effects. Not all of us have refineries or steel works on our doorsteps, but other industrial sites all provide good opportunities and electricity generating power stations seem to have been built with low light photography in mind – the shape and form of the cooling towers photograph best in evening and morning light, whilst the whole power station complex makes an excellent subject with a dramatic orange sunset. Factories of all types when taken from a distance need surprisingly long exposures – often 2 or 4 times that which the autometering camera gives. We find it best to take one shot on auto – carefully timing how long the shutter is open (it is often difficult to see the exact shutter speed at night on some cameras even if it is shown in the viewfinder) and then take two or three more at progressively longer times.

BUILDINGS AT NIGHT

We have given this subject a special little section of its own as it sets problems which do not fit into any other branch of town photography. First, there is the problem of getting the whole building properly in the frame, correctly aligned with the verticals straight: in our experience this can be the most difficult part of the exercise. One seldom has a lens of a wide enough angle, or a view-point sufficiently far away to get a good perspective with a normal or semi wide angle lens. Ideally one needs a view-point half as high as the building to be photographed and far enough away to use a normal lens so that the sides of the building do not tail off too rapidly. There are some special wide angle lenses made for architectural photography, whereby the lens can be shifted up and down or from side to side to help correct converging verticals. These lenses are ideal if you do a lot of architectural photography but they are expensive and since they do not have an automatic diaphragm (which is not needed since they are meant to be used on a tripod) are difficult to use as normal wide angle lenses. Fortunately the low-light photographer is usually more interested in the impact of the photograph than convention, so converging verticals, deliberately done, and excessive enough to show that they are not just bad technique, are often used to dramatise a tall building. Skyscraper office blocks look very effective with this treatment but you should be careful how you use it on old buildings like cathedrals or churches. Parts of such buildings – like the towers or steeples – respond well to unconventional

photography, but not decorated facades or intricately carved stone recessed doorways or windows – these look grotesque if not taken properly square on. Of course there are some buildings like the old timber-framed homes of the English midlands and parts of central Europe that do not have a square face to present to the world and a little more convergence or tilt induced by the photographer can be acceptable. If you are intent on portraying the architectural merits of a building, it is often best to take it in sections to show the individual features.

If the building you are interested in is in a narrow alley there is no chance of getting a good picture of the whole building – instead you will have to take what angles you can and show it in relation to the other buildings nearby. Most historically interesting buildings photograph best in any light other than unobscured midday sunshine. Large majestic stone houses in their own grounds photograph best in the warm light of evening when leaded windows or other decorations can be best shown. There are times when the colour of the light is critical; we have seen some timber-framed houses where the characteristic yellow brick of the locality has been turned to a normal red brick colour by the evening sun. However, such circumstances are exceptional, and most audiences for slides or prints are not so discerning: we have seen far worse colour casts in prints that even the photographer had accepted as normal.

Getting the exposure correct for some buildings can be a problem. Well-lit lightly-coloured stonework can be 3–4 times as bright as the sky, so if you expose for the stonework, the sky assumes an unnatural navy blue tone which belies the intensity of the light, and any foliage around looks heavy and dark. It is far better to wait for hazy light to even up the contrasts – there are times when clouds in the sky are an advantage.

Many historic buildings are floodlit at night and are easily photographed from a distant vantage point, but getting the correct exposure often presents problems when using normal and wide angle lenses. We easily solve the problem by fitting a telephoto lens to the camera and using it as a spot meter (this technique can be used for all sorts of situations, not just floodlit buildings). The camera and lens we like best for this is a spot metering camera like the Olympus OM4, fitted with the 100–200 mm zoom. Remember to set the correct ASA on the camera if it is not the one being used for taking the pictures. The zoom lens allows us to fill the frame with the building and sometimes even meter parts of it. The taking camera is set on manual and the readings transfered to it: we use a 35 mm camera fitted with a 200 mm lens to take spot readings when we are using colour film in a 5 × 4 inch (large format) camera, where, because of the cost of film, bracketing exposures is both time-consuming and expensive.

Floodlit buildings from a distance can look flat and uninteresting after the initial impact. Close to, the familiar features look odd and totally different, because the lighting comes from below and shines upwards, putting shadows above instead of below the detail. It is best then to photograph the building from a middle distance and include some other

buildings, or parts of them, to give depth to the picture. Once when photographing a castle we managed to get a viewpoint on the roof of a house some distance away and were able to use the intervening roof tops to make a more complete picture. We even used flash on some old house chimneys about 40 feet away to create a different type of picture. The technique was to give a long exposure for the distant floodlit castle and during that exposure we used the test button on the flash to fire the flash guns. Because flash guns take up to 10 seconds to recharge it would have meant very long exposure to give the time to get the required number of flashes in – fortunately we had three flash guns with us and managed to fire them all twice or three times in a 40 second exposure. Floodlit buildings can also be photographed to advantage against the early night sky, as detailed in the section on city-scapes and industrial areas, but they prove even more difficult since the exposure needed to record some colour in the sky is usually far too long for the floodlit building. The floodlights of a large building are expensive to run and are often not switched on early enough for you to get an exposure that will be correct for the building and still give a hint of light in the sky.

THE FABRIC OF A CITY

You will recall that at the beginning of this chapter on towns and cities we mentioned the two groups into which our photographs fall: now let us look at the problems of photographing the 'fabric' that goes into the making of the city or town.

The fabric comprises objects like the street lamps, the statues and monuments, the plaques to the famous and notorious. The city fountain and even the pattern of the flagstones on the squares can be very revealing. The city, or parts of it, may be known for its fashion shops, its restaurants, or decorative inn signs. There is a proper approach to photographing all this, and whilst at times the constraints of low light do not show things to their best advantage, there are many times when flood-lighting, spotlighting or just the low ambient light in a street will enhance your subject. You will have to be careful when using colour film, since it is quite usual to find a white marble statue spot-lit from the front to show the best side perfectly, only to find the sides and back lit by orange street lamps or red neon advertising signs – as long as you are aware of it the effect need not be unpleasant and can be deliberately used, timing your exposure, for instance, to coincide with the flashing red neon sign so that you make the most of its light and colour. Statues demand very special care; more often than not a dark bronze statue can only be photographed to perfection during a short period each day, or when weather conditions provide dark clouds, whilst the statue itself remains well lit. Much the same can be said for monuments – we saw some very dramatic and moving scenes when we were photographing in a small town on the west coast of Ireland, where there was an old disused cemetery right on the sea coast. The old granite Celtic crosses were just catching the last rays

Christmas market at night. A striking picture of the mixed light sources of a Christmas market, with the floodlit castle beyond. Taken on Fuji 50 film, following the meter on auto, except for giving +1 stop compensation, so that the final exposure was 4 seconds at f3.5.

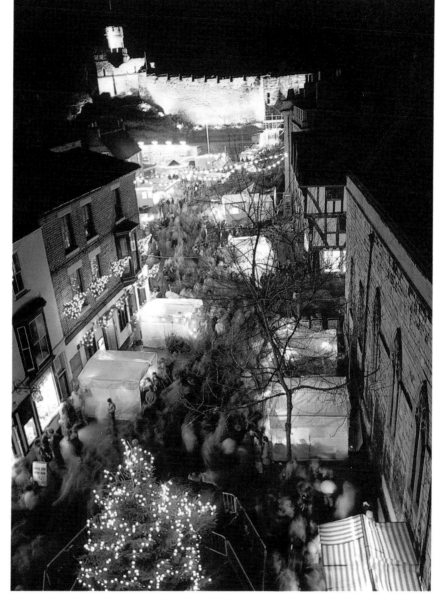

of the evening sun while the background cliffs and sombre town houses were now in deep shadow – an unforgettable scene. Similarly, we have seen the magnificent monument to Henry the Navigator in Lisbon lit by the low sun coming across the sea to make it stand out in a way that it never did during the day. Sometimes the light does this to a whole city.

You do not have to go to exotic places to take views that will show the character of a place: a photograph of the twin rows of chimney pots taken from a high viewpoint of northern England's back-to-back homes in the early morning is just as evocative and character-revealing as anything to be found in the Mediterranean. The chance to take advantage of the low

angled light of early morning and evening gives you the opportunity to reveal the character of the place; those plaques commemorating the famous that we mentioned at the beginning can look very dull by normal daylight, but take them in the evening or at night under artificial light and you will find they have much more texture – the lettering will stand out in high relief and you will have a distinctive, quite different picture to anyone else. When wandering around a city take a good look at the 'street furniture': the lamp standards, the manhole covers and the seats in the squares and parks. We were recently in a city park where cast iron 'S' shapes supported the wooden slatted seats. Closer examination showed the 'S' shape to have been designed as a snake – scales, tongue, and all – and we returned in the evening when there were fewer people about and the seats threw long patterned shadows across the grass – the whole scene showed lots of contrast and was well worth photographing. We returned again early next morning – no one wanted to sit on the wet seats and the cool misty morning created quite a different mood to the evening before. Needless to say we used a tripod for these shots, not only because there wasn't much light but also because we wanted a very large depth of field. We used both black and white and film for prints and colour transparency film but our taking technique varied on each occasion. For the evening pictures where the lighting contrasts were high, the medium speed black and white film was rated at its normal speed and given a slightly longer exposure than we normally use in average hazy sunlight – a note was made on the cassette to underdevelop the film (Ilford film has a nice little panel on the cassette for writing such instructions as 'cut dev', or '2/3rds dev'; there is not room for much more but it is sufficient to draw attention to the film's need for special processing – see Chapter 3). For the colour slides we used Ektachrome 100 – a film that is very tolerant of high contrasts. In the morning, using the same sort of film but a different cassette we slightly underexposed the black and white, making a note on the cassette to develop it for a longer time. If you do not take many pictures it may pay you to use 20 exposure cassettes, even though they are a bit more expensive. The colour film we used in the morning was Kodachrome 25, a colour transparency film well known for its clarity and high contrast, but one quite capable of capturing a mood or atmosphere.

Fountains seem to have a special fascination for everyone. We have never yet been to a city square where fountains are playing and not found someone taking photographs, and we can understand this as they are very attractive to us as well! You must try and take them at night: often they are lit with coloured lights at various points, though sometimes the water is switched off after dark. Do not despair; fountains and their figurines, sporting cherubs and unlikely fish, lit only by street lights, can give a wonderful composition, and you do not necessarily need the artistic bits either – recently in Trafalgar Square, London, we found a superb composition using the wet rims of the fountain bowls which gave a wonderful lead in to the floodlit building beyond.

The interior of a ruined church in Lincolnshire. A long exposure, with the camera on a tripod, was given for maximum sharpness and depth of field since there are no moving objects in the picture.

Street lights are always worth a second look; not only may they be worth photographing or incorporating as a dominant feature in a picture, but the light from them also deserves attention. We have seen street lights that light up small streets in France with a lovely golden glow whilst little narrow alleys off the street are lit by lamps giving a metallic greenish light – the whole effect is most intriguing and is enhanced by the use of daylight colour film. Often in towns and cities the scene will be lit by several lights of different colours. Learn to look for these effects and use them, even though occasionally you may find them too distracting and lurid.

It may be that you will find the character of a place best expressed not with its monuments or architecture but with the local transport – the 'red six-wheeler 97 horsepower London transport omnibus' of a Flanders and Swan song is as characteristic of Metropolitan London as are the hordes of cyclists in Peking. Taking pictures of transport at night does not create great problems; a fast film, camera on a tripod and a few minutes walk-about will soon find a corner where there is either a traffic hold-up or a crossroads regulated by traffic lights. There will always be some slight movement showing even if it is just a bus vibrating with its own diesel engine – but many satisfactory pictures can be taken at exposures of between 1/5 and 1/2 a second. Do not be afraid of movement: try a long exposure of a moving bus, or try moving your camera by slackening off the panning movement on the tripod head and slowly follow a bus or brightly lit car down the road – a sort of slow panning motion during the course of a 1–2 second exposure. Start the camera movement before you release the shutter. On a single lens reflex the viewfinder will black out for the duration of the exposure so to keep the vehicle in the same place in the frame all the time (the object of the exercise); try aligning a distinctive part of the bus with the gap between pentaprism and shutter speed dial and keeping it there as you swing the camera. All this is to get a reasonably sharp image of the bus, taxi or cycle against a blurred background, and the pictures will be a talking point if nothing else!

You should also try some abstract pictures of the city lights. We have a series of slides which we call 'up, down and across' and we did just that; with the camera shutter set open on 'B', we moved the camera up down and across, whilst aiming it at a set of street lights. We made a few trial runs at the group of lights to make sure the composition did not run out of the frame and once we got the movement perfect we did it again, after releasing the shutter. We knew from experience that street lights need only a very short exposure at large apertures so this particular set of lights was taken at 2 seconds at f16 to give time to do the movements.

Another idea to try is to take several pictures on one frame. You do not need to have a special camera or a special device in the camera that lets you do this. All you need to do is set the shutter on 'B', hold it there with the lock on the cable release, and use the lens cap as a shutter. For example, you could create a 'motorist's nightmare' picture as follows. First make a normal long exposure at a city street corner with cars going by, recording

Rila monastery, Bulgaria. Dull days such as this can still be used to good effect if you are prepared. The detail and tonal range show up better in dull, more uniform, lighting than in sunshine, and in this case the strength of form in the subject is emphasised.

only their tail lights and winkers. This initial exposure should be under-exposed by about 1/4, e.g. 2 seconds instead of 8 seconds. The camera should be on a tripod, and the exposure timed by releasing the shutter on 'B', and after two seconds putting the lens cap on and locking the cable release. Then go round photographing traffic lights and road signs. Use an independent meter to get the exposure for these extra pictures and again use either 1/2 or 1/4 of the indicated exposure, resetting the aperture to give fairly long exposures – it is difficult to time short ones using the lens cap as a shutter. After accumulating several images release the locking

A different approach may yield a striking picture; in this case, the temptation to fill the frame centrally with the window and cross was resisted in favour of a more unusual composition.

If you are organised for low-light photography, and have a faster film or a tripod with you, then a very wide range of subjects present themselves. Still-life close-ups, like these old scales in a working oast house, can be very worthwhile subjects.

screw and close the shutter. You must only give partial exposures for each subject on a multiple image, as the exposure is, of course, cumulative. You can also divide a 4 second exposure up into four exposures of one second each, but you will find it much easier to use the method described above.

We suggest that you take pictures where the lights of the traffic make up the picture. Again a high viewpoint is ideal, and one overlooking a crossroads or a winding road is perfect. With the camera set firmly on a tripod, arrange the picture to make the best use of the pattern of the car lights. The shutter is set on 'B' and locked open with the cable release. A fairly small aperture is needed – try f11 for a start, using 100 ASA film. The rear lights of traffic will record as red streaks and the orange indicators as orange dashes. Cars coming towards you will record as white streaks. We find it best to hold a hand over the lens when the cars coming towards the camera get close, as the lights are very bright and will swamp everything else with flare. Using your hand or a bit of black card, you can select which bits of the scene you prefer to expose for. As in many street scenes a wet road surface gives an extra reflection.

Before leaving cities at night we ought to mention the use of simple automatic cameras. These 'auto-everything' (exposure, wind on, flash, etc.) can be used to take low-light pictures; it is best to use a very fast film, hand-hold them, or use a wall or post for support, and fire away. Mostly

you won't know what exposure you are giving so you won't be able to try some of the ideas we have suggested but do try to take at least some pictures – it is always surprising what modern films are capable of. Some of these automatic compact cameras have the disconcerting habit of firing off the built-in flash as soon as the light gets dim. It won't have the slightest effect if you are trying to photograph a large building, but it will register on any nearby trees, traffic lights etc., which is not necessarily a bad thing.

Flash in the city

A flashgun is recommended when you are out at night photographing the various things that a city has to offer. This is not to frighten stray dogs but rather to lighten over-dark areas and help lower the contrast on spot-lit subjects. It is also helpful to put a little light on wrought-iron gateways or overhead branches that you are using to frame the main subject, although we do not suggest that you put enough light on such things to make them look as though they were taken in daylight. You will need a fairly power-ful flash to be of any use, so, since we recommend you use it with a diffuser both to soften the light and give you some extra degree of control over its power, a flashgun with a guide number of 36–40 meters with 100 ASA film would be ideal – this is about as powerful a single piece unit as is normally available. You can also use flash to light several areas during a long exposure – the flash is used off camera and fired manually at the dark areas, though do not take too much notice of the flash's guide number when calculating the effect. If a flash on maximum power used indoors gives an aperture of f11 then outdoors it will only give *at the most* half this, i.e. f8, due to lack of reflection off walls or ceilings.

AIRPORTS AT NIGHT

If you arrive at a place by air be sure to take some pictures at the airport. Many of the cheaper flights arrive or depart at what are euphemistically referred to as unsociable hours. Take full advantage of the opportunities to photograph the airport at night – such photographs can be much more interesting than during the day. You won't get much of a chance to take pictures of aircraft taking off and landing as they will usually be too far away, and the only really bright lights on an aircraft are those that point forward like car headlights (and you are not going to get permission to sit on the end of the runway to take pictures). More realistically, you will want pictures of the airport to form part of a series to show your holiday. We usually travel with a largish camera bag as our cabin luggage, con-taining all the camera gear we use most often.

As we step out of the aircraft, or just before boarding, we try to have a few moments to take one or two pictures. An automatic camera helps and some sort of support is helpful since you won't have a tripod, or time to use one. At various times we have pressed our camera against a stationary air-

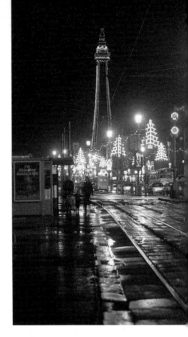

Blackpool illuminations. The autumn illuminations at Blackpool, in northern England, are a famous spectacle drawing photographers and sightseers from a wide area. This view was taken in the rain, giving an added dimension of reflections to the picture.

Shop window at night. The careful design and lighting of shop windows can produce interesting night-time pictures, and exposure is usually reasonably even.

port bus (its engine was switched off) or the pillars of the airport building. A standard or normal wide angle lens (28–35 mm) is most useful, and if you have automatic exposure, so much the better, for it will save any dithering.

Generally the smaller the airport, the better chance you have of taking pictures of your aircraft. If you do have time to take pictures out of the airport windows whilst waiting for your flight, you will be better off concentrating on the activity around the aircraft as they are being re-fuelled and restocked, as this is done under bright floodlights. Aircraft and airport vehicles are brightly coloured, and this is emphasised against the darkness beyond the floodlights. You won't need a super-fast film, and a normal 100 ASA will do if you can support the camera somehow.

It may be that you will be at the airport at dusk and be able to see planes coming into land. Do not be put off by the movement of the aircraft: it is surprising how slow a shutter speed can stop distant aircraft movement

Floodlit buildings make good straightforward subjects, and it is often worth picking out small areas to photograph as well, like this small section of the walls of Westminster Abbey lit by different floodlights.

especially if it is not moving directly across the frame. A shutter speed of 1/60th will often be found satisfactory. Do be careful of reflections in the windows – it is best to get as near to them as possible, or even place the outer rim of the lens housing against the glass. One last word of caution; some small airports in Europe and larger ones in other parts of the world are also used by military aircraft, and photography is not allowed; have a good look round for warning notices before attempting to take photographs.

BUILDING INTERIORS

No book on low-light photography would be complete without a section on photographing the inside of buildings, by which is really meant grand buildings – churches, cathedrals and stately homes – but the broad principles that apply to these can be used for any interior pictures. You can try to take kitchen interiors and the like, like those seen in glossy magazines and kitchen unit brochures, but you will probably not succeed since these are usually taken in mock-ups, open on two sides, in studios of warehouse proportions. Most of us, when thinking of interiors, will picture the banquet room of a stately home, the interior of a Saxon church or the lofty aisles and transepts of a cathedral. Interior photographs in stately homes may or may not be allowed and it is as well to check before going in; even where photography is allowed there may be restrictions on the use of tripods because they obstruct other visitors, and flash because it is thought to contribute to the damage of paintings and fabrics as well as being distracting to other people. You will often get a better response to a request to take photographs if you go at off-peak times. In some cases a special photographic permit can be obtained though you will almost certainly have to pay extra for this. With a permit there may still be restrictions on how you can use your photographs – some owners are very particular how and where pictures of their paintings are published. Even if photography is freely allowed or a permit obtained, we much prefer to take pictures at off-peak times (daily or seasonally) when there are fewer people about.

For most interior work the medium speed films of about 100 ASA (both colour and black and white) are preferable because they have fine grain and are better able to cope with the high contrasts often found in interiors than the slower finer grain high resolution films of 25–50 ASA. Though these slower films have their uses.

Most interiors need maximum depth of field and therefore exposure times will be long because of the relatively low light levels and small apertures needed to get everything sharp. A tripod is necessary, and its use will make the correct alignment of horizontal and vertical lines easier, as will a small spirit level which helps considerably to get the camera platform level. Only rarely can one use one of the very fast films of 500 ASA plus for hand-held exposures, and even so its use is best restricted to

photographing flat objects where a minimum of depth of field is required so that the highest possible shutter speed can be used.

We have found that there are two major problems when taking interiors, especially those open to the public. One is the other visitors who will, even if you go at off-peak times, often walk into your view during exposure. You can overcome this either by a lot of patience and timing your exposure when people are out of the picture, or by giving very long exposures so that people moving through the picture do not record: this works best in very dimly-lit large interiors such as cathedrals where there are few points of interest to make them pause for very long. Another way of avoiding recording people moving through the picture is to break one long exposure into a series of short ones which are made only when people are out of the picture area. To do this you will need to lock the shutter open on the 'B' or 'T' setting and use the lens cap to give the exposures – a 30 second exposure can be divided into three exposures of 10 seconds each with gaps of several seconds or minutes between the various parts of the total exposure. The individual bits of the exposure do not have to be all the same length of course, and the method works best with exposures of longer than 10 seconds. The camera needs to be on a very firm tripod and you do have to be very careful not to move the camera whilst making the exposures. If you are going to use the divided-exposure technique very often, you might consider making a hinged flap for the lens hood – it need not be very elaborate: a piece of black card and adhesive tape for a hinge are often adequate. A lens hood with a hinged protective flap is marketed by Camera Care Systems Ltd. and could be used in the same way as a homemade one. In addition, a neutral-density filter is useful for *lengthening* exposure times in these circumstance. The second major problem often encountered when photographing interiors is the high lighting contrast due to sunlight streaming in from side windows across an otherwise ill-lit room, leaving you with no choice but to wait for a cloud to pass over the sun (and often this will not reduce the contrasts enough) or return on a day when cloud cover is complete. The only alternative to this for the casual visitor is to expose either for the highlights or the shadows, since the contrasts on a sunny day will be too great for the film to record detail in both highlight and shadow areas. Except when taking a picture showing the window light spotlighting something, we have normally found it best to expose for the middle and dark tones of the room and leave the bright patches to burn out – this method is not wholly satisfactory but the darker areas of an interior generally make up most of the picture area. To find the correct exposure we take several meter readings of the parts of the photograph where we are trying to record detail, and average them out – for instance if the 5 separate readings for an aperture of f11 are 1/2 1/4 1/8 1/15 and 1/20 I would expose it at 1/8 at f11. The highlight area we are discounting in our imaginary situation might well give a meter reading of 1/125 at f11. This will be some sixteen times too bright for colour film (in other words 4 stops difference) and the recom-

Old buildings at night, in the snow. Snow lying on the ground can be a considerable asset when photographing cities at night, as it reflects more light into shadow areas, reducing the extreme contrast.

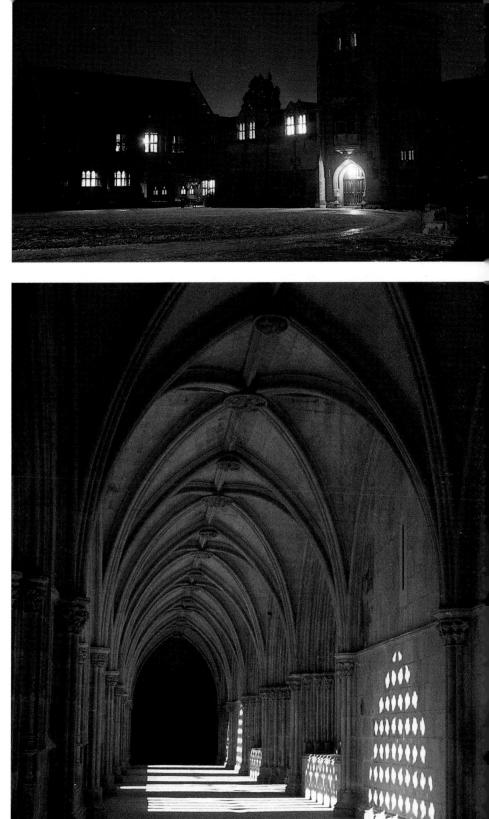

Cloisters. Building interiors, lit by daylight, can be treated in the same way as any other low-light subject with great effect. The only difficulty here was in giving extra exposure to ensure that the roof detail was visible, since the bright patches of sunlight tended to dominate the meter reading.

mended difference is only one stop either side of the correct exposure. You will need to learn by experience whether it is worth biasing your exposures towards lighter or darker areas. This will largely depend on how much of the finished picture these areas occupy, or where other important features that need to have their full texture and detail recorded are. If you have taken the trouble to set up a tripod, and waited for the right moment, you are not going to take just one picture; you will, of course, bracket your exposure but do not just leave it there; take time to study the finished photograph so you know exactly which exposure produced the best result. Of course many of your exposure problems will be solved with cameras with sophisticated metering systems like the OM4 and Nikon FA, but even when using such cameras we still find it useful to record exposures and methods in a small notebook, an invaluable aid to memory when prints or slides come back days or weeks later. Your recordings need not be elaborate, just enough for you to establish the type of camera used (if you have several in case it goes faulty), the subject, how many frames were taken, the exposure (speed and aperture) and, importantly, how this exposure was obtained.

Stained glass windows in churches are, perhaps, the best-known example of high lighting contrasts. It is almost impossible to record a church interior to its best advantage *and* do justice to the beautiful colours of the stained glass. The only thing to do is to photograph the windows separately, taking a reading of light coming through them. You may have to do this first with a hand-held meter or with the built-in meter from the camera (taken off the tripod) close to, then using the meter reading from the camera position. If the window fills the frame, then you can use the camera's built-in meter from the taking position. A top quality zoom lens of 70–210 mm is ideal for stained glass windows. It can be used to fill the frame with a window to get the correct exposure, and at the 200 mm setting can close in on the interesting little scenes which often make up a story in stained glass. The longer telephoto setting is also useful for helping to control the converging verticals in the window supports, though you will never do this completely unless you can get on a level with the window. Converging verticals are worse the wider the angle of lens and the closer you are to the window. With a telephoto lens, or the zoom on its telephoto or narrow angle setting, used from a greater distance the converging verticals of the stone or metal work will be less noticeable.

If you have plenty of time and a fair degree of freedom to wander around the interior of a large building or stately home, look for different and interesting angles; attempt to get away from the standard view from the doorway. Try a 'dog's eye' view along the carpet showing chair legs leading up to the old master high in the frame at the end of the room, or a wide-angle view from low down against the fire with the fire-irons brassy and large at one side. It is just possible you may be able to use a high viewpoint: if you can find one make the most of it. Some really old houses had a minstrel's gallery above the main hall, giving superb views of the

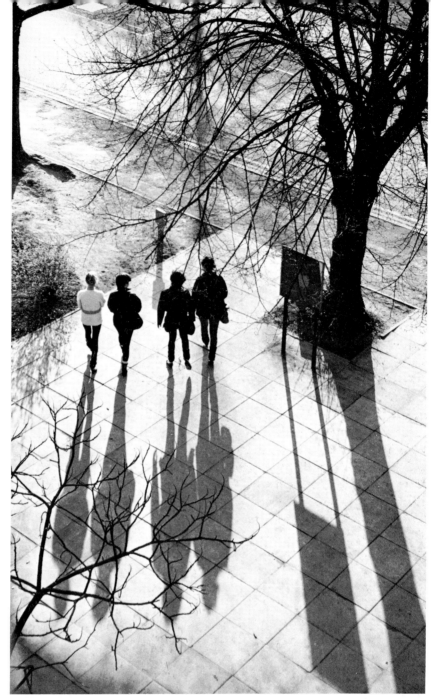

Evening sunshine in cities often gives fascinating lighting effects with long shadows, and these can often be best appreciated and photographed from a high viewpoint.

activities below – nowadays you will only see a formal display, but the high viewpoint is well worth using. We once used a set of cleaner's steps to get a viewpoint some 9 feet up, of a long room; the trouble was well worth it, and we had a camera on the largest Benbo tripod plus an extra extension arm. The whole system was not 100 per cent shake proof but indoors there is no wind to worry about (though springy floor boards can be a menace!).

Before you leave a church, cathedral, stately home or even a modern hotel or office block, take the trouble to look upwards. The ceilings of

many old buildings were handsomely painted; cathedrals and churches have spectacularly vaulted roofs, and modern buildings have intriguing views up stairways. The easiest way to take these views is to lay the camera on its back on the floor, and set the self-timer to fire the shutter, which gives you time to get out of the way. You will have to align the camera carefully, since you won't be able to use the viewfinder. You may also have trouble focusing but with both normal and wide angle lenses the camera can be focused from eye level, and an extra 5 feet added, and any aperture, smaller than f5.6, will give enough depth of field to take care of any focusing errors. Some cameras such as the Nikon FE and FM series use the wind-on lever to switch the camera on and consequently the camera will not lie flat, but it is easy enough to get over this by supporting the camera on a book, lens hood, or anything that lets the wind-on lever hang out over the edge. Exposure for ceilings presents few problems as they are often the most evenly-lit parts of an interior.

Occasionally we have used flash for interiors both to provide the main light and as a fill-in. When using flash as the main light a whole room can be 'painted' with light from a single flash whilst the camera shutter stays open; very large dark rooms require many flashes but small country churches with light stonework interiors may need only 15–20 flashes from a medium size flash such as the Vivitor 283. If you are using a camera with off-the-film metering, all you have to do is to set the camera on 'auto' and keep firing the flash, and the camera switches itself off automatically when it decides the film has had enough light.

When firing many flashes off in a building try to visualise where the shadows will fall, as we have seen some pictures using this technique which showed hardly any shadows and others where there seemed to be a separate shadow for each firing of the flash. You should also take great care when using flash as a fill-in, since it is easy to create some local hard shadows out of keeping with the rest of the photograph – we normally use a diffuser on the flash head or bounce the light off a large white card or special Lastolite reflector.

Needless to say, if you are using flash, then you have to use daylight-type colour film (see Chapter 2). You will do this anyway, especially if the interior is lit solely by daylight, and a daylight type of film is best where lighting is a mixture of daylight and artificial, since warm daylight tones recorded on daylight film are much more pleasant than the greeny blue tones of daylight recorded on artificial light type film.

In any interior situation you should be aware of the possibilities of small objects, quiet corners, arrangements of work tools, etc. Once, whilst photographing in a still-working Kentish oast house we came across a lovely little natural arrangement of a set of old weighing scales and sticks of sulphur used to bleach the hops which made several satisfying pictures in both colour and black and white (see picture). But we almost missed the opportunity at first by being more concerned with photographing the whole oast house interior.

5 Animals, Insects and Plants

Although one traditionally thinks of nature photography as taking place in bright, sunlit conditions, in fact a whole range of different possibilities open up as the light levels fall. A completely different range of nocturnal or crepuscular creatures emerges, which you rarely see in the daytime, whilst other daytime species behave quite differently. Some amphibians, for example, may be visible during the day, but only call, or perform their courtship displays at night. Some highly mobile insects, normally difficult to catch up with and photograph, become still and torpid as the light level (and hence the temperature) falls, making them easier to photograph. Some plants only flower, and therefore look their best, at night, whilst some colours of flowers, especially white or yellow, are best photographed in low light to prevent harsh shadows and highlights from forming. Some species are only active in the rain, and the only way to photograph them is to be out there in the rain with them!

One way and another, the possibilities for low-light nature photography are endless. However, it is a specialised subject, needing knowledge of the subject, patience and dedication, and a certain amount of specialised equipment for success. We cannot cover all the background material necessary to do the subject justice, since normally one would only move into low-light nature photography after mastering the easier aspects of the subject. For readers wishing to delve into the area more deeply, the book *The Wildlife Photographer: A Complete Guide* (1986) in the same series as this book, gives much more information. In this chapter, we have picked out some of the more interesting and rewarding aspects of low-light nature photography that do not require too much specialised equipment or knowledge, though if you get hooked, as it is very easy to do, you can use the techniques in more complex situations. The range of possible equipment required to photograph the whole gamut of nature, from large mammals through to insects, or mosses to trees, is so wide that it is easier to treat the equipment for each subject separately.

FLOWERS AND OTHER PLANTS

At first sight, it might seem superfluous to talk about taking photographs of plants in low-light, when they look so nice in sunlight. However, some plants are never found in well-lit situations, so you have little choice; many pale-coloured flowers look better in more subdued light; others only flower in the evening or at night; and there are also some interesting

effects to be gained by 'painting' plants with flash in low-light situations, so there is ample scope for taking interesting low-light pictures. There are even some luminous plants, to which justice can only really be done in low light.

Low-light habitats

Although the majority of plants prefer to live in well-lit situations, there are many that do not. Normally these are plants that either have a low ability to convert the sun's energy into organic matter, or have a particular requirement for humid conditions, and they are unable to compete normally with more vigorous plants in the sunlight. Fungi are a typical example, in that they have no ability at all to utilise the sun's energy, and they are most frequently found in conditions of deep shade, living on rotting leaf mould or wood, and demanding quite different photographic techniques to dwellers in bright sunshine. Although it is perfectly possible to use flash on fungi, and sometimes you have to, we believe that much better pictures result from working *with* the natural light rather than *against* it. To do this, you will need a good tripod that can be set up firmly, close to the ground if necessary. Some manufacturers like Velbon and Cullmann produce good tripods on which the legs can be splayed widely, allowing photography at about 8 inches from ground level, and these are satisfactory for most situations. Beware of the type that advertise low-level photography by means of a reversing centre column, since they are difficult to use and there is always a leg in the way of something! The best tripods for this type of work are undoubtedly the range of Kennett Benbo tripods, which can be manoeuvred into any position, right down to ground level, and held very firmly. They are unusual in design, and not cheap, but worthwhile if you do much low-level photography.

There are also alternative supports like 'bean bags' or 'ground spikes' for this sort of photography, though a good solid tripod is best. You will also find use for a cable release, a reflector (see Chapter 1), a manual flashgun, and a graduated neutral density filter. A macro lens, either 50 mm or 100 mm is ideal, but a normal lens with extension tubes or close-up lenses will suffice. If you have the option, you will find that an automatic, aperture-priority camera, with off-the-film metering is best, since you can then accurately meter exposures up to about 2 minutes, with or without fill-in flash, with compensation as necessary.

Once you have located a suitable subject, and there are plenty of species about in autumn especially, set the camera up on the tripod and frame the subject to suit your needs, bearing in mind that groups often look better than individuals. Rather than now simply taking the picture, there are various things you can do to improve matters. Firstly, on any exposure longer than 1–2 seconds, you will experience reciprocity failure (see Chapter 3), which means that the picture will appear too dark, and you need to compensate accordingly. Very low levels of light can look very flat, and you will also find that, in these low-light situations, any sky that

Buffalo in mountain mist. The low-light and thick mist concentrate the attention on the buffalo and its puzzled expression, rendering all background detail as neutral. A 500 mm mirror lens picked out the key elements in the animal's head, and the film was uprated to 500 ASA.

appears in the picture will be much brighter than the subject, altering your metering readings and threatening to look burnt-out. A good reflector can be used to bounce some of this skylight back onto the front of your subject, enhancing the modelling and reducing the contrast. In very difficult situations, it will pay you to use a flashgun and bounce its light off the reflector, subtly to light the face of the subject up still more.

If much sky is appearing along the top of the frame, as it often does, then a graduated grey (neutral density) filter will reduce the contrast and exposure problem, and blend the two elements together better. Strong backlighting can be satisfactorily used as part of the picture, bouncing some light back onto the front (or filling-in with flash) to lighten the main subject. These techniques work well with woodland flowers, lichens, mosses, and other small plants of low-light situations.

With the smallest subjects, such as lichens, or in very low-light conditions, such as in caves, you will find flash to be more satisfactory. This can be used normally, hand-held or on a bracket, coupled to the camera, or, in conditions where you can set up a tripod, you may get the best results by 'painting' with the light from the flashgun. To achieve this, you detach the flash from the camera, and fire it manually via its test or 'open' button while the shutter is open. For off-the-film metering cameras, simply set a small aperture, press the shutter, and whilst it remains open fire off the flash frequently, balancing frontal light and backlight as you go; the shutter should close itself when enough light has been received. With other cameras, you need to set the shutter on 'B', hold the shutter open for about a minute using a locking cable release, and fire off as many flashes as you judge to be necessary bearing in mind the power of the flash, the film

speed, and the aperture. This technique can produce highly attractive results.

There is a small selection of plants that are luminous; in other words, they actually emit light in some form or other. Most of these are fungi, but the phenomenon also occurs in other groups, too. The only way to record this luminescence, which is usually very faint, is to ensure that the ambient light is paler than that from the plant. If the plant is found in caves, you are unlikely to have a problem, but in outdoor situations, you will probably have to wait until dusk, at least, to achieve the desired effect. To photograph luminescence, you will need a good strong tripod, a lockable cable release, and a probable exposure time of at least 2 minutes to record the light adequately, more for a faint luminescence.

Light-coloured flowers

White, yellow, cream and similar coloured flowers do not photograph very satisfactorily in bright conditions, especially in close-up. They look attractive to the eye in sunlight, but the range of light intensities represented may be enormous, and no film can satisfactorily cope with it without burning out the highlights, and making any shaded areas too dark. The result is poor definition of the flower structure. This can be overcome by photographing light-coloured flowers in dull light, and even in very dull conditions you will get good detail rendition, though flowers without inherent relief and structure may look a little flat if the lighting is

House mouse at night. Most small mammals are only active at night. This house mouse was photographed, by twin flashes, as it came to take bait after several days of baiting without any photography taking place.

Garden spider on web, evening light. The low angle of evening light, and its orange-red cast, gives a different appeal to a common enough subject.

completely shadowless. A tripod is likely to be essential, unless you are using fast film, and you will need to choose your moment carefully to avoid any subject movement.

Evening flowers

Some plants habitually only flower in the evening, or even at night, and these are worth seeking out and photographing, especially as many people have never seen them. Examples include the various evening primroses (*Oenothera spp.*), night-flowering catchfly, moon carrot, and others. In most cases, the petals of each new flower open in the evening, remain open during the night, and fade rapidly the next morning, to be replaced by a new flower that evening. The most difficult task is usually that of locating the plants, since they are barely visible during the day without flowers, and many people will not notice them. Once located, they are best photographed on a calm, sunny evening, with medium speed film (e.g. Ektachrome 100 or Fujichrome 100), including some into-the-light shots to emphasise the fact that it is evening. Light levels will be surprisingly low on the main subject when the sun is setting, even though the sky may be bright, and it may become almost impossible to obtain adequate available light if conditions are breezy.

Some flowers, whilst remaining open all day, become scented in the evening, which is when they attract their pollinators, giving possibilities for other interesting pictures. In addition, almost any plant, especially if it is translucent, can be photographed against the evening light either with the sky visible as part of an evening scene, or purely as an against-the-

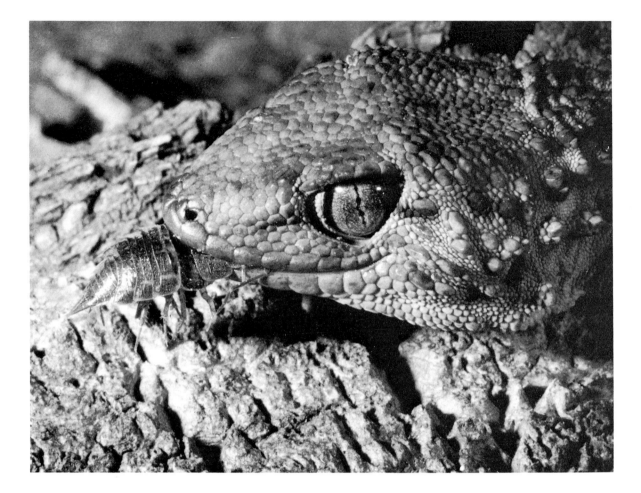

light plant portrait. The colour shifts caused under these circumstances are usually quite acceptable, especially if the fact that it is evening is emphasised rather than hidden.

 The evening, or early morning, is also a good time for taking silhouette pictures of winter-bare trees. The individual pattern and shape of each tree species shows up starkly against a coloured evening sky, and the combination is very attractive. Expose for the sky if you do not need any detail in the front of the tree – this makes the shape stand out more as a dark counterfoil to the bright sky. There is little difference between evening and morning, and the best sky is one that is strongly coloured but not too cloudy.

Spotlighting flowers with open flash

One of the advantages of low-light conditions is the possibility of selectively lighting a scene with open flash to highlight some parts at the expense of others. To achieve this, you need to set up the camera on a tripod, with a slow film loaded, and set an aperture that gives a shutter duration of at least 60 seconds; this is quite feasible with slow film at f 16 or

A gecko, photographed at night on the wall of an old house. Twin flashguns, mounted on brackets, were used to light the subject, metered by TTL flash metering. A built-in modelling light, operating through the flashgun, was used for focusing on the subject.

so in very shady conditions. Your picture should include a good display of flowers such as a scattering of orchids on a shaded bank. Charge up a flashgun, which should not be attached to the camera, and as soon as you release the shutter, walk amongst the flowers in the picture and give all the important ones a 'flash' from close to, preferably from the front. You should work out roughly how close you need to be to light each flower at the aperture you have set the camera at. You can walk through the picture without any likelihood of registering on the film, using a torch if necessary (not pointing at the camera, of course), and should be able to fire off about 10 flashes during a one minute exposure. The results are somewhat unpredictable, always different, and usually interesting!

INSECTS AND OTHER INVERTEBRATES AT NIGHT AND IN LOW LIGHT

If you are prepared to go out in the evening, early morning or night looking for insect (and other invertebrate) subjects, you will be well-rewarded. A completely different range of invertebrates, including moths, spiders, centipedes, and many others, come out at night, while many daytime species behave quite differently in low light. Daylight insects are very affected by temperature and light intensity, and as soon as the light and heat levels drop, they become inactive and torpid; this can be a good time to photograph them if you can find them. Some diurnal (daytime) species behave differently in the early morning or at night; dragonflies, for example, frequently emerge from their aquatic larval stage to transform into adult insects – not only is this the most marvellous spectacle to watch, but it also involves several very static stages which are easy to photograph if you are prepared.

Insects at night

A whole new world of insects and related animals comes alive at night. Many of these are quite invisible normally during the day, as they hide beneath stones and logs, underground, or amongst foliage, but they become active at night. Clearly, they are not as easy to photograph as insects in daytime, but there are many possibilities if you go prepared. You need a camera loaded with medium speed film (about 100 ASA), a close-focusing lens of some sort (the ideal is a 100 mm macro lens, but other focal lengths will do, and ordinary lenses can be used with extension tubes) that will focus to $\frac{1}{2}$ life-size or closer, and one or preferably two electronic flashguns mounted on some form of bracket to avoid having to hold them, and to keep them away from the lens axis. There are several specialist flashgun set-ups that are particularly suited to this form of work (as well as to general daylight work) because they have built-in modelling lights which can be very satisfactorily used to help you *find* subjects and then *focus* on them. The Olympus T28 flashguns mount on the front of the lens, or on brackets, while the Olympus ring flash and the medical Nikkor

macro lens both have lights built into their ring flashes which encircle the lens. The Olympus products also couple up with the excellent through-the-lens flash metering system of the OM2n, spot/program, and OM4 cameras. If you do not have flashguns with this facility, the next best thing is either to tape a torch onto the lens barrel (taking care that it will not prevent you from focusing), or wear a miners' type headlamp, either of which allows you to have your hands free for camera work.

Finding subjects is not as difficult as it might seem. For moths, choose warm still nights, and search areas that you know to be rich in flowers, long grass and sheltered areas, such as a woodland ride, a good garden, or an old railway line, preferably well away from the lights of houses and streets. Move gently around searching flowers ahead of where you are walking, looking all the time for moths feeding on flower heads. The larger ones, in particular, make most attractive subjects, together with the flower they are feeding on, and many of them will not be disturbed by you or your lights if they are engrossed in feeding, though the lights should not be too bright. At the same time, you will notice that there are more spiders on the bushes than in the daytime, and more molluscs, centipedes, earwigs, ground beetles, and many other things about than in the day, and all can make interesting pictures.

If you are looking for insects that are normally active in the day, such as roosting butterflies or dragonflies, you will find it easier to work in the late evening or dawn than in the dark, but you may come across such insects by chance, and can treat them as any other nocturnal insect.

Gauging the exposure for this type of work may, at first, seem difficult, though there is a reasonably standard procedure for working it out. Fortunately for us, the fall-off of light away from a flashgun (which decreases inversely with the square of the distance, i.e. it is $\frac{1}{4}$ the power at twice the distance) is exactly balanced by the light loss as you focus closer to an object, within certain limits. What this means in practice is that, if you mount your flash on the camera or lens, the same amount of light will reach the *film* from the flash over quite a wide range of distances from, say, a few centimetres to $\frac{1}{2}$ a metre or more. So all you have to do is calibrate your flashguns with a series of trials, working roughly around the guide number of the flash (see Chapter 3), and adopting the aperture that gives you the best results for all your close-up work. This calibrated figure will only work for a given set of circumstances of course, and if you change the focal length of the lens (which will alter the flash to subject distance) or use a different film speed, you will need to adjust accordingly. Also, it is a purely manual method and takes no account of the brightness of your subject, so if you have calibrated for a neutral subject you need to stop down a little for a bright subject, and open up a little for a dark one. If you have TTL flash metering (see Chapter 1), you have no need for calibration, but we find it best to give about minus 1 stop compensation to allow for the meter over-reacting to dark backgrounds by attempting to expose them correctly. In daylight close-up natural history work, considerable

Dragonfly emerging. The emergence of a dragonfly adult from its larval skin is a slow and vulnerable process which often takes place at night or in the early morning. If you can find such a process taking place, it is possible to spend considerable time over taking the photograph; this early morning picture involved an exposure of 1/4 second, with the camera tripod-mounted, and a reflector held below to brighten the lower parts of the subject.

effort is expended in attempting to counteract the black backgrounds that tend to occur anyway if you use flash, but in night work this is far less necessary since the fact that it will look as though it was taken at night is perfectly reasonable!

Insects that should not be photographed at night by using flash are the luminous ones. There are a number of them, of which the most famous, perhaps, are the glow-worms and fire-flies (actually both groups are beetles). In glow-worms, both adult and larva produce a soft greenish light, though this is strongest in the adult female, which is sedentary, and helps to attract the flying adult males. Photographing this glow is not easy, since you have to expose for an illumination from the beetle which is very low in intensity. The problem is basically the same as that of photographing glowing plants, but it may be compounded by the habit of female glow-worms of sitting on grass stems to make themselves more visible; unfortunately this also means they are more likely to move during an exposure. You have to search carefully for one that is immobile, or try moving one to a better position. Exposure times are likely to be long, probably over a minute, depending on your filmspeed and aperture.

Insects at dusk or dawn

Virtually all day-active insects cease their activity towards evening and begin to seek out roosting sites. In some species that require particularly warm well-lit conditions, this may happen quite early in the evening; other species, like bumble bees and a few dragonflies, may fly on until dark. The advantage to us, as photographers, is that the insects become almost immobile under such conditions, relying solely on camouflage and concealment to avoid being seen by predators (or photographers). The disadvantage is that they are very hard to find. In order to achieve much in this form of photography, reconnaissance is crucial to find good sites for the species you are interested in, and if possible you should be there as they go to roost. If you have no reference points, you will almost certainly spend several fruitless evenings looking around until dark!

Once you do discover the roosting-places, you can often treat the subjects as static objects, depending on their position, and use tripods, reflectors, flash set-ups and other devices at will, though you may have to work fast as the light fails. Normally the only problem is insects that roost on taller stems, since a breeze invariably springs up in the evening when you begin photography, making available light pictures difficult. Mornings offer similar possibilities, though the problems are slightly different here. Many species, and especially large soft-winged insects like butterflies, need a warm-up period in the morning before they begin to move far; they may crawl or walk short distances to catch the sun, but they are reluctant to fly. There is thus an excellent range of picture possibilities for the early rising photographer who may encounter many attractive insects, often in perfect poses as they flatten their wings to catch the early sun. The light levels are usually good and improving, though you have to beware of the opposite possibility to dusk – that the insect may warm up sufficiently to fly away.

We find it pays to use the natural light and frequent lack of wind at this time, and prefer to work with a slow to medium speed film, and the camera mounted on a tripod. Reflectors can be useful for bouncing a little more light into the scene, especially if you are working against the light, and a medium telephoto makes it easier to avoid casting your shadow over the insect when you attempt to get at right angles to its spread wings.

Emerging dragonflies

One wonderful possibility for the very early morning photographer, and occasionally for the evening photographer, is that of emerging dragonflies. Many of these attractive insects, especially in the warmer parts of the world, emerge from their aquatic larval stages to become adults at night. The stages they go through during this final transformation are slow and highly vulnerable, and there are obvious advantages in beginning them at night. In average cool conditions, the transformation can take at least four hours, and there are long pauses between stages as the insect rests, or

Toadstool in dense woodland. This particular example was photographed using a 135 mm lens, mounted on a tripod, together with a reflector to brighten the front of the stalk. An exposure of 2 seconds was required.

allows wings to expand, and so on, and this allows perfect photographic conditions. The insect cannot fly, or even move, until the processes are complete, so you can treat it as if it were a studio subject; you can set up a tripod, use reflectors, backlight with flash, wait for better light, or whatever, with little danger of losing your subject, and you may even be assisting its survival by keeping predators away during this vulnerable stage. It is also the most marvellous transformation to watch, as a drab small aquatic larva turns into a resplendent large, colourful insect.

MAMMALS AND OTHER ANIMALS IN LOW LIGHT

In many countries of the world, the great majority of mammals are nocturnal, leaving little choice as to when they can be photographed.

Many other diurnal mammals, like deer, are most active and more easily found in the very early morning or in the evening, when light levels are lower. In addition, many amphibians, though sometimes visible during the day, are most active in courtship, calling, breeding and other photogenic activities at night. So, if you are interested in photographing wild animals, at some time or other you are almost certain to need to work in low-light conditions, and your range of opportunities is greatly expanded by doing so.

Mammal photography is no easy option. You are dealing with creatures that are usually highly mobile, have excellent senses, especially the sense of smell which is infinitely better developed than ours, and which normally appear at low densities, making finding them that much more difficult. For many species, the only way to obtain satisfactory pictures, especially if working at night, is to find their home and photograph them as they enter or leave it, whilst for many small mammals, the only practical way to obtain portraits is temporarily to capture and confine the subjects, photographing them in a studio set-up.

Morning and evening work

In the more crowded areas of the world, most daylight creatures are active for the first few hours of the day, before they are disturbed, and then again in the evening, and these provide the best opportunities for photography. The most likely subjects for this sort of approach are deer, but it applies to a number of other species, depending upon where you are working.

The first requirement is to know your quarry's habits. You may be fortunate in having a garden where they visit regularly, but for most people it will be necessary to go out and find the animals. Thus you not only need to know the area to look in, but also exactly where to expect the animals. Most animals are creatures of habit, within limits, and you will be well rewarded if you spend several mornings or evenings studying your subjects, finding out when they go where, what direction the light is in, looking out for potential places to photograph from, and deciding what equipment will give you the results you need. There are two choices; either you can establish yourself before dawn in a position from which you expect to see deer, or whatever your animal is, or you can stalk your quarry using all the knowledge of its habits and the conditions that you can acquire. Deer are often culled in forests with the aid of deer towers sited for clear views of feeding areas; you may be able to get permission to use one of these as a base, making sure you get there early, though some are sited too far off the ground to allow attractive pictures to be taken. If you are stalking, you will need a medium to fast speed film, depending on the conditions, to allow you a shutter speed of at least 1/125th second, preferably more; an automatic metering camera helps get the correct exposure under active conditions; the lenses you use will clearly depend on the size of your target and your anticipated closeness of approach, but

Oxlips, early morning. Early mornings and late afternoons can be fascinating times to photograph flowers, as the low angle of light spotlights subjects, and backlighting emphasises their halo of hairs.

it is highly unlikely that you will need less than 300 mm, and you may require 4–500 mm lenses. You can use a tripod for stalking, but it limits your mobility and speed of action somewhat; an alternative, if there is enough light, is to use a rifle-grip, which supports the camera and lens against your shoulder, and releases the shutter smoothly via a cable release, allowing rather slower shutter speed than if you hand-held the same lens; even so, you will require a shutter-speed of at least 1/250th second with a 500 mm lens. Unless you are looking for group shots, a small aperture is rarely important in this form of photography, and you will do better to use the fastest shutter speed you can, with an aperture no smaller than f5.6. When stalking, always move slowly and smoothly, go round corners or over brows very slowly, making sure that you see animals before they see you. Try always to work upwind, though strongly breezy conditions are best avoided, and wear dull, non-rustling, clothing.

Some animals are best photographed at their lair in the early mornings. A particularly good example is that of cubs, such as fox cubs, where the cubs will play close to the lair for several hours in the early morning, but are often difficult to photograph at any other time. In these conditions, you have the advantage of being able to set yourself up in advance, after considerable reconnaissance to establish what the best position will be. Your scent, and any movements that you make, are more important than your static appearance, so take care to site yourself upwind, or choose the right morning, and make a minimum amount of movement when you are working. A tripod is almost essential for this sort of work, when you may be viewing for hours on end. If you are quite close to the site, muffle your camera as much as possible to deaden sound, and do not use a winder. You should be in position well before the animals emerge, which means that you need to be well-insulated to avoid extreme cold, and should be familiar with the approach to the site since it may be dark when you have to arrive.

Working at night

It is unlikely that anyone would choose to photograph animals at night, but there are a number of opportunities that can only be taken at night, so there is little choice but to make the best of the conditions. These opportunities include animals that live below ground during the day, only emerging at night; bats, which though often photographed by day, are almost invariably living in very dark conditions; and animals, particularly many amphibians which, though visible during the day, are most active at night and only then show their full range of behaviour.

For obvious reasons, it is highly impractical to go out searching for animals at night speculatively, and you need to narrow down your options considerably by working at the animal's home, or by baiting.

At the lair

A typical example of working at night at an animal's lair is provided by

Pied flycatcher at woodland nest hole. Perhaps surprisingly, even day-loving birds, if they nest in woodland, have to be considered as low-light subjects since light intensities in deep shade are very low indeed. Here, the light from two flashguns was balanced with ambient background light to give a more natural-looking daylight picture.

the badger. Although other animals vary in their situations and habits, most of the problems can be looked at with reference to this example. Badgers are characteristic nocturnal animals, spending the whole of the daylight period (usually) below ground in the sett, emerging shortly after night has fallen to forage widely during the night. It is possible to photograph them in their setts, by the construction of artificial setts and glass walls, and this has been done regularly, but we are dealing here with the rather simpler option of photographing them as they enter or leave their natural home.

First, find a suitable sett, where you can a) get permission to work; b) be undisturbed; c) find a suitable position, preferably above ground, from which to observe and take photographs. Many setts are regularly watched by local naturalists, and they may be prepared to share their experiences with you, though equally you should endeavour not to upset any work that they are carrying out. Once a suitable sett is located, some preparation and reconnaissance is necessary. This should be carried out during daylight, with minimum heavy trampling, especially if you intend to watch or photograph the same evening. You need to establish a suitable place to sit where you will be well above nose-level, to avoid your scent reaching the animals; this may also be your photography point, or you may require a remotely controlled set-up nearer to the sett if there is no other way of doing it. With badger setts, in particular, there are frequently several entrance tunnels, and it may not be clear which is being used; indeed, the badgers will vary the tunnel they use according to circumstances. If you can, it is best to spend several nights watching and establishing routes and the best photographic points, but if you are unable to do this, you can at least check which entrances are being used by placing light sticks over the likely holes, and investigating which have been disturbed on the following day.

You will need flashguns, ideally two, and for preference these should be mounted away from the camera and its optical axis, to avoid 'red eye' and improve the modelling effect. It is easier if these are mounted somewhere that you can reach, to avoid leaving them switched on for hours, though you can also arrange a master-switch, with the help of an electrician, workable from your base to control them as we have done. With any early efforts, you may not be too worried about perfect lighting arrangements, but it is worth at least getting the flash off the camera to ensure that there is no 'red-eye' which can be very unattractive.

To allow you to see what is happening, and to focus if you are controlling the camera, you will need a light. Most mammals are more affected by intensity of light rather than colour, so any very low level of illumination will do, though it is probably best if it is red, such as a weak torch with red cellophane or a red filter taped over it. This will be no more than adequate, and you should set as many controls as possible before darkness descends, including your calculated flash exposure; or if you are using TTL flash, making sure that the aperture you set is within the

Candle-snuff fungus. Fungi almost invariably grow in low light, yet they make very attractive pictures, even on slow film, if a tripod is used and some extra exposure given to allow for reciprocity failure.

Little owl at nest hole. Nocturnal birds present additional problems of composition and focusing, but one need be less concerned with avoiding contrasty lighting and black backgrounds since this appears natural for a night-time photograph.

flashguns' capabilities. Focusing will be difficult, and it will be aided by good (or suitably corrected) eyesight, using a focus-screen recommended for low-light work to avoid the central split-image blacking out, and by setting the focus as closely as possible in advance. Normal SLR autofocus systems will fail to work in the dark, though you could use a Minolta 9000 with its infra-red emitting flashgun fitted, if the flash is on the camera (though this is not where you really want it).

Whilst waiting, remain as still and quiet as you can, and remember to go well wrapped up. Badgers have rather poor sight, and no concealment is necessary, but other animals have better vision, as well as a good sense of smell (e.g. foxes) and you will need some form of concealment if only a loose screen of leaves and branches; the higher you are, the easier it is,

since few animals look up, but it may make your position unsuitable for photography if you are too high.

When the action begins, you will probably only get one chance at a picture, on the first night at least, so choose the moment well. Most animals will become accustomed to gradual regular increases in illumination over a period if you have time to do this, and they will also gradually become accustomed to you and your flashguns, allowing more than one chance per night. With all wild animal work of this sort, the longer you spend at it, and the more you study your subject, the better your chances of getting good pictures. If you have had to mount your camera somewhere away from where you are sitting, you have to prefocus carefully on a position that you can memorise, and then have some means to fire the shutter with. A pneumatic cable release is the easiest and cheapest, but you have to remember the slight delay between beginning to squeeze the bulb and the shutter firing, which may frequently lead to focusing errors; in any case, you have to expect a high failure rate. You can also use an automatic relay, based around a solenoid which will fire the shutter (via an autowinder where noise is not a problem) automatically when an object breaks the light beam(s).

Baiting

With some animals, especially smaller ones, there is little chance of photographing them 'at home', and many have no regular home as such. Equally, you may wish to photograph species like badgers in situations other than at their sett, where you can control the circumstances somewhat better. The solution to these requirements is baiting, i.e. putting out suitable food, in a suitable place, to attract animals regularly. This is not quite as straightforward as it sounds, and there will still be hurdles to overcome before you can get good pictures. Most mammals will come to bait, though it is best for the herbivorous or omnivorous species, like voles, mice, foxes, badgers and hedgehogs.

First, you need to choose a suitable site. This will be determined by a combination of photographic suitability, absence of disturbance, freedom from cats, and the likely presence of species to photograph. It is ideal if you can use your own home, or a shed in the garden for photography, since this saves any process of accustoming your species to a new object. Failing this, you can use a hide for smaller species, or a car, or remote control. For small mammals, unless you are after something special, almost any site will do, as they are to be found everywhere. It is best to choose a site sloping towards you to exclude poor foregrounds and improve the lighting on the background.

Begin baiting by putting down suitable food (e.g. grain, nuts, bread) on a flat stone where you intend eventually to carry out photography. This is best kept dry, and hidden from birds, by erecting a light cover over it initially. This arrangement helps the animals to find the food, and allows you to assess more easily whether any of it is being taken. Assuming you

intend to work on night species, it is a good plan to introduce a low-level light early on, especially if you are near the mains, putting it on well before dark and leaving it on as long as necessary; this will accustom your animals to the light, and allow you to focus and compose adequately when you begin photography.

After a few days, you should have animals coming regularly, and staying to eat the food rather than removing it to eat elsewhere. At this point, you can place the bait exactly where you want it, preferably more naturally distributed than at first. You can place some on a perch above the introduction site, where it will soon be found, or on the ground, mixed with soil if necessary. If a hide will be required, you can introduce it now, and leave it for a night or two before attempting photography. When you finally start, your choice of lens, position of flashguns and so on will be determined by your circumstances. With small mammals, you can expect to work within about 2 metres of the subject, and a lens of a 135–200 mm will be required. The flashguns can be mounted on separate tripods, away to each side; your camera must be tripod-mounted, and a cable release used. Other techniques are as for lair-photography, though you will get more chances to try again with small mammals at bait.

Hedgehogs provide a slightly different challenge in that they are most readily attracted to saucers of milk with bread. You can either leave these and make them part of the picture, which is quite interesting in itself, or adapt them to coming regularly, and then place soaked bread in a depres-

Green toad, at night. Many amphibians are most active at night, and are best photographed then, if you can find them. They are often relatively tame, and can be approached and photographed with flash.

sion when you wish to photograph them. They are reasonably tame animals, and you can often move while they are there to allow you to photograph them as they approach the bait. For other animals, such as a racoon or a red fox, you may prefer to show them in their best-known role – that of raiding rubbish bins or trash cans. The principles are the same as with other baiting, but you do not need to be concerned with camouflaging the bait, though it needs to look realistic.

If you wish to combine some photography with regular viewing, you can construct a small mammal table, rather like a bird-table, but for use by mammals at night. This is best placed adjacent to a window, for easier viewing and lighting, and baited each evening. It will need an access route, such as a sloping log, and as usual you will need to watch out for cats who may cash in on an easy source of food, if you are not careful. Once you are regularly attracting mice and voles, you can begin to vary the set to let them stand in more photogenic poses if you intend to do much portrait photography.

AMPHIBIANS

Amphibians behave rather differently to mammals. In most cases, they do not come to bait, and they have no recognisable home such as a lair. Most species do, however, gather in breeding grounds, usually in the spring, where they are frequently most active at night. The traditional survey method for newts, for example, involves counting them at night by torchlight in the spring at their breeding place. Thus the photographer who wishes either to photograph nocturnal species, or see the full calling and courtship behaviour of other species, has to be prepared to go out at night.

As with most other forms of night natural history work, it pays to prospect a site in advance, looking at likely pitfalls and obstructions, and checking the best access routes. For this branch of photography, we find it best to be mobile, since you are never quite sure where your subjects will be, and it is better therefore to mount flashguns on brackets attached to the camera, and hand-hold the whole apparatus. The flashguns are better away from the camera's optical axis, giving better modelling and fewer distracting reflections from subject or water. The camera is best loaded with medium-speed film, and the best lens is a 100 mm macro, or similar, to give close-focusing with a reasonable working distance. A pair of Wellington boots are invaluable, since amphibian breeding sites are invariably wet! As with insects, you will also need a light to find subjects by, and to focus on them with. It is wise to ensure that your hands are free, as with insects, so a built-in modelling light or a miner's-type headlight is best, though the light should not be too bright or you will disturb your subjects. Finally, don't forget to put on some insect repellent!

Many smaller nocturnal animals are best photographed *in captivity*, capturing them by a safe means, looking after them well, photographing

them in well-prepared sets, and subsequently returning them to their habitat. This is a difficult and time-consuming field, which we do not have space to deal with here, and reference should be made to books dealing in more detail with natural history photography.

BATS

Bats are attractive small nocturnal flying mammals. Since they spend their sleeping hours in dark places, such as caves, lofts, and hollow trees, as well as being nocturnal, they present special problems. In many countries, bats are now highly protected by law, since they are one of the most threatened groups of animals, with many species facing extinction. In the UK, a licence is required to photograph bats at any time, and if follows that, even in countries where this does not apply, they should be treated with the utmost care and respect. The most difficult part is usually finding and gaining access to bat colonies, which are often in difficult places like caves or lofts, or completely inaccessible as in old hollow trees. Caves are frequently wet, with many narrow confined areas. Thus it is essential to prepare and pack your equipment carefully to be protected against knocks, and against water. When using electronic flash, this should be protected against water since there is a distinct danger of getting an electric shock from a wet electronic flash. Some species wake up rapidly when disturbed, others do so very slowly; this depends on the conditions, on the species, and on whether they are roosting or hibernating. Hibernating bats should not be disturbed, since they will be unable to find food in mid-winter, and the increased metabolic activity may make them unable to last the remainder of the winter. Bats have also often been photographed in flight, and the technique for this involves confining them in a room with an electronic beam shutter-release, such that they take their own picture as they break the beam. The technique is actually quite complex, and in most cases the bat will be found to be facing the wrong way, or in an unsatisfactory pose; since you would be highly unlikely to obtain a licence to do this in the UK, we do not advise attempting it unless there is some particular requirement for it.

BIRDS AT NIGHT

There is not a great deal of scope for taking pictures of birds at night, as most birds are diurnal in character. Natural history film-makers have gradually developed some remarkable techniques for photographing birds at night away from the nest, usually with the aid of long baiting procedures or, sometimes, captive birds. As far as the ordinary photographer is concerned, the only readily-available opportunities to photograph nocturnal birds are with owls and other nocturnal species at, or very close to, their nests. Photographing birds at the nest is a demanding technique requiring considerable preparation and some skill; for more

details of getting going on easier subjects, building hides etc, we advise the reader to consult the book in this series on natural history photography, or a specialist book on bird photography. The following gives some additional guidance for those who are ready to tackle nocturnal birds.

With owls, the first point to bear in mind is that they can be dangerous. One well-known bird photographer, Eric Hosking, lost his eye when photographing an owl, and the same could happen to anyone. A less dangerous option is nocturnal sea-birds like the petrels, though there may be additional technical difficulties since the nests are usually in burrows below ground, and the bird can only be caught for a brief moment as it enters or leaves the hole, often very rapidly. Whichever species you select, it is virtually certain that you will need some form of hide. As with all nest-photography, this will have to be introduced gradually, either by bringing it slowly in from a distance, or erecting it *in situ* from a pile of materials, through half-height to full-height. The choice of nest-site is crucial to allow you to get clear views of the adult birds as they enter and leave the nest. If the nest itself is hidden, e.g. in a hole, you need to be sure that you will get a chance of a picture of the adults on a perch prior to entering, or on their way to the nest. If the nest itself is visible, your problems are lessened.

The technical difficulties of setting up are somewhat different to those of photographing birds at the nest in daylight. There is no attractive green background to balance with the picture of the bird; instead you have the likelihood of black backgrounds, and you have to decide whether you want these or not. Black backgrounds can look unattractive if the fall-off of the flash is visible as a gradually-darkening patch behind the bird, and this is best avoided, either by choosing a higher than normal viewpoint so that the background lies close behind the bird and is well-lit; or by choosing a low viewpoint so that the birds stand out against a totally black background. Flash is, of course, essential, and we find it useful to use zoom-adaptors on the flashguns, set at the telephoto setting, so that they can be used from further away, minimising the relative fall-off of the light. A zoom lens is useful, too, to allow for changes in pose of the bird, the unexpected arrival of both parents, or other eventualities. The hide has to be set up during the daytime, and when it is fully erected you must be totally familiar with where everything is so that you can operate with minimum light or noise.

6 Low-light Landscapes

It came as no great surprise to us when we looked through our Landscapes file to find that the majority of the best 'mood' and dramatic pictures had all been taken either in the early morning or in the evening, often under such poor lighting conditions that most photographers would have put away their cameras. Not a few were also taken under adverse weather conditions, during drizzle, light snowfall or fog.

This experience seems to have been shared by notable landscape photographers in the past such as Ansel Adams, and more recently by Harold Sund, Yuan Li and J.C. McCurdy of America and Shinzo Maeda of Japan, all of whom have commented on the suitability of the light at each end of the daylight hours and the often dramatic effects of low slanting light coming from behind clouds to accentuate parts of the landscape. In contrast with some other forms of low-light photography, landscapes demand a fine grain film since there are large areas of even tone in which coarse grain will be very apparent and fine detail easily lost. Hence the great emphasis laid on tripods and clean lenses for low-light landscapes since it is pointless to use a very fine grain film only to have its properties spoilt by camera shake or poor lens definition. The films we specially recommend are Kodachrome 25 ASA and Fuji 50 and 100 ASA; these modern films are virtually grain free and we have yet to meet a low-light landscape that needed faster films. Of course much faster films *can* be used or fast ones uprated (see the section on processing) to give a special grainy appearance where this is judged to enhance the mood. Such grainy films have been used to great effect on foggy industrial scenes but their use is very limited.

When the level of light diminishes we always carry a tripod, which is one of the most uncomfortable things to carry around. We compromise a bit by using a fairly light one of about 5 lbs (2.3 kg) without a geared centre column, which on a non-professional type of tripod is worse than useless. It should seldom be necessary to raise the centre column by more than a couple of inches; with any more than this the stability is much reduced and even more so if the centre column is of small diameter, as most geared centre columns on amateur tripods seem to be. Small accessories that we have found essential for landscapes include a cable release ringed with dayglo tape, and efficient lens hoods for all lenses; those made by the lens makers for their own lenses are best – some independent ones are almost useless. We also like to keep a 'skylight' or 'haze' filter on each lens as a protection against rain and dust but they should be removed when taking

St Michael's Mount, Cornwall, at sunset. The very long exposure needed for this late-evening picture has the effect of blurring wave movement into an eery mist which can be very attractive.

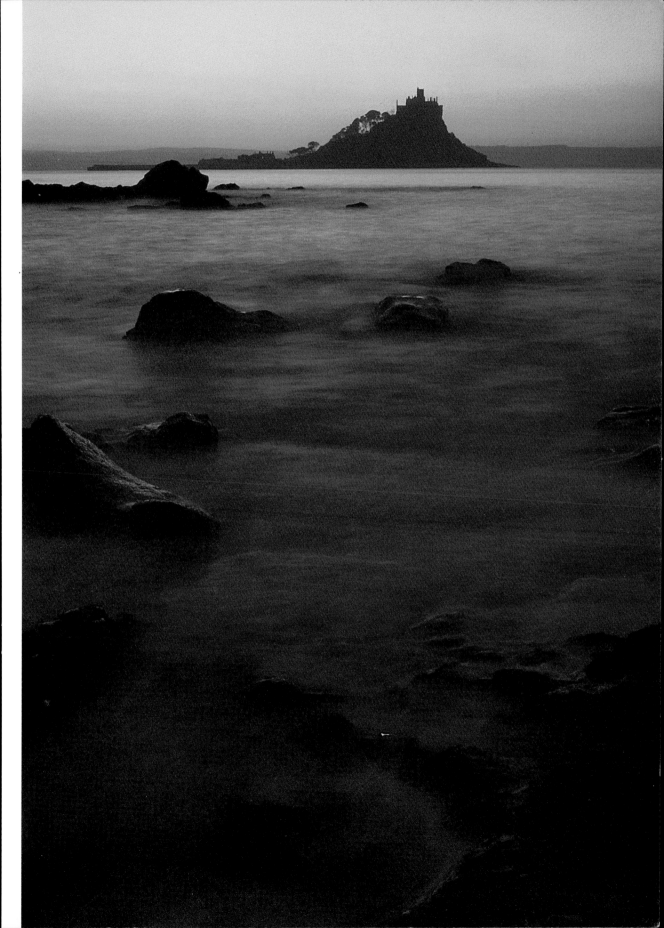

pictures into the light or when the sun is in or nearly in the picture since there are times when a filter will increase flare and either give an overall degraded 'flattened' image lacking in contrast or give rise to odd halos and patches of flare, often of a blueish or orange shade. We also carry in our camera case two lens brushes, and one should always be used on the lens before taking pictures into the light, as dust on the lens easily degrades the image. The second lens brush is usually one that has seen better days and is used to clean out the camera interior, ideally each time a film is changed.

COMPOSITION

Taking low-light landscapes is not an end in itself and whilst the effect of lighting may be dramatic or the key feature in the photograph, where possible attention should be given to good composition too. There will often be highlights ranging from pin points to broad masses – these should be kept well within the frame. It is very dissatisfying to have the frame edges cutting through the brightest part of the scene. It is often difficult under low-light conditions where the lighting is misty or flat to give an impression of depth to a scene. The reverse is true with low angled light where an impression of great depth can be given through the recession of several planes in the picture. This is true whether you are using colour or black and white materials. The type of lighting will obviously also create a 'mood' or atmosphere, e.g. harsh aggressive light giving long shadows, sharp diagonals and high contrasts on either side of mountains. The low contrast created by mist or fog can be mysterious, frightening, or, in the warm evening light, soft and gentle; it can also be used to isolate nearby bold shapes or lines. While photographing landscapes in very low light when most of the scene is poorly lit, it will not be detail and texture that create the picture but rather the positioning of bold shapes and outlines against each other. Exceptionally, snow or frost can be used to add another dimension, often a welcome overall increase in contrast, an outlining of shapes and an emphasis of lines rather than dark masses.

You should learn to be aware of the 'quality' of light – it is almost indefinable, but you should be aware that the light coming out of a midday blue sky can be quite different to the light from the same sort of sky and at the same time the next day – and the effect is increasingly variable as one moves away from the mid-day hours. Therefore it pays to look around for scenes and re-visit them at different times trying to envisage the effects of morning and evening light. We normally reserve the time between 9.30 am and 4.30 pm for reconnaissance or photographing objects or insects, returning in the evening light to an area that has impressed us during the day. Late evening light can produce some wonderful colour effects on a landscape, and late evening may be 9.30 pm in July or 3.30 pm in midwinter. It is best to watch the clouds; on a warm summer evening with a few white clouds against a blue sky, the texture and colour of the clouds will be affected as they change from being lit from above to being

Stormy evening light, such as this in the English Lake District, offers fine picture-taking opportunities, especially where water catches the light from parts of the sky to contrast with the black clouds.

lit by pink and later red light from below – this is the time to be watching for beautiful lighting effects. It is as well to remember that although the lighting levels may be very low with the lighting effect indicating late evening or early morning, a correctly exposed photograph can look as bright as one taken at mid-day. The following may help you to realise in your pictures not only the full effects of the lighting but the atmosphere and time that the picture was taken.

LOW LIGHT PICTURES OTHER THAN AT NIGHT, DAWN, OR DUSK

There are times, particularly during spring and autumn, when unsettled weather produces dramatic lighting effects where the normal light sky/dark land situation is reversed, and the sky becomes very blue-black with a light foreground. A typical 'storm light' exposure with 50 ASA film will be 1/25 at 2.8 if you hand-hold the camera. To enhance the effect of storm lighting, try giving less exposure – often half a stop is sufficient to heighten the gloom or increase the density of the sky whilst retaining a well-lit foreground. There are various ways of achieving the half stop increase: you can uprate the film from, say, 25 ASA to 32 ASA or 100 ASA to 150 ASA. We find this much the easiest way with automatic cameras

though it will be difficult with the newer automatics using DX coding without provision to alter or compensate on an independent ASA setting dial. Some cameras with DX coding do have a compensating switch allowing up to two stops compensation either side of normal. This sort of compensator is also found on most good manual/automatic cameras. A small lever is usually found surrounding the ASA setting dial which makes exposure compensation easy without altering the main ASA setting, and with most up-market cameras some form of warning indicator is visible in the viewfinder. Compensation is of course much easier if the camera is on manual metering and of the match-needle type when a half or full stop compensation can be seen in the viewfinder. It is even easier in cameras where the actual shutter and aperture settings are visible in the viewfinder but is almost as easy to judge with cameras where a needle has to be put in the centre of a gate, or LEDs light up to indicate correct exposure. Here, the needle can be made to move off centre by turning the aperture ring half a stop towards a smaller aperture, and similarly LEDs can be set for correct exposure and the aperture ring turned: some cameras using LEDs give half stop over/under indications. This sort of refined control will lead to much better pictures but it does mean that you must become very familiar with your camera controls, so it is well worth reading and re-reading your camera guide book and practising handling your camera. We stress the exposure compensation because the effects of 'storm lighting' are often fleeting as are some of the other weather-created effects described below. 'Storm lighting' may be seen as a relatively rare effect to be seized upon and made best use of without delay, and other similar cloud-sun situations may also result in very low-light situations in an open landscape, often enhancing an otherwise relatively dull scene. We have often been walking on a dull day in hilly country when a momentary

Granite tors, evening. The granite tors on their own made an interesting picture, but the fortuitous addition of a figure on the skyline improved the picture enormously.

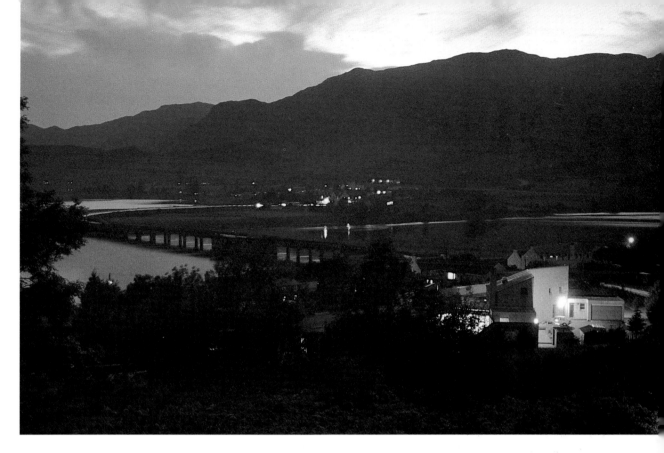

Port at twilight. A typical twilight picture, where there is still enough light in the sky to register, but all the lights are switched on. The inclusion of water in the scene helps to make the picture.

break in the cloud cover has allowed a broad shaft of sun to light up a valley or distant lake, transforming a flatly lit landscape to a beautiful picture with depth and colour. It is better if there are several breaks in the clouds at the same time so that more than one area of the scene is spot-lit; it is fascinating to watch the changing pattern of light across the landscape from a high viewpoint, and it can be a great film waster too! If you are walking in hilly country remember that even the mildest exertion can create camera shake problems and it is best to err on the safe side. If you use the rule of thumb of a shutter speed of the nearest equivalent to the focal length of lens, i.e. 1/100th for a 100 mm lens, 1/50th for 50 mm lens, as the slowest that one can hand-hold a camera for that particular focal length of lens, then we suggest you increase this by at least one speed, i.e. 1/100th up to 1/200th for a 100 mm lens making the appropriate aperture compensation – better still, use a tripod for increased versatility.

LOW LIGHT PICTURES AT DAWN/DUSK

The typical dusk picture to most photographers is a dramatic sunset, and we deal with this situation below, but you should be aware of the possibilities that exist just before sunset or for that matter just after sunrise, since, with one or two exceptions explained below, the effects are very similar. In the last half hour or twenty minutes of daylight the light across a landscape may be some of the best you will ever see, but it can also

seem very bright when in fact the light level may be extremely low. The human eye compensates for low-light levels by opening up a sort of automatic aperture and the mind accepts any sunlit scene as being very bright. At times, a low slanting sun giving an apparently brightly lit scene will need much more exposure than you will normally expect – you will have to learn to trust your light meter although it can seem wildly out. We were once photographing on the Welsh border in just such conditions: the scene was spectacular, with rich autumn colours and an almost clear sky; the subject was Welsh ponies on a lightly wooded hillside. We had an informed guess at the exposure and came up with 1/200th at f5.6 with 64 ASA film – the exposure from the camera's meter and the one we used was 1/25th at f4 – an exposure difference of eight times! Around dawn and dusk, unobscured sunlight will be 'coloured', the colours shifting from a blueish mid-day light to a warm yellow light deepening to orange just before sunset. In a landscape, the greens are less affected than the light rocks and tree trunks which can often seem to glow with warm reflected light. If there are clouds about then the light can be very blue, especially if it has recently rained – this is mostly around dawn when early morning mists look very blue, later becoming yellowish as the sun rises higher. Early morning mists may be present for a very short time, especially in the late spring and late summer when a rising sun quickly warms the air and dispels them – you must make the most of any of these gifts of coloured light and mist as they can considerably enhance a scene.

THE SUNSET

The sunset is the most widely appreciated scene ever likely to be photographed. If you show a series of landscape photographs to a non photographic audience and include a good sunset it will be the one picture most remembered and favourably commented on by most of the audience; show the same set of slides to an audience of photographers and the sunset will have to be exceptional to get the same appreciation. This is because sunset photographs are the common denominator of all scenic photography – we all take them; they are dramatic and evocative and nobody has one as good as yours, not because yours is better but because you were there and yours has that little extra in the way of memories and experiences. So how should you make yours different to everyone else's? Try these three things. Firstly, vary your exposure – the standard sunset exposure on Kodachrome 25 ASA is 1/25th at f5.6 but always meter for the sky: cut this down to 1/60th f5.6 and shapes will start to 'block-up' and become very dark masses, trees will lose the filigree of fine twigs against the sky – and burnt out areas that would be clear film will have some colour. Exposure can be so reduced that even the sun becomes just a coloured disc. Take several pictures, progressively decreasing the exposure, and you will be surprised at the richness of the colours. Conversely, you can increase the exposure, but this is only effective if you have some

areas showing texture which will add to the scene, and if you do increase the exposure, try not to include the sun or any highly reflective surfaces, as these will 'burn out'. In short, get away from the standard exposures. Think about using neutral grey graduated filters – these usually come in two grades of density, G1 and G2. You will find the stronger G2 best to even out the colours of the sky and those seen in a foreground reflection, for instance (see below). Other graduated filters to consider are the tobacco which can be most effective, and strengthen up a rather weak sunset, and the various blues and purples, though these last three types are of limited use, and the opportunity to use them may come only once or twice a year. Other filters include the starburst types which can be most effective when the sunset strikes rippling water, but again the use of this type of filter is strictly limited, and hardly justifies carrying it around all the time. Before leaving the subject of filters we suggest that you try using one or two that are usually meant for black and white films with colour film. The orange and red filters used to cut through haze and enhance clouds when used with black and white film can be used intentionally with colour film to give a very strong colour cast to an otherwise indifferent sunset that has not come up to expectations.

Snow scenes can become stereotyped into sunny 'Christmas'–style scenes, but here the very dull cloudy winter light is given life by the strongly monochromatic image of dark field boundaries and white fields.

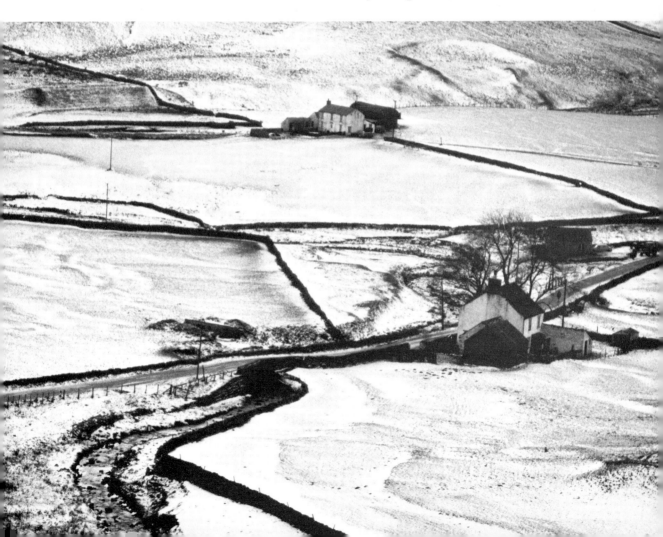

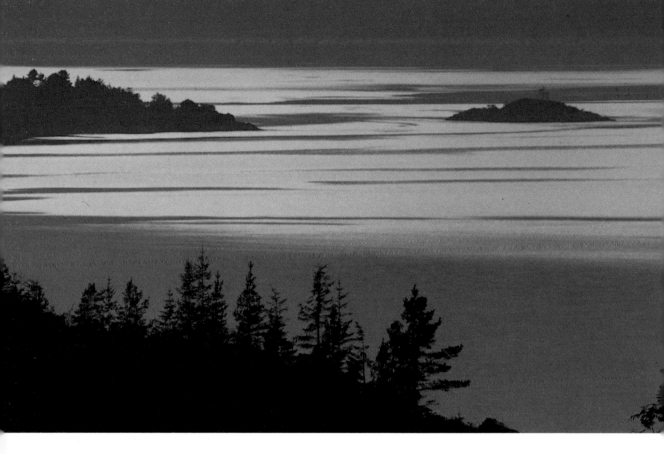

Secondly, do not just accept the sunset as first seen; vary your position: for example, hide a too bright sun behind a tree. Balance up the silhouette shapes of buildings or trees across the skyline. The most common sunset fault is an uninteresting and unimaginative foreground to an unforgettable cloudy fiery sunset. Look for water-filled cart tracks, puddles, reflections in windows and polished car roofs. A sunset will transform a dirty canal or slimy pond to a golden track across a flat scene or a pool of glowing golden light. Get close to trees, and shoot up into the branches against that red/gold sky. To avoid flare and reflection from the lens elements and diaphragm spoiling the picture it may be necessary to hide the sun behind the main tree trunk or behind one of the larger branches.

In an urban area look out for a washing line – multicoloured sheets and chimney pots against a duck-egg greeny-blue sky shot through with orange clouds will give you pictures that are more than just records of the sun going down.

Thirdly, look for the extra dimension: mist, smoke, a sleepy dog, silhouettes of people, multiple reflections in glass-side tower-blocks, will all add that extra interest to an ordinary scene. If no object immediately strikes you, then change your viewpoint – get down on your knees (far too many pictures are taken at eye level). If that does not do the trick, then look for a high viewpoint: an estuary or beach taken from higher up assumes a grandeur with the reflected light from a dramatic sky. Water in almost any form is a great help in transforming a normal run-of-the-

Twilight view. This picture was taken on the same evening as the picture on p. 111, a little earlier, but the use of a 300 mm telephoto and the exclusion of all lights make for quite a different picture.

Stonehenge at sunset. A well-known landmark like Stonehenge gains considerably by being photographed in low-light conditions, especially as people are absent and no cars or barriers can be seen.

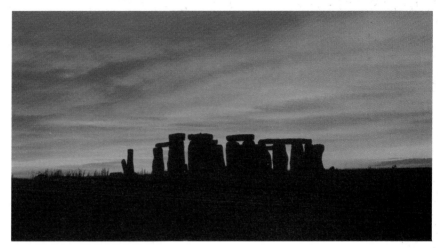

mill sunset. On still windless evenings the whole scene reflected in the still waters of a lake or tarn to give a mirror image, gives a picture of tremendous impact, and the more imposing the scene the better. We have seen some magnificent reflected sunsets including snow-capped mountains lit by the warm pink light: when this sort of thing presents itself make the most of it and take lots of pictures.

If all else fails and you can find nothing with which to enhance the sunset, then put on a wide angle lens (something in the region of 20 or 24 mm) and give 9/10ths of the picture to the sky, reducing the foreground to a single thin strip to give scale only. You will find that the wide angle lens recommended will give a most interesting and acceptable convergence of clouds about a central point (see diagram).

Sunset picture taken with a wide angle lens.

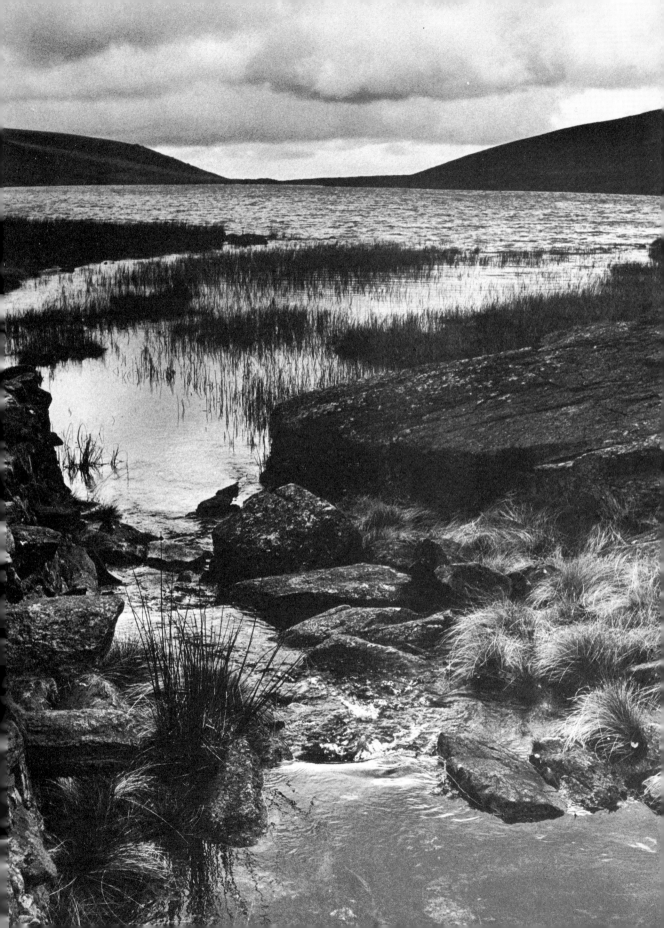

Good sunsets are quite predictable; on a short term basis, good cloud formations can be seen building up an hour or two before sunset, and recent rain seems to help. Long term, on a year to year basis, good seasons for sunsets follow very large volcanic eruptions, which throw enormous amounts of dust into the atmosphere creating striking sunsets world-wide for periods from a few weeks to many months afterwards. The best areas for sunsets are the northern latitudes − northern Scotland, and particularly northern Norway where the 'midnight sun' provides about four hours of marvellous sunset-sunrise conditions, often of such magnificence that combined with the dramatic scenery the photographer will be hard put to find time to sleep. We have had some quite stupendous photographic evenings in the Scottish islands and the islands off the north west coast of Norway.

Finally, do not use all your film up early on − save some for the last view of the sun as it goes down below the skyline. With a seascape or a long view across a plain you will see the sun's diameter apparently increase as it approaches the horizon resulting in some very spectacular pictures, made even more so if you use a telephoto lens. The disc of the sun is largest just as it touches the horizon and since it is seen through a greater thickness of atmosphere it is not as bright as it is higher in the sunset sky. The disc colour is usually a gorgeous shade of red rather than the white hot yellows of the previous half hour.

DAWN

Taking photographs of the dawn is not as attractive to most people as taking photographs of the sunset, since it usually means getting out of a nice warm bed for what may not be a superb photographic opportunity. The best way to minimise discomfort is to try to take dawn pictures around a normal getting up time. Most photographers of my acquaintance seem to get up between 7.30 and 8 am, and fortunately some of the best dawn pictures are seen during spring and autumn when sunrise is about this time. Dawn pictures differ little from sunset pictures except that you face the opposite direction − east instead of west − and the light intensity increases instead of decreasing. There are, however, one or two important differences for photographers: dawns are often accompanied by a thin ground mist, often to a depth of a few feet, through which hedges, trees and buildings stick out. Photographed from a high viewpoint, this can be most evocative as the sun rises, tingeing the mist first with reds and pinks, and progressing through pale blues and finally greys. If you are down in the mist it can often take on an orangy/brown shade, giving a mysterious and often evil mood to a picture. As with sunset photographs, lakes or other stretches of water will more often than not enhance a misty early morning photograph. We have found when exposing for these low contrast misty scenes it is often best to decrease the exposure by 1/2 a stop e.g. set the aperture to between f5.6 and f8 instead of f5.6, or uprate the film from

Mountain lake in wet weather. The use of a wide-angle lens has emphasised the foreground, giving a more dramatic picture to suit the rainy conditions.

say 25 ASA to 32 ASA or 40 ASA. If you are using a fully automatic camera, then use the exposure compensation switch to decrease the exposure by $\frac{1}{2}$. We have on occasion, when the scene has been more brightly lit, decreased the exposure by one stop. It is surprising that more photographers do not try doing this exposure compensation more often, instead of relying implicitly on their camera's built-in meter. Make the most of any early morning mist, for it is soon dispelled by the warm rising sun.

Even when there isn't any mist about, dawn light is usually much softer than evening light, with lots of delicate pastel shades. There are times when the whole landscape is bedecked with sparkling dew – use small apertures for maximum depth of field and use gaps in dew-soaked hedges to give depth to a scene; or move in close to the wet droplet-hung twigs and photograph them against the light. Exposure for into the light pictures may be difficult to calculate; we find it best to turn away from the sun and meter the average scene with the light coming from over our shoulders, and use this exposure as a starting point for back-lit subjects – decreasing the exposure will increasingly darken the background, making any sparkling water droplets really stand out. Dawn backlight on dew-sparkled spiders' webs in the autumn show these minor wonders of nature to perfection, but you have to be quick; a dawn may start calm but a slight breeze can easily ruin a shot that had taken you ten minutes to line up accurately.

LANDSCAPE PICTURES BY MOONLIGHT

It is possible to take landscape pictures by moonlight but the right conditions seldom occur with the right scene. Briefly, what is needed is either an open light-coloured landscape with a bright full moon – the sort of conditions one gets on frosty nights in early spring or late autumn – or a full moon over a flooded landscape or beach. The exposures will run into several minutes even at relatively large apertures, making it impossible to include the moon in the picture. It seems to us there is little merit, except for the photographic exercise, in taking normal landscapes by moonlight since with such long exposures the lighting direction will change making it difficult or impossible to judge the precise lighting effects. It is far better to use the moon's reflected light off water or wet surfaces. Here one has a chance to include the moon, but unless some manipulations are carried out it will record as a bright disc without detail. To avoid this, try using the grey graduated filters. We use a G1 and the denser G2 mounted together to try to get a moonlit scene with a moon showing its surface detail, but it is actually easier to take both landscape and moon separately and copy them, as outlined in the section on special effects. Just occasionally, we have been fortunate enough to have a situation where there have been patchy clouds drifting across the surface of the moon, and it has then been possible either to expose the scene whilst shading out the moon and then expose for the moon coming through the clouds, or, where a small cloud

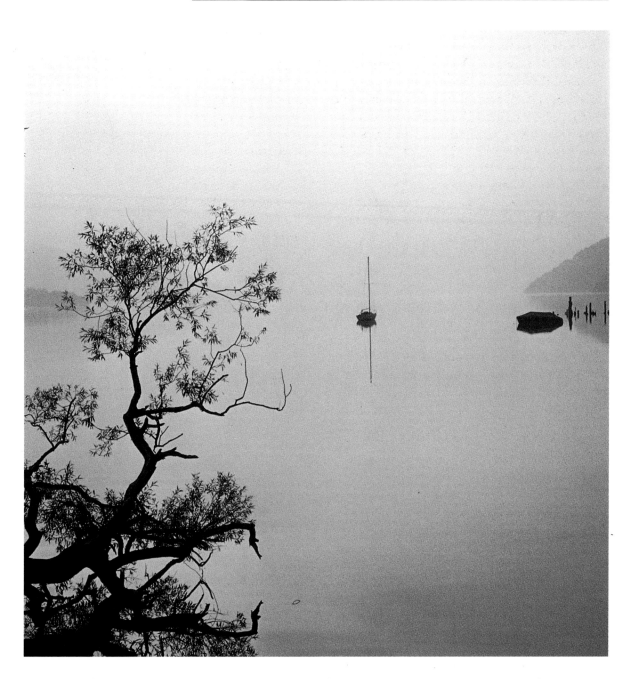

Misty scene, Loch Tay, Scotland. Mist can make a dramatic difference to a scene, picking out just one or two elements, as the remainder blur into insignificance.

was thick enough, to take it as one exposure. To shade out the moon, or any other bright source of light, all you have to do is look through the viewfinder with the camera on a tripod, and shade out with the hand or a piece of dark card the part of the sky where the moon is – in practice usually the whole sky area, though with experience smaller sections can be shaded out. Once you are satisfied you are covering the area, make the exposure for the landscape and just before the end of the exposure remove hand or card to make the exposure for the moon. To give you a starting

point, the full moon not covered by cloud will need only about 1/4 second at f22 on 25 ASA film. If you have time and a spot metering camera then the whole procedure is made much simpler, since one can just meter the moon and various key features of the landscape. It all sounds complicated, but with the camera mounted on a rigid tripod it works well enough. Try not to nudge the camera or tripod, however, and do remember that the moon will seem to move quite quickly across the viewfinder, and will certainly be well out of the place you first saw it at the beginning of a long exposure. Judging the precise position of the moon at the end of a long exposure is made much more difficult if even moderate telephoto lenses are used.

LOCATIONS FOR GOOD LOW-LIGHT LANDSCAPES

Not many of us get a chance to take our holidays just for the pleasure of taking landscapes by evening or morning light. With most people it will be a matter of going on holiday and seizing what opportunities present themselves. Often whilst on holiday it is possible to assess various areas during the day and return later. Fortunately, most people will take their holidays in attractive areas which, whilst photogenic enough by ordinary daylight, are much enhanced by morning or evening light. It may be that you do not have to travel very far and that suitable locations not previously noticed will be found near home. Here are a few guidelines on what can make up a good low-light landscape, to help you recognise the possibilities.

It always pays to buy a large-scale map of the area where you are photographing. A walker's map is ideal, and a scale of 1 : 50000 is about right, especially if it shows tracks, small woods, cairns, windmills, and other objects of interest. For a start, it is worth looking for geographical features that run north-south such as limestone edges. If the escarpment faces east, the best light will be on it in the early morning, and if facing west the low evening light will show the features to best advantage. Similiarly with coastline cliffs: those down the western Atlantic coasts of Europe are best photographed in evening light. With all linear geographical features, it is best if you can find a projecting headland or outlying hill so you can look along them; this is often possible with sea cliffs but more difficult inland. East-west geographical features need handling with care, as it is easy to get patchy lighting which is most unattractive, but if timed carefully, low light on an east-west feature can reveal all the features that would almost be lost with flat overhead lighting. When photographing some typical U-shaped glacial valleys in the border counties between England and Wales we were delighted to see the sinking sun bring into sharp relief the truncated side-valleys; from the high vantage point, we could see one side of the small side-valley lit up, whilst the other was in deep shadow, and as the sun went down, the shadows from the side valleys extended across the main valley floor.

An evening view in the Himalayas. The loss of distant detail that is so characteristic of misty backlit evening pictures matters little where the situation and composition are strong enough to speak for themselves.

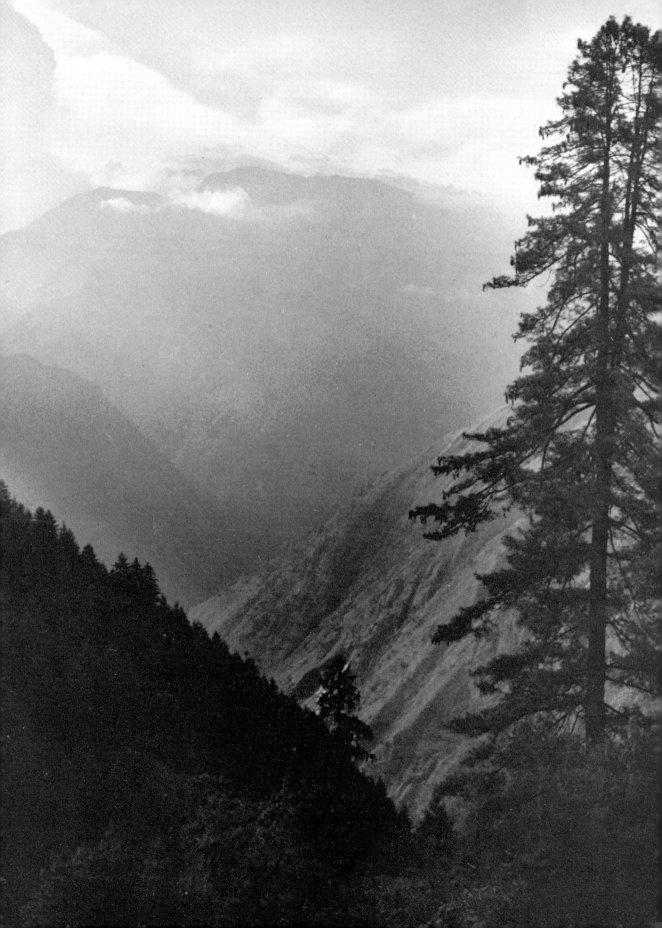

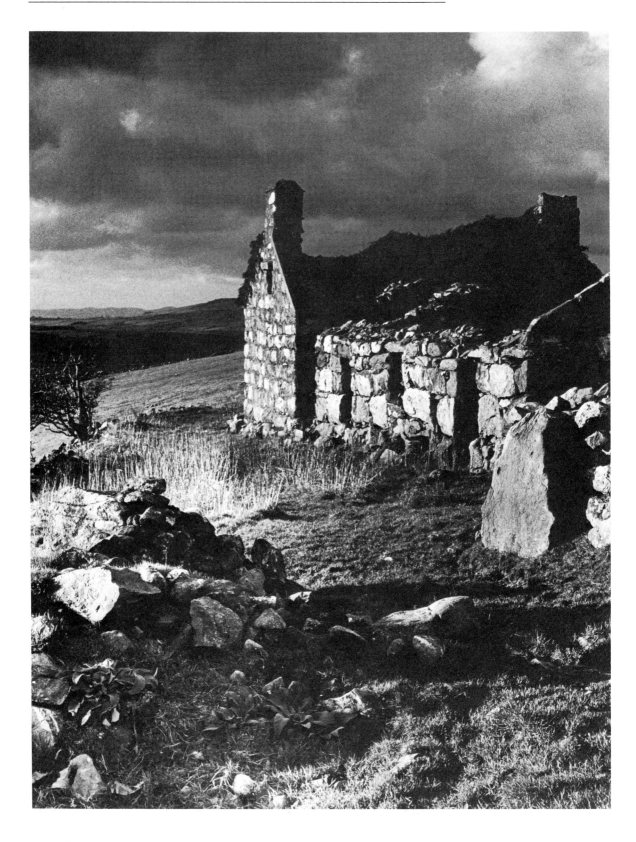

It cannot be stressed too greatly how important a high viewpoint is to demonstrate the vast grandeur of hill or mountains by evening or morning light. It is seldom practical to be on the hill or mountain top just as the sun goes down because of the difficulty in getting back to base in the dark. If, however, you do have the opportunity to be high enough to look across the tops of hills or mountains in the evening, you will see the sunlit sides changing from yellow through to pink, whilst the side in shadow is at first bluish and finally black. You do not have to be a mountain climber to see this. A few moments with a map which has correctly marked contours will show roads worth taking and many new tourist maps even indicate the good viewpoints. In the British Isles most of the upland areas such as the Peak District, Lake District and central Wales have good roads which go over the mountain tops or through relatively high passes. It is much the same throughout the mountainous areas of the world, where not only are there excellent, if tortuous, roads, but often ski lifts and cable cars are available to reach high vantage points. Make sure you know the exact time of the last descent of cable cars and ski lifts. We once spent an uncomfortable night high in Yugoslavia's northern snow-covered mountains because the cable car attendant mistakenly informed us in poor English that the last descent was 6 o'clock when he meant 1600 hrs. It pays to double check or get it written down.

Do not despair if you cannot find a high viewpoint to photograph a particular mountain. Many mountains may photograph well from a valley viewpoint and here you have the chance to include features such as trees and winding rivers. Not all successful landscape photographs are made up of mountains and craggy hills. Many excellent landscapes featuring sinuous hedges and winding lanes have been taken in lowland areas, where low-light conditions serve to enhance the elements of the composition. It is always worthwhile being at the water's edge with a camera when light levels are low and there is adverse weather. If you are going to be plagued by rain and fog you may as well use it to give mood or texture to a picture and the lakeside is certainly one of the best places to be. Here boats, landing stages, reeds, boulders or almost anything can serve as either the key feature or foreground interest to a larger view. The rain spattering on the water can give an interesting texture but to see this it needs to be almost calm.

Do not be afraid to use long exposures of 2–10 seconds. This will blur the wavelets breaking on a lake shore but in almost calm conditions they will break in almost the same place and some interesting patterns will emerge. Do not be afraid to experiment with different shutter speeds since the exact effect is almost impossible to judge. Water always makes good photographs, but trying to photograph water rushing over boulders and cascading into pools can at first sight be a frustrating subject in low light. In fact, exposures of 1/15th to 1 second can give all the impression of the water's speed and movement even if it is blurred – the effect can be stupendous and again you will have to experiment a little, since too long

Stormlight, when shafts of orange-yellow evening sun just break through black clouds, is one of the most dramatic of all natural lighting conditions. Here, the ruined mountain cottage picks up texture from the slanting light, and the sky shows the stormy conditions.

an exposure will 'burn out' the more highly reflective whiter areas. Try getting low – almost to water level where water pours between two rocks so that the main waterfall or cascade fills the top of the picture. You will have to be careful of spray, so protect your camera (see Chapter 3). A lens hood and an ultraviolet filter or skylight filter are best kept on at all times. Do not only concentrate on the main elements of a waterfall; look around for the interesting little pictures: they may be ferns hung with water droplets and flash can be a great help here, not to provide the main light but to put a sparkle in the drops or to highlight a frond. A small flash – one with a flash factor of 20 (100 ASA metres) will be most useful.

Perhaps the best time to be at a waterfall is in the autumn where, even in dull conditions, some autumn colours, especially if wet, seem to glow with light and those trees with light trunks like birch really stand out from the background. Autumn leaves floating in water provide an almost endless subject to an imaginative photographer; some of the best have been taken in low light with a long exposure of leaves slowly drifting round in an eddy. The outer areas are really blurred, but the inner leaves in the pool are quite still and sharply recorded – to do this sort of thing you will have to position the camera rather carefully and often precari- ously above the water. The necessary exposure can be easily assessed by watching the leaves and approximately timing their movements basing your exposure on how much movement you want – you could even start a long exposure with a flash which will still the movement of the leaves momentarily and the long exposure will blur them from that moment as they drift round or across the frame. The flash can either be synchronised or fired manually with the test button. The flash can of course be fired in the middle of the exposure, at the end, or several times during a long exposure. The exposure will have to be calculated rather carefully – fire the flash manually (not on auto) using the flash factor to calculate the aperture needed for correct exposure and then stop down on extra aperture.

Use the camera's meter to calculate the correct time for the new aperture and give half this time. This will provide a good starting point and once you start taking pictures like this we are sure other ideas will occur to you.

7 The Sky at Night

You might at first think that photographing the sky at night – whether it is stars, comets, the moon or anything else – is simply the province of the specialist astrophotographer with ultra-long focal length lenses or telescopes, expensive drive mechanisms, mountain-top observatories and so on. While there is some truth in this, and it has to be admitted that normal everyday photographic equipment does have some limitations, there is still great scope for a wide range of interesting and attractive pictures. The acquisition of some extra equipment will extend your horizons and give more opportunities, but it is not essential. It is not an easy option, though, and you will probably find that you have become cold and frustrated, and used a fair amount of film, before you get results that you are pleased with!

SOME GENERAL POINTS

Before venturing out to attempt pictures of the night sky, there are a few general points to bear in mind. Firstly, even in summer, it is almost invariably cold at night; and since you are most often working on clear nights – for obvious reasons – then the speed of heat loss will be even greater, and you can soon become very cold. You have to expect to use long exposures, which naturally means that you will be standing about, making things even colder! So, the message is clearly to wrap up well, taking into account the need for mobility while you are working. Thin gloves or fingerless mittens are a reasonable compromise between warmth and the necessary 'feel' for taking pictures and adjusting settings. The new photographers' coats, such as the excellent warm ones made by Camera Care Systems, are very useful because you can store so much equipment and film around you, readily available, while keeping warm and dry too. Rain protection is probably less of a problem in this branch of low-light work, since you are almost invariably working with clear skies, but if working in uncertain, showery conditions, check the recommendations given in Chapter 1. In any case, an umbrella is always worth carrying if you can.

Secondly, you should consider the safety aspect of working at night. This need not hinder your work severely, but it is worth bearing in mind; if working where cars are moving, or indeed when walking to where you will be working, do make sure you can be seen. If working in more frequented places, remember that you will probably be carrying quite a valuable set of equipment, and all too many robberies happen at night.

LIGHT POLLUTION

'Light pollution', as it is often known, is the bane of the astronomical photographer. The term refers to the fact that all the great variety of lights which are nowadays kept on all evening, and often all night, greatly affect the quality of viewing and photography of the night sky that you can achieve. Factories, houses, shops, cars, and worst of all, the ubiquitous street lights, all send much of their light up into the sky, and a good deal of it reflects back from particles and haze in the atmosphere, or clouds. We have all seen the 'glow in the sky' over some city or other, and this is the same effect. As far as photography is concerned, the effect is that, on any exposure long enough to record the dimmer objects in the sky (in practice, anything but the moon), the light pollution will record even more strongly, and your chosen subject will be very poorly-defined, or non-existent. In the USA, during the period when Halley's Comet was most visible, there was a 'Dark skies for Comet Halley' movement to try to persuade local authorities to switch off street lights for key viewing periods!

In practice, the only way that you as an individual can solve the problem is to go somewhere where light pollution is less for your photography. This may simply mean travelling a few miles into the country for some people, or it may mean a considerable trip. Unless you are dedicated to photographing a specific object at a specific time – such as a comet – then you might consider doing some astrophotography on holiday. Holiday sites are often more rural and less developed, and, better still, often have mountains nearby. Most major observatories are sited in mountains for the two reasons that they are further from any possible light pollution, and that the atmosphere is thinner above them, and less polluted. Anyone who has been out at night in high mountain country will have certainly noticed how clear and bright the stars look – and this comes out on your photographs, too. If you are going to the mountains, it is worth going prepared for some night work in the best possible conditions.

We should also mention here that the moon, though it can hardly be called pollution, can have a similar effect on your efforts to photograph dimmer sky objects; if you are working on stars, comets or planets, choose a time when the moon is new or not showing for the best effects.

FILM CUTTING

If you do much night photography, and especially sky photography, you will soon experience the problem of having your films cut in the wrong place. Most cutting and mounting machines work by having the operator align the first frame, and the remainder is automatic. It is very difficult to be sure where one frame starts and the next ends on photographs of the night sky, so the start point may easily be wrong; this will mean that all the remainder will be cut wrongly, often across the important part, which is very frustrating. There are two ways to solve this problem; you can either request that your films are returned unmounted and *uncut*, which

does, however, mean that you have to go to the bother of aligning, cutting, and mounting them yourself; or you can take the first frame or two of a normal subject, if necessary using flash if you change films whilst out at night, and this will allow the processor to line the films up correctly.

Colour *print* film (negative) creates the additional problem that the printers will either discard the negatives as worthless, and not print them, or overprint in an effort to make more highlights register. We would advise against using colour print film for this sort of work anyway, but if you do, put in a note to inform the processor of your requirements.

THE NIGHT SKY MOVES!

As you will quickly discover if you did not know already, all the celestial bodies move regularly through the night (well, actually it is the earth that moves!). This movement may not be instantly visible to the naked eye, but it is actually quite considerable. Its effect on the photographer is that stars or the moon very quickly begin to produce a trail. The effect of this is naturally magnified, or at least becomes more visible, when using longer focal lengths of lenses. You can calculate the expected effect roughly by the equation:

For example, with a 50 mm lens, the effect would be visible in a 14 second exposure; but with a 1000 mm lens, it would become visible in a 0.7 second exposure. In practice, this means that it will occur in almost all photographs taken of the night sky, except of the moon, unless you have access to an equatorial drive (see below) which keeps the relative positions of camera and subject constant.

Comets and meteorites, of course, do not follow the same pattern since they have a visible movement of their own superimposed upon the earth's movement. To solve this, if you are looking for really clear pictures, you need a device which allows you to track your subject manually, aided by an optical tracker, to keep it in the right position, but it is a difficult and demanding technique requiring both skill and considerable concentration. The same technique is necessary for any work on deep sky objects, where standard drive mechanisms are not accurate enough.

If you do have a drive mechanism, it has to be set up for your particular latitude, either by alignment on the north star, or from a calibrated table; it should be explained in the instructions with the device.

EQUIPMENT FOR NIGHT SKY PHOTOGRAPHY

Much run-of-the-mill camera equipment will suffice for night sky photography, and you do not have to buy extra to achieve results. General

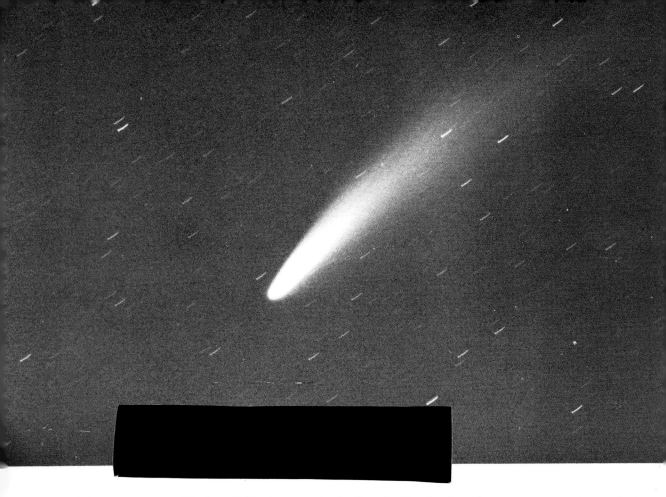

Comet Bennett, photographed with a 30 second exposure. Other details as for the picture on p. 132.

advice on equipment for low-light photography is given in Chapter 1, and we will concentrate on the extras, or the best ways to use what you have, with regard to astronomical photography.

With cameras, the two most important factors are: 1) that it is a single lens reflex camera with interchangeable lenses; and 2) that the camera has the capability of giving long exposures, longer than 1 second, and preferably with a 'B' or 'T' setting so that you can expose the film for as long as you like.

With lenses, you are unlikely to find the standard 50 mm lens useful for very much, and focal lengths of at least 200 mm are desirable. For interesting shots of anything but the moon or the aurora borealis, except under exceptional circumstances, you really need much longer focal lengths. Simple 2 × teleconverters are useful in this respect, doubling your focal length, and you need not be too concerned about loss of definition or light. Many telescopes are now available with camera adaptors, especially since Halley's Comet stimulated so much interest, and you can usually acquire an adaptor for any modern telescope without too much difficulty.

We cannot review the whole telescope market here, and few people will buy a telescope just for photography, but if you are considering it the following two examples will give an idea of what can be achieved. The Tasco

8100 8× −24× zoom telephoto 'multiscope' is attachable to cameras via an interchangeable T-mount, and it offers the equivalent of 800 mm at f16 or 1600 mm at f32 or even 2400 mm with the 1.5 × converter available. The 132T is a short catadioptric (mirror) telescope which can be set, as a telephoto lens, at 600 mm f8 or 2250 mm f30. It is useful, when following objects, to have the tripod mounted on an equatorial mount, to allow you simply to turn the telescope at the same curvature as the movement of the celestial bodies, but it does not particularly help your photography. If, however, you can afford an equatorial drive, which is relatively expensive, then this will automatically follow the stars as they 'move', keeping them in precisely the same place in your frame. Clearly such equipment is essential for very long exposures of distant subjects where definition is more important than effect (see under techniques, below).

A good solid tripod is essential (see Chapter 1), and so is a cable release that allows you to lock it in the closed position; otherwise you have to hold it for the duration of the exposure, which is cold and boring as well as giving rise to increased possibilities of camera-shake. To ensure absolutely shake-free results, you will probably find it worth having a black card, which you hold over the lens as you release the shutter, and smoothly remove after the shutter has opened and any vibration has died down. With very long exposures, this is unnecessary since the effect of the first second on the whole exposure is minimal. To ensure that your eyes remain reasonably well adapted to the dark, in order to aid the process of finding objects to photograph, it is best to have a torch that has red cellophane or plastic, or even brown wrapping paper, over the light; this will be good enough to see most things with (except red numbers and letters!) but will not cause your pupils to close down too much. A pair of reasonable binoculars with good light-gathering power, say 10 × 50 or similar, especially if they have a tripod-mount on them, will be invaluable for finding and checking objects that you wish to photograph. This is usually easier than trying to scan the sky through the camera. If the binoculars are mounted on a tripod, they give much better definition – for instance, you can see four of Jupiter's moons with tripod-mounted 10 × 50 binoculars – and you can then maintain the tripod in the same position for mounting the camera on.

A standard right-angle viewfinder attachment can be very useful, especially if your tripod is not as tall as you, for preventing back strain whilst viewing for long periods. Ones that invert the image can be irritating to use, as you are always turning the wrong way, but are ideal if you are photographing through a system that has already turned the image the wrong way round. A lens hood is essential for this sort of work, both to keep out any stray light from torches, matches, passing cars, etc., and to help prevent dew from forming on the lens. Many experienced sky photographers use a hair-dryer (portable if you are working well away from power sources, as you probably will be) to prevent condensation from forming. It does form very readily in cold weather, especially when

you are looking through the viewfinder, and gently playing the warm air from the drier over the lens will prevent it.

The possibilities for films to use for night photography are very wide, though naturally some are better than others. As already explained, we prefer transparency film for colour work, though print film can be used. Slower films will give an inherently better definition, but greatly increase exposure times, meaning more subject movement. This may be what you are after, for effect, but if it is not, then one of the many excellent medium or fast transparency films will be ideal. We find something like Fuji 400 or Ektachrome 400 to be about right, though a slower film is better for shots of the moon, where short exposures are the norm. Most black and white films will suffice, following the same general principles. Chromagenic films, such as Ilford XP1, are ideal if you do not expect to expose whole films on night sky photography, since they can be used as a slower film as well, on the same roll (See p. 29). Many experienced astrophotographers use Kodak Technical Pan Film 2415, specially hypersensitised and then processed accordingly. Contact Kodak if you are convinced that this is what you require, for fuller details of the technique.

'Light pollution'. Even when photographing well away from towns, the effect of reflected urban lighting is such that it pervades many rural areas, and the star trails in this 15 minute exposure are almost lost.

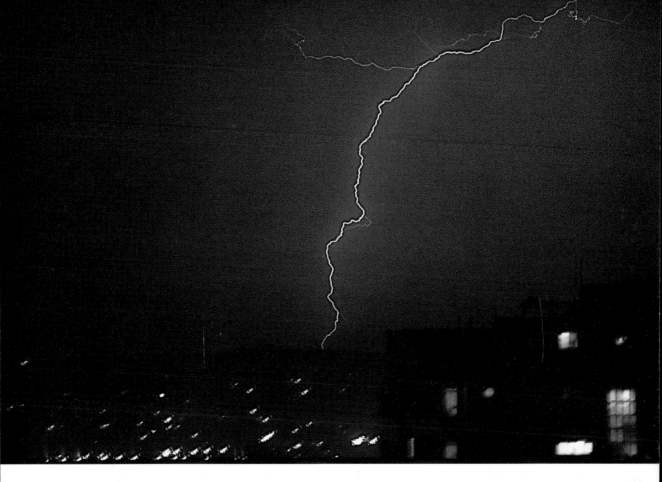

Lightning in tropical storm, southern Africa. Lightning is best photographed from a clear viewpoint, leaving the shutter open long enough to catch at least one lightning flash, but not so long as to overexpose all other features.

TECHNIQUES

Photographing the moon

Far and away the most obvious object in the night sky, and the most immediately photogenic, is the moon. It is not difficult to get reasonable photographs of the moon, and its constantly changing shape and colour as it moves up through the atmosphere, in addition to its appealing combination with clouds or landscapes. For the purpose of this chapter, we are dealing solely with photographing the moon directly, rather than using it as a source of light for landscapes and other scenes, or as part of such scenes – though there is a way of combining the two, with a bit of trickery, as we shall see later.

The moon may be a sizeable object, but as it is about 250,000 miles away, it appears fairly small. In photographs, it is likely to look disappointing, unless part of a wider composition, with standard lenses or even

short telephoto lenses. For a full moon, you can work out how large the moon will appear on the film by dividing the lens' focal length in millimetres by 110, giving the answer in millimetres; in other words, a 110 mm lens (if one existed!) would give an image size of 1 mm on the film; whilst a 1000 mm lens would give an image size of 9 mm. The frame size for 35 mm film is 36 × 24 mm, so this gives a clear impression of what you can expect. You can estimate the size of the moon when less than full, as the maximum diameter is always about the same, but it takes up less space in the other direction. For portraits of the moon itself, you really need at least a 500 mm lens (on a 35 mm camera), and a 1000 mm is better. A teleconverter is a reasonable way of enlarging the image for colour work, though for monochrome it is often as good to enlarge the image later, during printing.

Gauging the correct exposure for a photography of the moon always causes problems for people the first time they try; it is much brighter than it appears, and unless it fills the frame, you TTL meter will be quite useless since it will respond far more to the great area of dark sky around than to the subject you want. If you have spot metering, and you are using a long focal length lens, you can spot-meter from the moon, assuming you can work out exactly the spot that the meter is reading from, though with focal lengths shorter than about 300 mm, you will find that the moon does

Star cluster M15, photographed using a $10\frac{1}{4}$ inch telescope for 10 minutes. Other details as for the picture on p. 128.

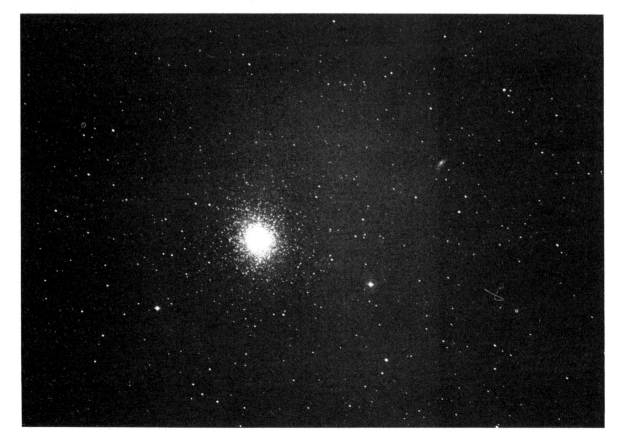

not fill the spot, and even this form of metering will overexpose it. If you do not have spot-metering, or cannot use it adequately, try exposures based on the following guides (it is not possible to give a precise exposure since the brightness of the moon varies according to atmospheric haze, and its position in the sky): you should need something like 1/125th second at f11 for 100 ASA film, or equivalents for different film speed or aperture. For example, with 400 ASA film, you could use 1/500th at f11, or 1/1000th at f8. One suggestion is that you use a shutter speed of 1 divided by the film speed at f16; in other words, 1/125th at f16 for 125 ASA film, 1/500th at f16 for 500 ASA film, and so on, and this is virtually the same as the earlier guide. Either way, it is surprisingly bright, because it is essentially a large area of bright rock reflecting sunlight, losing only a little of its power as it passes through the earth's atmosphere. Bracket whatever exposure you do use, at one stop either side, and you should be sure of good results. If the moon is partly obscured by haze or clouds, or what you are particularly after is its ring of ice particles, then you will need to give a little more exposure.

Because you are using moderately short shutter speeds (in contrast to very fast or very slow ones) with long telephoto lenses, not only is a tripod essential but so is a good cable release. It is very easy to get vibration on all but the most solid of tripods with a heavy long lens on, even at 1/125th second, so any extra aids will help; if you have a mirror lock-up, or a delayed action that releases the mirror before it takes the picture, then use it. Also, make sure that the tripod is firmly anchored, with all joints adequately tightened.

You can use these techniques to provide a variety of good sharp well-exposed moons to double-expose onto other pictures, as described more fully in Chapter 10, though we would advise that you try out one or two moon pictures before exposing the whole roll as required for that technique.

Photographing the stars

Star trails

Because of the rotation of the earth, as already described, stars very quickly begin to 'trail' through the picture. Instead of trying to overcome this to produce sharp portraits, you can use it to produce interesting effects as the stars streak across your frame. With good colour film, the effect can be enhanced because stars from different distances away show differing shifts in their apparent colour, making some look redder than others, and giving an extra interest to the picture. The same general principles of night sky photography apply: i.e. a firm tripod, a lens hood, a site where light pollution is going to be the least noticeable (and this is particularly important for star photography, since stars are so much fainter than the moon), and a cable release. You need to use a large

aperture or a fast film to ensure that the trails register reasonably well, though we prefer a slower film and a wide aperture for best results.

Stormy evening sky over Denmark.

As already described, the effect of movement begins to show, on a 50 mm lens picture, after about 14 seconds. Beyond that, the length of time you expose for depends on several factors; you really need a minimum of about 15 minutes to produce worthwhile streaks, and the upper limit is determined by the threat of light pollution swamping the stars. Because the stars are moving through the frame, they are not building up their brightness on the picture, whereas the light pollution will be, so there comes a point when it is no longer worth exposing the frame. The moon, if reasonably full, has the same effect. This can only be judged in your circumstances by trial and error, bearing in mind that it will be worse in hazy conditions, but we suggest starting with about one or two hours.

You can do a trial run, on one frame, to judge the best aperture to use, as follows: Set the camera up as you want it; then take a 5 minute (or slightly longer) exposure at one aperture, say f11; put the lens cap on for about

1 minute, then expose another 5–10 minute picture at the next aperture down, i.e. f8; continue doing this until you reach full aperture and note what you are doing as you go along. When you get the frame back, you can see which effect was best, as the different apertures will be clearly separated by the one-minute intervals. It will then be clear which is right for that film speed, in similar night conditions.

The stars do different things, in effect, in different parts of the sky. If you photograph the sky to the south, then the star trails will be more or less straight, with an apparent east to west movement (opposite to the direction of movement of the earth). If you photograph the northern sky, then the trails curve, with a rotation around the north pole star. The latter is probably more interesting, but obviously you can try both. You can also include parts of the landscape in your picture, but they should not have any lights in, or they will overexpose and cause flare.

Star 'portraits'

Really good star portraits are beyond the scope of this book, in view of the amount of equipment needed specifically for the purpose. You need a powerful telescope with an equatorial drive fitted, a star chart to find suitable subjects to photograph, and really good light-pollution-free conditions. If this appeals and you are prepared to acquire the equipment, it will be worth joining your local Astronomy Society or going to astronomy evening classes to find out as much as possible. Give some thought to how you will use your finished pictures, and how you will describe them to other people who may be less interested than you. Always try to include a known constellation when photographing planets or selected stars in less magnified pictures; it is more satisfying to photograph a major constellation anyway.

Comet photography

The general principles of comet photography are very similar to those of star photography, as described above. Halley's Comet has come and gone, without producing much of a lasting image for most of us, but there are other comets and similar bodies that come and go through the night sky. If you are aware that you are photographing something that is not a star, and you may well not be, then you can provide any compensation necessary; in other words, you cannot use an equatorial drive for long exposures because the path of travel of the comet is different to that of the stars. Without special tracking equipment, you are limited to short exposure distant shots, or comet streaks.

The aurora borealis – the northern lights

Most people will not get the chance to see the famous aurora borealis, since it is a feature of the far north, but if you are expecting to be in the area it

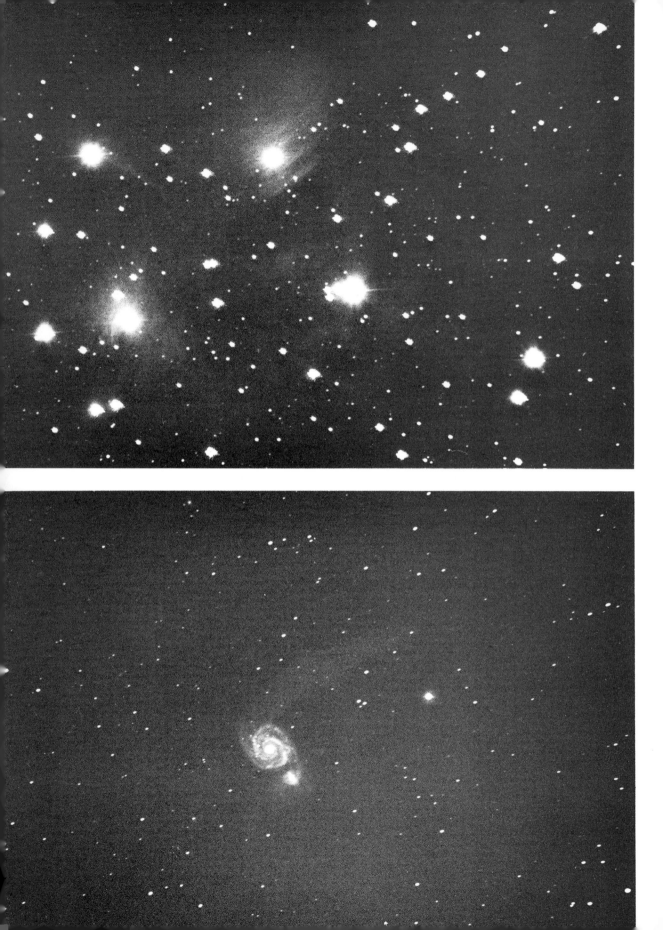

The Pleiades. Photographed through a 10 inch driven telescope for 30 minutes, on Tri-X, developed in D76 for twice as long as normal.

is worth being prepared for it. It is not a particularly bright phenomenon, though the brightness varies according to latitude, atmospheric conditions, and other factors. On good automatic cameras, with metering facility of up to two minutes, you can simply set the camera to 'auto' and expect it to do a reasonable job, as long as you set a large aperture. Failing this, some trial and error will be necessary, using medium-fast film (200-400 ASA), at a large aperture, giving exposures around 1 second, 8 seconds, 30 seconds and one minute. Since it is not an event you are likely to see very often, it is worth using a little extra film to get the results that you want.

Note

There are several special techniques for the development of normal black and white films such as H P 5, FP 4 and Tri-X used in photographing stars. Most of them are variations on a standard developer used for twice the normal development time or even longer. However, one small British company, 'Speedibrews' of Pyrford, Woking, Surrey, has developed a small range of developers especially for astrophotography. These are high energy, low contrast and low preservative developers which produce an easily printable negative with a high optical density. In addition, they have remarkably short developing times. One of these developers, called Celer-Stellar®, is also excellent for normal aspects of low-light photography where a speed increase of 2−3 stops is required.

The whirlpool galaxy M51, with its smaller companion galaxy at the end of a short 'arm'. Details as for the previous picture, except that exposure time was 20 minutes.

8 Celebrations, Displays and Indoor Events

A lot of events that go on at night, or in very low-light conditions, make marvellous photographs – if you are prepared for them! It is all too easy to put away the cameras as the sun goes down and forget the possibilities of such occasions, but if you do make the effort, you will be well rewarded. You may have a personal interest in an event, perhaps because children or friends are in it, or wish to record an interesting occasion, or you may simply have a detached photographer's view and wish to create some striking images out of the situations. In any case, the films now available, coupled with good technique and suitable equipment, will allow you to obtain satisfactory, and often striking, pictures from such occasions. We take the view through this chapter, as through the book, that it is best to use the exciting qualities of the available light, whatever form it takes, and only to use electronic flash as a last resort. This chapter overlaps with Chapter 9, in that photography of people is involved, but we deal here more with groups and action, leaving the close-up and portrait work, where the individual is more important, to Chapter 9. We are looking here at funfairs, carnivals, wedding celebrations, firework displays, circuses, indoor or floodlit sports events, and shows and concerts, in all of which there is plenty of action and usually interesting colours and lights.

Equipment

In most circumstances, you will need only a limited range of equipment. You are frequently dealing with active situations, where a lot of movement is involved, and there is no alternative to using a hand-held camera, loaded with fast film, and an appropriate lens. Automatic cameras are useful; shutter-priority cameras make it easier to control the shutter speed (for stopping action), but you can do this perfectly well with an aperture-priority camera, and you will almost always be working at full aperture anyway, leaving little scope for manipulation of the shutter speed. Also, aperture priority automatic cameras are more useful for fireworks and some other static events where you wish to set up the camera on a tripod, press the shutter release, and allow the camera to meter the fireworks as they explode, closing when enough light has been received (with off-the-film metering). See page 10 for further details. A tripod is essential for these more static displays, but for active events you will find a rifle grip or monopod more useful, especially if using telephoto lenses.

A photographers' waistcoat, or photographers' coat where conditions

are bad, is very useful in active situations, allowing very rapid access to different lenses, films, filters and so on, and you can easily have two cameras set up in readiness with different lenses on, to save changing lenses at a critical moment. We have used the custom-designed Camera Care Systems waistcoats and coats for this sort of work, and found them excellent in practice, making action photography much easier.

The lenses you will need are as varied as the situations, and they depend on the sort of photograph that you require. Zooms are tempting for any action photography, especially if your viewpoint is constrained, but you have to bear in mind that they are heavier than a single equivalent lens and that they usually have a smaller maximum aperture; therefore, if you are really working at low-light limits in action photography, you are better off with a prime lens with as large an aperture as possible. For the more static subjects, like firework displays, a zoom can be very useful to allow you to frame the subject carefully, and even to alter the focal length between fireworks *during the exposure* to alter the balance between small and large bursts (see page 152). Wide angle lenses are useful for carnivals

Fair in Germany at night. At times, a high, more distant viewpoint can give a better overall impression of the activity and lights of a fairground. This shot was taken from a bridge, using a 200 mm lens. Exposure values within the picture were so varied that the meter was followed, giving an average reading.

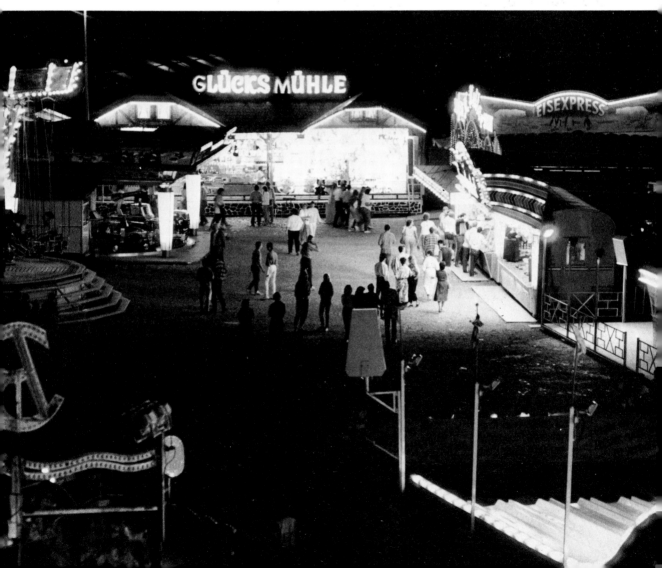

or other activities where you may be amongst the action, but for virtually all other events, a telephoto lens is essential. For general purposes, a lens of about 100–200 mm is very useful and not too difficult to hand-hold; but for some sports and concerts, where you are physically unable to get close to the action, then focal lengths of 400 mm or so will be useful.

For any low-light action photography, unless you are using flash or in certain very specific circumstances (e.g. action that has temporary static points that you can 'freeze'), a fast film is essential. You are working close to the limits of normal photography here, and we would advise using the fastest film that you are satisfied with for such situations. For slide film, try the Ektachrome or Fujichrome 800/1600 ASA push-processing films, which you can even uprate to 3200 ASA if necessary. These will allow you to use a reasonably fast shutter speed in most circumstances, and the results are very acceptable, especially as they both give reasonable results in mixed lighting situations. The new print films, such as Kodacolor 1000 or Fujichrome 1600, also both give excellent results, and are very forgiving of exposure inaccuracies. For black and white work, we find Ilford XP1 specifically uprated to 1600 or 3200 ASA, and processed accordingly, is excellent, and ordinarily fast films like Ilford HP5 or Kodak Tri-X can be uprated to 1600 to 3200 ASA quite satisfactorily. Do not expect perfect ultra-sharp grain-free results, as you will not get them, but you should be able to capture the atmosphere in technically acceptable pictures if your technique is right. For firework displays, if you are using a tripod, you can use slower film quite acceptably, and indeed it may be preferable if you are capturing a number of fireworks on one frame, to prevent excessive overexposure and flare from occurring.

CARNIVALS AND STREET PROCESSIONS

Most carnivals, and many other street procession events, have a night-time version of the event that is normally not only bigger and better than the day-time event, but also much more photogenic.

Carnivals vary enormously from place to place; most towns and cities have one at some time or other, usually in summer or autumn, and these vary greatly in quality and size. Some carnivals have become particularly large and well-known, like the Rio de Janeiro carnival, or the Notting Hill carnival in London, and such events provide a complete spectrum of photographic possibilities. Smaller carnivals should not, however, be ignored; you may have a smaller range of possibilities, but you can often get much closer to the action and choose your viewpoint without competition from press photographers and TV crews!

The keys to successful carnival-style pictures are good preparation, and good photography positions. Before going out, carefully select your equipment and films, make any adjustments that you are able to – e.g. uprating the film, setting the largest aperture, setting the exposure compensation dial, and so on – and then pack your equipment carefully in your bag

or in the pockets of your coat or vest where you can find them easily. It also helps to get to know various key things about your equipment — which direction to turn the lens to focus closer or further away, which direction the compensation dial turns for which effect, how to change lenses in the dark, and so on. Then a reconnaissance of the route is bound to be invaluable, looking carefully at potential compositions and viewpoints; will a high viewpoint give a compelling image? Will the procession look best coming through a particular archway, or round a particular corner? If you do decide on a particular viewpoint, say high up on a wall or building, look carefully at the framed scene to estimate what lens or lenses you will need to get the best effect; in other words, plan carefully, and think ahead.

It is well worthwhile getting to the event early to make sure of a good position — even if you are not competing with other photographers (and in our experience, very few people take good photographs at provincial events), there is bound to be competition simply from other viewers for any good positions. If the procession is repeated on two nights, or makes the same circuit twice — as many do — then try to get to the first one to allow you to repeat the process and learn from any errors or unforeseen circumstances. All too often we may have believed we've had a good position, only to find that the view was blocked in the event by people, a lorry, or something unexpected!

In action, your techniques will vary according to what you are photographing. *Floats* are a big feature of most carnivals. They are impressively decorated, often well-designed and attractive, moving vehicles. Most will be very well-lit, as part of the design and to ensure that the scene portrayed (or product advertised) is clearly visible. One problem, though, is that many of the lights often shine outwards away from the float; these tend to affect your meter, leaving the main scene underexposed. In such situations, it is useful to have a flashgun with you charged but not switched on or plugged in, so that you can use it as a fill-in source of light (see page 48) to brighten up the scene without detracting from the general effect, by switching on or plugging in as soon as you see the need, but leaving it out when not needed. As long as you balance the flash to be less than the general level of light, you will be able to keep the excitement and variety of the original scene whilst brightening up the duller parts of it. Don't forget that such fill-in flash will not 'freeze' subject movement; you will be governed by the camera's shutter speed, which *must* be at, or lower than, the flash synchronisation speed. A telephoto lens will often allow you to isolate a subject on the float, and avoid the effects of the outward-pointing lights, which makes exposure estimation easier but may mean that your light levels are relatively low for hand-held telephoto pictures.

Torchlit or candlelit processions are a part of many carnivals and celebrations, and they can be very exciting. A particularly famous and dramatic one takes place every January in the Shetland Isles at the festival

of Up-helly-a, in which a replica of a Viking ship is burned after a procession of flaming torches. For close-up pictures, you will find that a fast shutter speed, for a sharp image, is more effective than a slow one for a blurred image. The exposure in such situations is not usually too critical, and a wide range of combinations will give effective results. Look for marchers, or groups of marchers, against a dark background to isolate and emphasise the brightness of the torches; if the background has cars, or windows, they will be partly and messily lit, detracting from the impact.

If the route of the procession is known to you, and there is a high point from which it can be viewed, then a longer shot of it snaking its way towards you can be very dramatic. A longer exposure will give a streaked, but effective picture, while a shorter exposure – if possible – will give a different effect. Try both, and give different exposure combinations too: it is a pity to hold back on film for a once-a-year, or even once-in-a-lifetime event. If the procession takes place before it is quite dark, a fine balance between the ambient light and the torchlight can be struck, for extra effect.

Most carnivals have numerous things going on around the main procession: hot-dog stalls, balloon sellers, and the activities of the participating members of the public. Many of these provide interesting opportunities for pictures, but you are likely to be much more severely limited by light availability since they are rarely directly lit. Look for things going on close

Opposite:
Firework display. Firework displays are best captured with long exposures which allow the fireworks to build up on the film. This was a 3 minute exposure.

Below:
Birthday cake, candle-lit. Birthday celebrations are photogenic affairs, and in this case the cake, lit solely by candle-light and a little daylight, makes an interesting picture on its own.

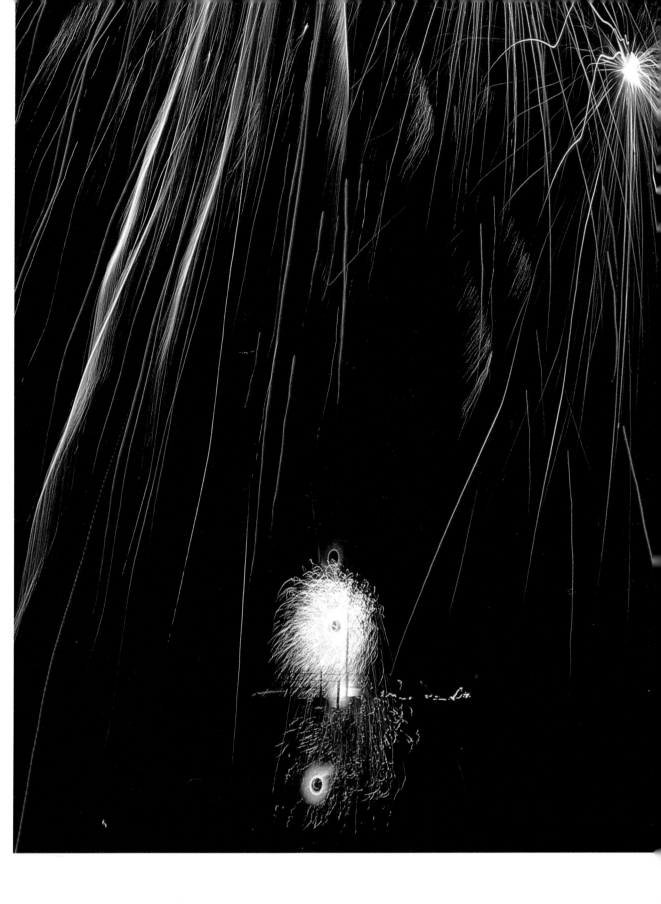

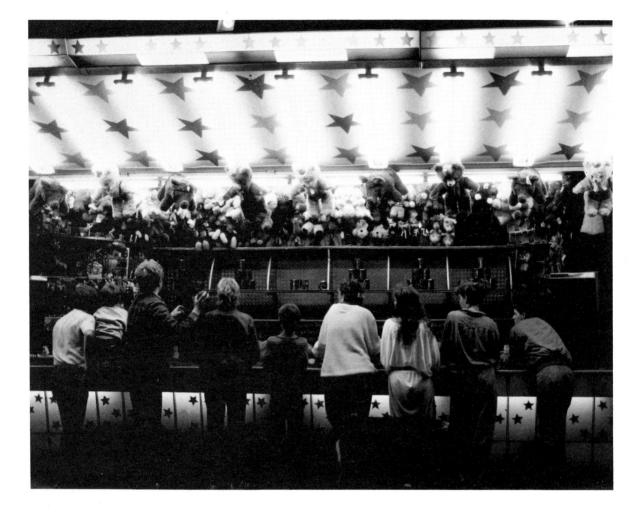

to the lights of the carnival, or lit by shop windows, or with their own light sources, e.g. a man selling chesnuts from a hot brazier, or someone selling those fluorescent necklaces, festooned with dozens of circles of light. The fastest film speeds, together with large aperture lenses, are essential for such efforts, but they can be well worthwhile. Flash will light up all these subjects readily enough, but it will kill any inherent light and also make your subject very aware that you are taking photographs.

FAIRS

The word 'fairs' covers a multitude of events, but almost all of them provide something of interest to the night photographer. There are huge annual well-known events, like the Nottingham Goose Fair, or Newcastle's Town Moor Fair; small travelling fairs that visit most towns at least once a year; or specialised events like steam rallies that have many similarities to a fair. They invariably continue operating at night, and then are at their most exciting, both to the onlooker and to the photographer, if he is prepared for it.

Fairground stall. It is surprising how much light there can be in a fairground at night; here the strong overhead lighting brightens not only the stall itself, but the participants, too. A tripod was used, hastily erected, and the moment of minimum movement was watched for.

The most obvious features of most fairs are the rides – the big dippers, dodgem cars, twisters and the like – and the side stalls, offering quite different possibilities. With the moving rides, you are looking at very active situations, though they are often very brightly lit, and you really have two options: either to try hard to freeze the action with the fastest film and fastest shutter speed you can manage, looking carefully for a moment of relative inaction, or to accept the movement and make it part of the picture. Your choice will obviously depend on the amount of light, the amount of movement, and the general possibilities. As a rule, we have found that wherever there are a lot of lights, moving in a lot of different directions – such as on many double-rotating rides or on dodgem cars – then it is rarely worth going for a long exposure: the result is too complicated and formless to be very stimulating, though there may be times when you can pick something out of the confusion. In these cases, it is better to go for the short-exposure action shot, picking your moment carefully to minimise movement, or deliberately leaving a little blur to convey a sense of movement. If you are taking a general scene of objects moving in various directions, such as a wider view of the dodgem car track, then you cannot 'pan' round with the objects, and you will need a speed of at least 1/125th to stop movement adequately. If you are follow-ing one car or carriage, then you carefully follow the object with the camera, i.e. 'pan' round with it, *as you take the picture*, which will allow you to get away with a much slower shutter speed (if correctly done), between 1/30th and 1/60th.

The 'Big Wheel' makes an excellent subject for a longer exposure; simply open the shutter at a large aperture and leave it open for about 5–10 seconds, or set your automatic camera onto 'auto' (if it has off-the-film metering) at a wide aperture, and you should get an interesting result. Big wheels that lift and tilt as they spin are usually less good, as the band of colour becomes deformed, but they can usually be caught, with a slightly shorter exposure time, at the period when they are upright.

Whatever your active fairground subject, you will find that most of the rides are good subjects for a combination of long exposure and flash. The technique is explained in Chapter 3, but essentially you operate for an exposure of several seconds, or more, and then 'flash in' a moving object such as a single bumper car, or a fast-moving seat full of screaming children, just before the exposure ends. You will need to do some approxi-mate flash calculations, based on where you expect the object to be when you 'flash' it, but the technique is not difficult, and the results may be very striking, though they are not easy to predict. It is much easier to operate if you have someone to fire the flash for you, on 'open' flash, while you concentrate on the picture, but it can be done on your own.

General views of fairgrounds are interesting. If you can get a little way away from the area, perhaps up on a bridge or road embankment, and set up your camera on a tripod, you will find that a range of lenses, or a good zoom, presents you with a number of possibilities. You can go for a simple

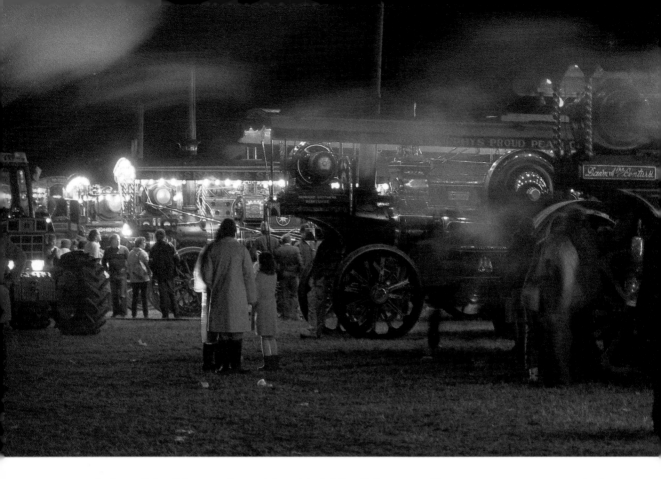

general view of the fairground, or pick out brightly-lit 'courtyard' areas between stalls where people are gathering, or even close in on groups of people talking or waiting. One useful point to bear in mind is that 'helter-skelter' towers are often much the tallest points in the ground, and they give a real bird's eye view of the fair. You are unlikely to be able to take a tripod up one, but you can certainly take up a camera with a zoom lens, loaded with fast film, and perhaps aided by a bean bag for greater stability.

In amongst the action, you should get plenty of opportunities for candid shots of people or groups of people. The situations to watch out for are those where people are facing a well-lit area, so that light reaches their faces. These may be stalls, food stands, or individual games, but the linking factor is the amount of light coming from the display and reaching the people. The light may not be very bright, and it will certainly produce a colour cast of some sort, but such pictures are fun to take and can produce very effective results. It is difficult to predict the exact effect, but if you can get the exposure right and have a fast enough shutter speed to prevent movement, then something will come out of it! When taking a meter reading, concentrate as far as possible on the faces – avoiding any bright lights in the metered area, and accept that some highlights may overexpose. This is better than having correctly exposed lights with the faces too dark. You may be able to get pictures of the stallholders them-

Steam engine festival. The atmosphere of this festival is much better captured by available light rather than by flash, though a fast film and long exposure had to be used.

selves, and they are often fascinating subjects for study, but the lighting tends to be more directly overhead for them, and therefore less helpful for photography (See Chapter 9 for more details of taking low-light portraits). Circular stalls that you can shoot across are often good for photographic opportunities, though it will depend on the lighting.

INDOOR EVENTS: CIRCUSES, CONCERTS, SHOWS

Set-piece shows and concerts do provide opportunities for photography, some of which can be very striking, but, in contrast to photography in the open air events above, you will be much more constrained by position, and sometimes by limitations on equipment that you can take into the event.

Pop concerts nowadays are almost invariably dramatically lit events. The lighting is frequently part of the show, and is often very sophisticated, giving photographers an interesting set of photographic possibilities. The single most important factor in this sort of photography is the position you take up for your photography, and this has to be planned in advance. Your main considerations are: 1) being reasonably close to the action; 2) having an unobscured view for most of the time; 3) not being below the level of the stage, if you can help it. You may find some difficulty in choosing a position if you have not visited a particular venue before, and tickets are sold in advance; some trial and error may be required, or alternatively, if the tickets are not numbered, you should arrive as early as possible to take up a favourable position.

If you are too close to a raised stage, you will find both that you may miss some of the action, and that you look steeply up at the performers; in addition, you may find lights shining directly at you, making exposure more difficult. In some concerts, especially smaller ones or those in which you have the opportunity to dance, you may find that you are able to move around to adopt the most suitable position for whatever is going on; this is ideal, allowing you to make the best use of whatever equipment you have with you.

A problem with events, that seems to be increasing in frequency, is that you may be restricted in what you can take into the hall. Many concert halls state 'No photography', which is obviously somewhat limiting! The reason is usually because the promoters wish to ensure sole rights to any pictures taken, although this seems to be a somewhat unnecessary approach. You may be able to get special permission to carry out photography, especially at a smaller venue, or if you have contacts with the management or performers, or for a special reason, though in our experience it is often refused.

Lighting, and therefore exposure, in these events is undeniably difficult. With most pop concerts, and more dramatic events, the performers are brightly lit, often with several colours, against a dark background. This has the effect of making you think that the scene is brighter than it

actually is, because of the strong contrast. It will have the same effect on the camera meter, too, as it tries to compensate for the dark areas, and consequently overexposes the main subject – and probably gives you more camera shake too as you set too long an exposure time.

You can estimate by eye the compensation that you have to give (which will involve either turning an automatic compensation dial towards minus, or setting a faster shutter speed than indicated on a non-auto camera), or you can try to avoid the problem by closing in on the well-lit areas with a telephoto lens. A camera with spot-metering, like the Olympus OM4, will allow accurate readings from the areas you are interested in, and you can easily take several readings and average them out if you wish. Conditions are constantly changing in some pop concerts, and you will usually need to meter just before you take the photograph.

If you are using an E6 processed film, like Ektachrome or Fujichrome (preferably in the professional version, as it is not process paid), you can take three or four pictures of the action, leave a blank frame or two, and then shoot the remainder. Many specialist labs, if advised correctly, can then test-process the first 3–4 frames, and uprate the remainder accordingly to the required film speed. If the lighting does not change too much during the performance, or you do not alter your manner of metering or composition too much, this can work very well. You cannot, of course, use Kodachrome for this purpose, as it cannot be uprated. Alternatively, you can bracket your exposures around what you hope is the correct value, but it does use a lot of film as you need to take three or more pictures for each situation.

If your subjects are strongly backlit, or you have light sources visible in your photograph, remember to 'open up', i.e. give more exposure if you require detail in the faces.

The variety of light sources at pop concerts and similar events is best captured on fast daylight-type film, but for the more even, predictably artificial lighting found in orchestral concerts and similar events, you may find an artificial light film is better for accurate colouring, or you could use a correction filter if you know what the light source is (See Chapter 2).

Circuses provide many excellent opportunities for the low-light photographer. There is not very much difference between the day-time and night-time performances in lighting, except that there is more diffused ambient white light from the 'big top' during the day. Light levels are generally good and even, though they may vary considerably from act to act. As with other events, your shooting position is very important: somewhere near the ringside is best, but if you can get permission to move around, then this is even better. A seat opposite the entrance and exit to the ring is good from the point of view of additional shots of the performers entering, and it may give you a plainer background when the curtains are closed, though you may prefer to have the audience in your shots. The actual events vary greatly, from static, through active but predictable, to totally unpredictable! With acts that move regularly round

Chuck Berry in concert. Photographed from the third row of the stalls using a zoom lens at about 135 mm, hand held at 1/60th at full aperture, using film uprated to 800 ASA.

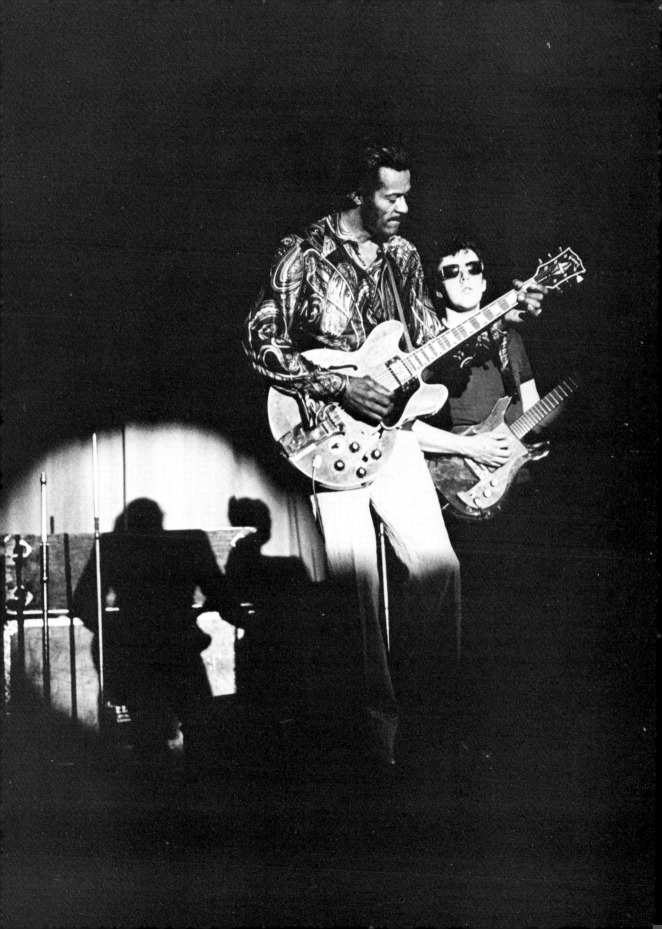

the ring, like groups of horses, you can reduce the difficulties of taking shots of moving subjects in low light by some pre-planning. Frame the area you want to photograph, and pre-focus as the performers move round, shooting just before they come into focus. You can also pan round with them as they move past you, at a slower shutter speed, creating the feeling of movement by the blurred streaked background. In between moments of action, scan around the whole big top area, including the audience, for photographic possibilities. The spectators are often lit by lights close to the arena itself, or elsewhere, giving you a chance to photograph excited faces and expressions. Do *not* use flash in circuses if you can avoid it: as with many other events it may unsettle the performers, as well as destroying much of the atmosphere of the event.

If you do get some good indoor pictures of the circus, it may be worth adding to them by photographing the performers, and their animals, off-duty, and some of the other aspects of circus life to complete the story. On a moonlit night, the big top can look ethereally intriguing from outside, as the light diffuses from it, balanced by the extra light from the moon; but you will need a tripod and a long exposure for successful results.

FIREWORK DISPLAYS

For the photographer starting out in low-light photography, firework displays are amongst the most frustrating of occasions. They look exciting, and you often see good photographs of displays in books or magazines, yet the results from your efforts, more often than not, are disappointing. We have often been at firework displays, and watched intrigued as onlookers photograph the displays . . . with flashguns. Like most events, firework displays can be photographed successfully, but only with advance planning and an idea of the techniques. There are really two main ways of getting interesting pictures, and neither of them involves flash!

The first method, which is the easiest, but which produces the least impressive results, is to load the camera with the fastest film you can and photograph individual firework bursts hand-held. You have to use a reasonably fast shutter speed, e.g. 1/125th second for a 135 mm lens to prevent camera shake from showing; if it does develop, it will be clearly visible as wavy traces of light, which do not look very impressive unless you want this particular effect. It is not easy to pick the moment to shoot, and this is made worse with SLR cameras because the screen blacks out at the moment of exposure. If you are watching a display with a number of similar fireworks being released in sequence, you can practise on the early ones, checking how the firework develops, seeing if the lens is the right focal length, and so on, and then photograph one of the later ones. In practice, though, we have found that many smaller displays seem to mix the firework types as a matter of course, so you never know what is coming. You have to follow each one up, and then react quickly if you like what develops. Exposure is virtually impossible to estimate accurately,

Fairground rides. In this case, flash was used to freeze the movement, which would have been impossible with the ambient light.

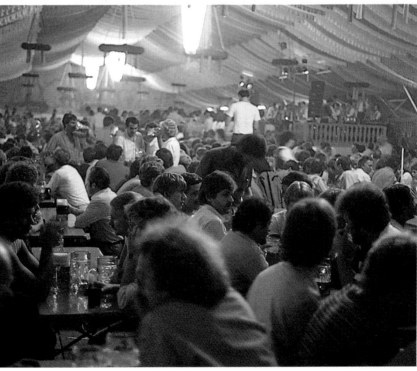

German beer festival. An impromptu shot of a beer festival, using 800 ASA film and a wide angle lens, set at full aperture, with a hand-held exposure of 1/15th sec.

and automatic exposure cameras are too influenced by the (usually) much larger area of sky in the picture, giving overexposure of the fireworks, and too long a shutter speed. You could set the compensation dial to its maximum negative extent, usually minus two stops, or try something like 1/125th at f4 on 800–1600 ASA film.

The second method involves a little more time and effort, but it is worth it, and it is the way in which most firework displays are professionally photographed. Find a good viewpoint, not too close to the source of the fireworks, where you will have an unobstructed view of the aerial display (you can do this for the ground fireworks too, but it is less impressive). The type of film you use is not particularly important, though colour, of course, is better than black and white, and we prefer to use a reasonably fine-grained slower film. Kodachrome 25 can be used successfully for fireworks, but something like ASA 64 or 100 is probably better. A zoom lens is very useful if you are uncertain which area of sky will be filled by the display, but otherwise you could take a 50 mm and a 135 mm and use whichever the position dictates. Set the camera up firmly on a tripod, put the aperture at about f5.6 for 100 ASA film, and you are ready. When the fireworks start, you have three ways of recording them, all of which give similar, though slightly different results.

a) If your camera has automatic off-the-film metering, you simply press the shutter, when the fireworks begin, with the camera set to auto, and leave the meter system to judge when enough fireworks have registered on the film for a reasonably exposed picture. In practice, such automatic metering systems usually have a maximum exposure time of 2 minutes, so this only works if the fireworks are coming fairly frequently. Nevertheless, we have used the technique regularly with an OM2, and it usually works well.

b) Secondly, you can use the 'B' or 'T' exposure setting on the camera to give as long an exposure as you feel you require (using a lockable cable release, with the 'B' setting). Successive fireworks simply continue to record on the film, overlapping and building up a dramatic picture, which looks as though it all happened at once. If there is much ambient light, perhaps from a bonfire below, or the fireworks are coming rather infrequently, then it is best to cover the lens carefully between each firework, removing the card or lens cap as soon as the next firework is launched, and covering it again as it dies down. Although in theory you can move the camera to point it in different directions while the shutter is open, in practice it is rather difficult because the mirror will be locked up and the viewfinder will be blank. You can, if you wish, alter the focal length of a zoom lens while the shutter is open, to give different emphasis to different fireworks. This is the method that we find gives the most reliable results without too much effort. If it is a reasonably long firework display, try several different aperture settings to ensure that one is spot-on, though nor-

mally the exact exposure is not too critical for this sort of work.

c) The third method of taking the fireworks has some advantages, though it is only easy to operate if you have a camera with a good multiple exposure facility. Set the camera up as before, but set the shutter speed to 1 second, then photograph each firework as it comes; after each exposure, retension the shutter without winding on, using the multiple exposure button, and then photograph the next firework in the same way, allowing as many as you wish to build up in the picture. The advantage of this method is that you can move the camera position between exposures quite easily, to capture fireworks in different parts of the sky, or to fill the different parts of the frame fully. This does not work if any other light source appears in the photographs, as it will appear in various different positions, and probably overexpose, thus ruining the effect; a good black sky background is required.

Any of these three methods can be used to photograph single fireworks, too, if you do not wish to build up the picture.

In Britain, most firework displays are associated with Guy Fawkes day on November 5th, and these have the added attraction of a bonfire, which is frequently huge. This can be photographed directly, using a fast film and as short an exposure as possible; fires, in contrast to fireworks, do not build up into interesting pictures during long exposures; they tend instead to bleach out and look disappointing and formless. However, they provide possibilities for atmospheric shots of people crowding around the fire, with their faces strongly lit by the orange glow from one side. You can use a tripod and a medium-speed film if the subjects are immobile, but you are more likely to need a fast film and a hand-held camera, set to give the fastest possible shutter speed. Take any meter readings from the faces of the subjects if you possibly can, and give extra exposure over that indicated if the fire is in the picture.

Another opportunity provided by the smaller scale firework display, such as you might have at home on bonfire night, or at a party, involves children and sparklers. These are relatively harmless domestic fireworks that can be hand-held and waved about in the air. With a cooperative subject, you can make long exposures of patterns made by whirling sparklers or a running child carrying sparklers. A fast film and a wide aperture are necessary, and you can, if you like, add great impact to the picture by freezing one moment of the action with a flashgun, capturing an expression on the child's face. This has to be done against a dark or distant background, or else the effect of the sparklers will be lost as the background exposes.

INDOOR SPORTING EVENTS

Almost all sports now take place sometimes at night, and the lighting required to play the sport adequately is usually good enough to take pictures by. Every sport and each lighting situation will be different,

Football action at night, captured on HP 5 film uprated to 3200 ASA to allow a fast enough shutter speed to stop the movement, though some graininess is apparent as a result. (Film developed in Ilford Microphen for 13 minutes at 23°C.)

making planning ahead more difficult; some sports have continuously spread-out action, others have periods when the players are all together; in some events the players are predictable in their positioning, as in horse-jumping, whilst others are quite unpredictable, as in soccer or ice-hockey. Nevertheless, there are a few useful general rules and suggestions.

However bright the light may appear, it rarely approaches the brightness of bright daylight, and you will certainly need a fast film to cope with the requirement for fast shutter speeds. It is highly unlikely that you will be able to use flash, except in practice-only events by arrangement with the coaches; people frequently do use flash at events, but it is not fair on the players, and can seriously affect their vision for a while afterwards. It does seem to be generally accepted at unlit events like motor rallying, but otherwise it is unwelcome. Being prepared and equipped with fast film and fast lenses does give you more flexibility, too, in choice of lens, composition and background, though you have to accept a lower degree of sharpness.

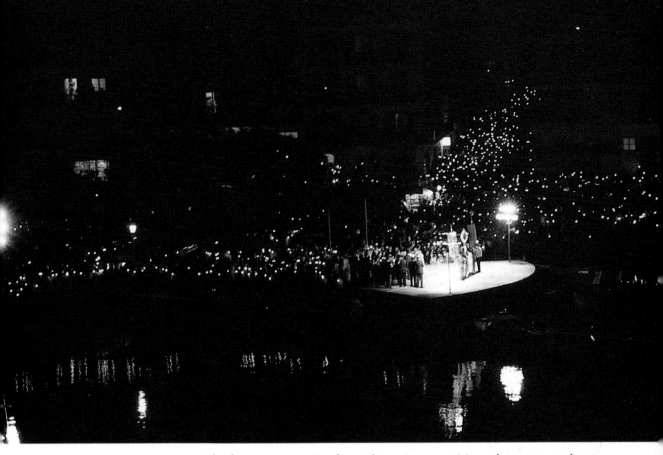

Easter candlelit procession on Crete. This gathering of hundreds of candle-bearing worshippers approaching the waterside was best photographed from a distance, using a telephoto lens.

The lens you require depends on your position, the sport, and your requirements, but it is almost certain that you will need at least a moderate telephoto. Zooms such as 70–210 are useful in allowing you to close in rapidly on distant action, or zoom back for activity near you, but they are a little more difficult to hand-hold than a prime lens, and usually have a smaller maximum aperture, at a time when you need all the light that you can get! If you have no idea what will be required, try taking a standard lens and a 105 mm lens; these usually have a largish aperture, and are very small and light nowadays. If you have more money, there are many lenses available for 'events' photography, combining longer focal lengths with very large apertures. Most major camera manufacturers make a range of these, or there are excellent independent ones, but all are expensive.

An autowinder can be a useful accessory at sporting events, but we advise you to use it on 'single' rather than 'sequence': rapid sequences of the same event are *more* likely to miss the peak of action than careful manual timing and observation.

As with other events, your position is all-important. In training events, you will probably have a free run of the sidelines, and may even be able to go into the playing area with the consent of the organisers. The lighting may be less good than in major events, and your pictures may not have much news value, but it will make things easier in your progress towards obtaining good pictures, and you may even find that the teams, or individuals, are interested in purchasing prints.

In larger events or matches, especially major ones, you are really much more limited in where you can sit. You may find it useful to observe where the professionals gather at big events, and choose a similar spot, if you can. Front seats naturally give you a better chance, unless there is a high barrier, but you will get less cluttered backgrounds and fewer metering problems if you are a little higher up, so that players are against the background of the pitch only. Points of activity like the goal area, the end of the pool where swimmers turn, the water jump in horse-racing, or the tape in athletics are all good points to go for, but of course you will be in competition with others, including professionals, at bigger events; the better the viewpoint, the more people are likely to want to be there!

It is likely that the lighting will be inadequate for really fast, action-stopping, shutter speeds; this means that you have to set the largest aperture you have (you are unlikely to detect any loss in quality of definition, since film quality, subject movement and so on will be more significant), and look for moments of temporary inactivity. In basketball, for instance, you could reckon to use a speed of about 1/125th for a player at the top of his jump, but you would need 1/500th or faster to stop him on the way up or down. Similarly the 'scrum-down' in rugby, the peak of a serve throw-up in tennis, or a player leaping up to make a smash in badminton will all give opportunities for using a slower speed than usual if your timing is good. The more you watch the game, analysing it with photography in mind, the better you will be able to make use of the limited capabilities of the film. In all-action games like squash, you may have to content yourself with pictures taken between points, during warm-ups, and so on, or look for possibilities of 'creative' movement and blurring. With more regular and predictable sports like racing or swimming, you can reduce the required shutter speed to about 1/60th by panning around with the action.

9 People – Formal Portraits, Informal Portraits and Candid Pictures

Most people naturally enjoy photographing other people, but there is a tendency to give up when the light gets low. Although low light does reduce some opportunities for photography, it also opens up others, and these may often have a quality quite lacking in run-of-the-mill daylight pictures of people.

For convenience, we have divided the business of photographing people into formal portraits, informal portraits, and candid pictures. Inevitably, there is some degree of overlap between the three, as well as some overlap with Chapter 8, but it makes the points of technique clearer to start with.

PEOPLE

A formal portrait can set out to exploit a low-light situation for its own sake: hand-held shots are really out and a tripod is a necessity. The two low-light situations most likely to be met with are firstly dull flat lighting where the background and subject tones are similar and you are relying on the personality and features of the subject to stand out. Imagine a white haired property tycoon posed against a dockland development area photographed on a typical drab winter's day. With careful use of differential focusing the person will stand out sharply from the out of focus docklands – white hair will separate the similar tones of the face and background, while a person in light-toned hat or jacket should similarly stand out from his or her surroundings.

The second situation likely to be met with is a portrait session outside in the evening, or indoors by available light, where the lighting is harsh and contrasting, and only coming from one direction. Here the situation demands a few simple accessories such as reflectors and supporting stands if one is working unassisted. We find the large flexible foil-covered fabric survival blankets are best for this purpose since they are big enough to bounce light into a $\frac{3}{4}$ length pose. These reflectors can be folded up quite small and the crumpled foil effect is a more efficient reflector than white paper or card; even so, you will find that is has to be used quite close for any worthwhile effect, and it is not unusual to have the reflector only 18 inches to 2 feet from the subject.

In such a contrasting lighting situation you must pay careful attention to exposure. Aim to have no more than two stops difference in exposure on either side of a masculine subject's face and a difference of only one stop is more acceptable for the feminine portrait.

With directional lighting some exciting possibilities are opened up. The subject can be back-lit and here the reflector really comes into its own, throwing a soft light onto the subject's face whilst the light shines through the hair and outlines the shoulders. You must use a lens hood with a scrupulously clean lens and carefully meter the subject's face. Try to position the subject where the background does not have any distracting highlights or obtrusive light lines or patches. In low-light situations where the lighting is directional and contrasting it may be possible to position the subject in a pool of light between the dark areas, almost like a stage spot-light effect. Such situations should be exploited to the full, and with careful positioning and metering it will often be possible to record the person correctly and still retain some background detail.

TECHNIQUES

Take a meter reading from the face and then from the background, as this will help you to envisage the likely effect of the finished photograph. If taking colour transparencies, there will be little you can do to control the situation since you will normally expose for and get a correctly exposed face, with either a lighter or a darker background. With the former, a reflector bouncing light into the face will help to bring the exposure nearer that of the background. With black and white film in the camera you have a chance of modifying things a little at this stage by calculating the exposure to take some account of the difference between the exposures of background and face, by taking a reading from the face and from the background and erring from the exposure for the face by half to one stop either way as the background demands. Any other compensations will be easier and can be done at the printing stage (see Chapter 2).

In the above formal type of portrait, we have been assuming an 'on location' situation where not all parameters are under control as they would be in a formal studio situation. Formal portraits 'on location' are an ideal and exciting way of portraying a person in a sympathetic or contrasting background and have much to recommend them. Whilst a portrait by available light as described above may tax one's efforts and ingenuity to the limit, a much more satisfying way to take people is perhaps to use the available light and use some supplementary light from portable flashguns. In this situation it is usual to let the available light set the scene and to use flash wholly or partly to light the subject: indeed, one can seldom if ever do it in reverse. The use of portable flash gives rise to some exciting possibilities: for instance with only modest portable flashguns like the Vivitar 283, or the Olympus T32, it is possible to light a full length person on a beach at sunset with the sun setting behind him, with the basic sunset exposure of 1/60 at f8 on Ektachrome 100 nicely balanced by a flash exposure from one of the above guns placed 8–10 feet away. Extension leads will be needed, or better still, small electronic slave units which are more reliable.

Fishermen. A very low-light picture taken in shade on a dull day. A wide aperture and a moderately fast film allowed the exposure to be hand-held at 1/30th second.

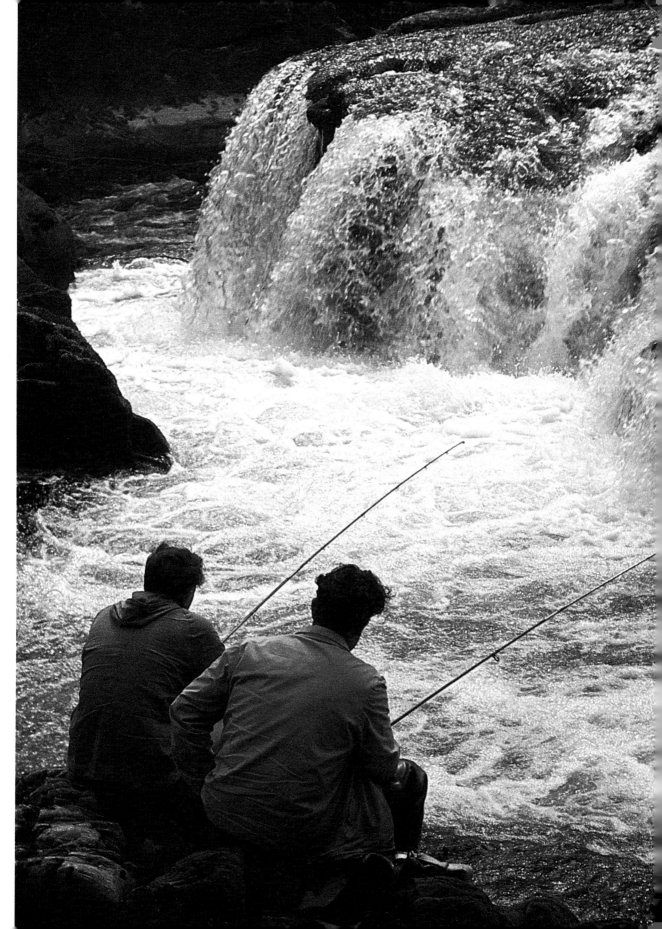

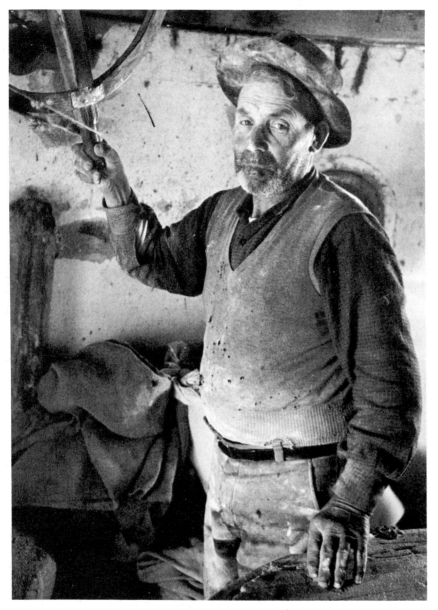

A Portuguese miller photographed by available indoor light at full aperture (f1.8), using a standard lens since that had the largest aperture available, with film rated at 400 ASA.

Some flashguns such as the Starblitz 3600 BTZ have built-in slaves and are an excellent investment. There are also possibilities for more sophistication – particularly by back-lighting the person with a second flash or using the reflector mentioned earlier.

Generally all that will be needed is one forward light, preferably diffused. (Diffusers are often provided with the flashgun or sold separately – or make your own using a handkerchief or paper.) If you use more than one flash frontally on your subject, then be careful to place him/her so that the flashes do not produce conflicting shadows or equal shadows on either side of the nose, etc. It is better to treat one flash as the main light and

modify the shadow it produces with a second less powerful flash, using a third flash to light the hair only, positioned from above, behind and to one side of the head. If such a 'hair light' is to be used, then we much prefer to keep the whole set up as simple as possible and use one front flash only.

If you are not taking a full length portrait but are concentrating on head and shoulders or half length portraits instead, then careful positioning is needed to make sure the background is seen and exerts its proper influence in the photograph. Putting the person on one side of the frame, looking across the scene, is often a good ploy.

A few words about the photographer-subject relationship will not be out of order here. Try to relax your subject. Lighthearted talk helps: there is always some topic that can be found even if it is the weather or what you are doing and what you hope to achieve by doing this, and moving that light, etc. You will be surprised by your sitter's ability to relax after a few pictures have been taken and you have established some rapport.

Try not to appear to dither or be indecisive: have the subject and situation well thought out before the portrait session and have a contingency plan if a flash fails or some small but essential item goes missing. Be firmly and amicably in control of the situation, and business-like in the practicalities of taking the picture. Above all, get to know your subject; on an amateur basis, this means using first names, talking about the sitter's background – work, family or hobbies. All this will help, and a little observation will often reveal a characteristic expression of either face or hands that will, if photographed properly, instantly put personality into a portrait.

Get to know your gear so well that it is second nature putting it all together, since precious time and lighting effect may be lost just setting up equipment. Arrive at a location with time to spare and if possible check out the place well beforehand, especially if the ambient lighting effect is as transient as a sunset or shafts of light down a narrow alley.

Never leave your model in any doubt as to the type of pose you want. A good natural model will automatically adopt a good relaxed pose but many amateur models and sitters will always look strained. Right from the start give your model or sitter a general idea of what you hope to achieve during a photo session. Then start by suggesting a pose such as 'shall we start with a full length shot with the head this way – and the arms held like this?'. It also helps if you, the photographer, adopt a quick system of checking the pose, starting with the head and finishing with the legs, from the camera position. Start by looking at the eyes – are they looking where you want them? (you will come back to this as the last direction you give before taking the photograph). Is the face turned around far enough? – keep the nose well within the cheek, or well outside its outline, since a three-quarter length view with the nose just touching the cheek outline looks messy. Next check the shoulders. Nine times out of ten with an amateur model, the shoulders will be high and tense, and this looks especially bad on a three-quarter length view when the far shoulder looks

lower than the one nearest the camera. Next look at the hands (perhaps the most difficult part of the body to pose correctly) which more than anything else reflect a person's work or position in life – properly placed they can tremendously enhance a portrait, badly used they can ruin it.

Pay attention not only to the position of the hands in the frame but to whether they are held stiffly and pointed (this may be needed), nervously grasping the edge of the chair or clinging for support to part of the scenery. When in doubt give hands something to hold – a pen, pipe, handbag or anything the subject is familiar with – or they can be held together. Do not overlook the well-tried pose with the right hand held to the side of the head or chin and the left forearm across the body with the hand near the right elbow. It is surprising how often one sees this pose even in a full length portrait.

A more formal portrait, taken at a camera club session, using two flashguns, one to light the face (heavily diffused), and one undiffused flash to light the hair from behind.

Ornamentation on the hands, whether the shape and paint of the nails, or the amount and type of jewelry, so accurately reflects the personality that you must be sure to check it over as thoroughly as jewelry round the neck or on the ears. Do not be afraid of asking your model to place the hands outside the outline of the body, often after talking with them for a few minutes they will make a characteristic gesture to emphasise a point – get them to repeat this, as it could be the most worthwhile pose of a whole sitting. Finally, make sure you get the hands in the right perspective – too near the camera and they will be much larger than the face.

Almost the last thing you will check is the position of the legs. The lower half of the body can contribute very little to the pose and yet make the picture twice the size it need be; a good model will naturally bend the legs so that in a sitting or reclining pose the body zig-zags nicely within the frame of the picture. As with hands, you must get the legs and feet posed in a correct supportive position. The feet wrapped around the legs of a chair will look most odd if the rest of the pose is all relaxed but will look natural and in tune if the pose is more dynamic, with the hands emphasising a point.

Having checked the pose, thoroughly, then is the time to give the model a few suggestions as to how to improve their already 'correct' interpretation of your original general instruction. You should always suggest: never use a 'do this, do that' tone of voice. Make all your suggestions from the position of the camera, since it is only that view that matters. It may even pay you to take a few preliminary shots which although you know will be wasted will nevertheless help to relax your sitter and get things moving.

The very last thing to do before taking the picture is to check the person's expression and eye position, making sure the eyes are looking where you want them to and the face is saying what you want it to say. As always, it pays to look at top-class fashion photographers' work, to see how the models are posed – bearing in mind that a lot depends on the model and that not all 'avant-garde' fashion photography is good or tasteful.

Portrait of a toddler. Indoor low-light shots of young children are not easy. In this case, he was sufficiently engrossed to be remaining still, and the low viewpoint has allowed the photographer to gain extra support by resting his elbows on the ground.

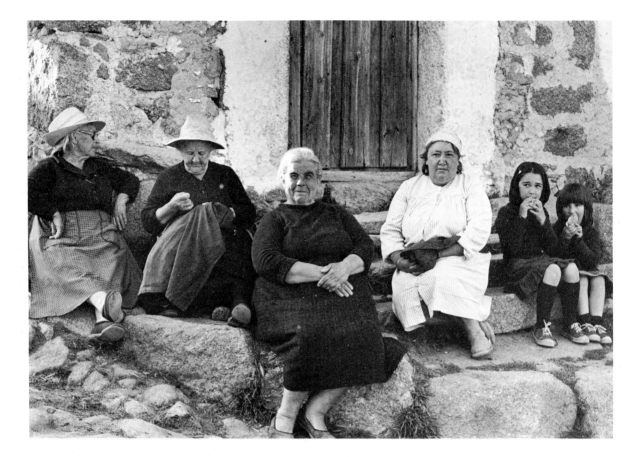

Spanish ladies sitting on the steps in the evening. Natural available light was used, with a standard lens at full aperture.

INFORMAL AND NATURAL PORTRAITS

In the formal portrait a photographer client relationship is formed even if the photographer is taking the pictures purely for his/her own purposes. In this section no such relationship is implied even though the subjects are aware of the photographer and indeed their permission to take the photographs has probably been sought and obtained.

The sort of thing we envisage is photographing people going about their daily work or doing something interesting that you would like to photograph. This is a situation where you have no control over the subject's movements or position in relationship to the surroundings, and if a different background is needed then it is the photographer that moves, not the subject.

You should remember that people working usually face the light so that the shadows fall away from their hands towards their bodies, though for some types of work, other lighting directions are preferred, but (almost) always the face will be in shadow. People will also naturally prefer to face you and talk to you with the light coming from behind them and the light full on you, so if you meet people in their own environment you will almost always find yourself photographing a face in shadow and you will have to expose for that shadowed face. This is not always the problem it seems,

especially in Mediterranean countries, where the shadows can be very luminous from the reflected light of light walls and light-coloured pavements and earth.

At times it may be possible to move some obtrusive object, asking permission first, of course, and on some occasions it may be possible to ask someone to repeat a movement or hold a pose for a split second whilst you take the picture. If it is necessary to do this, then it is best to establish some form of friendly relationship with the person; for instance, after having a go on a fun fair shooting gallery, asking the proprietor if you can photograph him against the prizes or targets. Stallholders at craft fairs or evening markets will often oblige if asked after you have purchased something, or perhaps you could offer to send them a print of the photograph (and then make sure you do). Craft workers or demonstrators in touristy areas are often more than willing to be photographed and are often very used to the clicking of unsolicited photographers: by asking permission you will get a much better response. In the very extremes of southern Europe and certainly on the other side of the Mediterranean, the Near East and India, you may be expected to pay for the privilege of taking people's photographs. If people do say 'no' to photography or do want paying, respect their wishes and either put the camera away obviously or pay up (you may wish to haggle over the price, though, which may be exhorbitant). Above all do not under any circumstances try to take candids as it could be disastrous (and embarrassing) if you are seen, especially in Muslim countries.

Natural and informal pictures of people are, to my mind, the most satisfying and informative way of portraying people at work or just going about their daily life. So, when taking photographs you should be as unobtrusive as possible – use the minimum of equipment and know your gear backwards. If you are intruding into peoples' lives for the sake of an informal portrait then you should be abe to move in, take a picture and move on, as you will usually either be able to take only one picture or wish to move on straight afterwards. For decency's sake, you will not want to stand clicking away close to someone who is either engaged in an intricate craft or just relaxing in the evening sun on their street-side doorstep. You will want to retain the atmosphere, and seldom if ever want to use flash; indeed if photographing for instance in cattle markets or cattle shows it may be dangerous to do so.

A tripod can seldom be used but a monopod is often useful, though both tend to restrict the versatility of camera angle. It will become obvious that informal natural photographs frequently turn either into almost formal portraits or approximate to candid photography. The automatic aperture-priority camera with the now standard fl.8 or 1.4 lens of 50 mm focal length is the instrument *par excellence* for informal pictures by available light. At times we have used a semi wide-angle lens of 35 mm, especially in crowded situations, and at other times a lens of 80 mm or so (which seems to have been specially developed for low-light situations with maximum

apertures of around f2). Many times we have just left the apertures on f2 or f2.8, or if necessary f1.4, and walked around a fairground or covered cattle market taking pictures at 1/30th second. Usually there has been no choice but to load the camera with a film of the required high ASA rating to achieve even this combination. Often we have to resort to uprating the film by factors of two, or very occasionally four, from the manufacturer's recommendation. It is best to do this from the start of a photographic session rather than swap half-used films when you move into a slightly darker area.

We normally carry three types of film for low light situations; firstly Ektachrome 100, which for low-light situations we always uprate to 200 with little noticeable difference from its recommended setting, and which at its normal rating doubles as my regular picture-taking film when the high definition Kodachrome 25 cannot be used.

Perhaps (secondly) the most versatile low-light film is Ektachrome 400 which can easily be uprated to 800, and, providing that high definition and good solid blacks are not high priorities, can be pushed to 1600 but with grossly increased grain and poor colour balance and saturation (characteristics which can, of course, be exploited if necessary). We have noticed that when pushed to 1600 Ektachrome 400 has a tendency to an unpleasant purplish tone. We have also recently tried the new Fuji professional 400 and 1600 films which seem to give excellent grain size and colour for their speed, even at 3200.

The third film we pack is the Ektachrome 160, balanced for artificial light, which we use only when it is necessary to record 'true' colours and good flesh tones. 'True' colour in inverted commas, since in artificial light situations there is seldom a single type of light source of a single colour temperature and that never seems to be the 3400K that the 160 ASA film is balanced for. The artificial light film also gives a blueish-looking cast to pictures which, whilst it may be natural, is normally less preferable than the warm tones of daylight films exposed in artificial light. Ektachrome 160 can easily be uprated to 320 and 640 without worrying about the colour shifts since few people notice these in artificial light anyway, unless the shift is towards the unpleasant blueish tone.

As mentioned above, street markets, craft markets, cattle sales, fairgrounds etc., are all good places to go looking for interesting people doing interesting things. If you are holidaying on the Continent or in such places as the Greek islands or southern Spain go out in the early evening to buy your souvenirs and take photographs. Most of your fellow holidaymakers will be in their hotels having dinner and missing the best and most interesting light of the day for taking pictures of the local people.

Try not to make a habit of going down the same street every day or taking the same type of picture, and if holidaying by the sea visit the local fishing harbour. There is often an area set aside for the local fishing fleet away from the yacht basin with its endless lines of hardly-used white plastic pleasure craft.

Portuguese boat builder photographed as described in the text (see page 168).

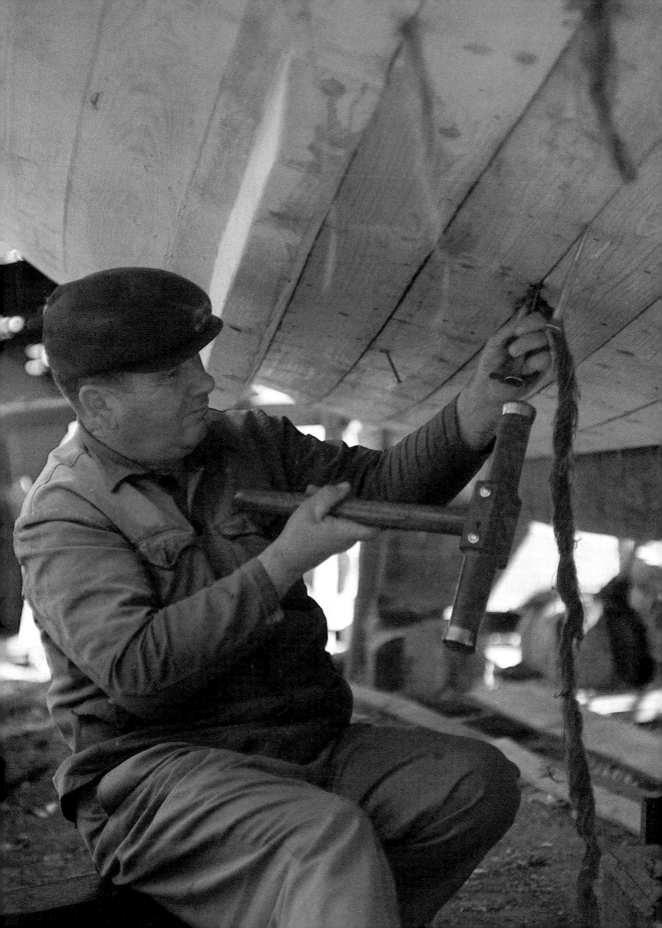

The local fishermen and boat repairers will often give permission for you to take a few pictures, especially if you take a genuine interest in what they are doing, but do not outstay your welcome. You have no need to worry about the language problem: just attract attention, point to your camera, and nine times out of ten you will get a brief nod and your subject will carry on working: you can take a few pictures and move on, but before doing so say 'thank you' in your own language and lift your hand as a parting gesture – the thank you and goodbye gesture sounds and looks the same in any language.

We do not wish to denigrate people or what they are doing by making them the objects of our pictures, rather the opposite. We once crouched under a fishing boat being built on a sandy Portuguese beach and watched in quiet admiration as the boat builder caulked the underseams, hammering in tow using a special but ungainly-looking mallet with precise stroke after precise stroke, never one out of place, never an unnecessary flourish. It was such a wonderful lesson in economy of movement and effect combined with rhythm that we almost forgot to take the pictures we had asked for. There were other lessons here, too (see picture). Because of the low light levels we had to use a shutter speed of 1/30th second: this was much too slow to stop the movement of the mallet but was adequate for the momentary pause just after impact and before the return stroke and the short pause at the end of the return stroke just before the mallet was swung up again. We tried to time our shots at these two 'halt' points. Although the light under the boat was at a fairly low level, it nevertheless had a lovely luminous quality due to the warm sunlight of the late afternoon being reflected off the sand and off the soft pale browns of the unpainted woodwork.

Sometimes the situation will allow you to ask permission to take photographs then stand back and allow your subject to carry on, even letting them get into conversation with your companions or another customer so that you get the opportunity to take pictures with different expressions. This was how the character study of a traditional wood turner at 9.30 pm at a Christmas craft fair in a castle precinct was taken. It is a good idea to visit such fairs early in the evening to look around to see which people and situations are worth photographing and return half an hour before closing when the crowds have thinned somewhat. It is also a good idea not to go on the last night when everyone is preparing to pack up, with little time for photographers. We have found the next-to-last night of a week-long market much the best time to visit. The crowds are not so great and the stallholders much more relaxed than on the first few nights. Fortunately such a Christmas craft fair is an annual event in our city and we were able to study the situation, but it is a lesson to be learnt and used at other times and places.

The lighting at funfairs, festivals and the like often is not very helpful for photographing people – there may be enough light, but it is usually harsh, from a single overhead lamp, and if your intended subject wears a

Wood-turner at Christmas market, night-time. This gentleman was photographed by available light from the stalls, using film rated at 800 ASA. Some adjustment in printing was necessary to improve the detail in the front woodwork, which was least well lit.

hat there will be a harsh shadow across the face usually to just below the eyes. On one occasion we wanted to take a traditional porcelain painter who was both demonstrating his art and selling his work at an evening market. He wore a tailed coat of sienna brown and matching top hat, the brim of which put most of his face in shadow. However, someone asked him about some fine detail, making him put on some gold rimmed half spectacles and tilt his head back, giving us a wonderful chance for a fine character study. This situation was also complicated by the unusually light appearance of the display area and the shiny nature of the porcelain, which grossly inflated the overall meter reading. Since we were using a fully automatic camera – the Nikon EM – we compensated by uprating the Ektachrome 160 film which was already being used at 320 ASA to 500 ASA for a few pictures and to 640 ASA for some more, with the films being processed for 320 ASA. The ones rated at 500 ASA were fine, but even better were the ones we took keeping the ASA setting on 320 and excluding the very light areas from the picture. An added bonus was that whenever the subject leaned over his highly reflective display area, a lot of light was thrown up into the shadow area under his hat giving us a number of more acceptable results than we had expected. The same sort of ploy can be used at funfairs and amusement arcades – watch out for situations where children lean over a glass-topped illuminated game: the soft light from below can be highly attractive, though you will need a good fast film and a wide aperture to make use of it.

You do not have to restrict your informal low-light portraits to out-doors, as with uprated films as described above, it is perfectly possible to take people indoors. It is common practice to photograph pop groups on colour films uprated to 1250 or 1600 ASA. The pictures we took of a group at such a concert in Germany were taken informally at 640 ASA with a 100 mm lens at f2.5 though only about one picture in six was acceptable, and all the unacceptable ones show subject movement. At the same concert we also took a most attractive picture of a young lady drinking from one of the huge German beer mugs; a wide angle lens was used to emphasise the mug size making sure it was nearer the camera than she was, and it makes an interesting scene-setting picture.

CANDID PORTRAITS

You should not think that all candid photographs of people are taken surreptitiously. Today, cameras are normal attire, in fact, they are accepted in almost every public situation. Few people bother when people take photographs in public or more restricted areas such as football matches, horse trials, race courses or any place where the public have access. There is an almost tacit permission to take photographs if you are seen wearing a camera in public places.

A candid photograph of a person, then, is not necessarily one which the subject does not want to be taken, but rather one taken when the subject is not aware of the exact moment of the photograph. The art of taking

candid photographs is to choose the exact moment to illustrate the expression, feeling and character of person and situation without disturbing them.

Woman with pram. A carefully planned 'candid' photographed as described in the text (see page 172).

In England, an individual's rights are not infringed upon if he or she is photographed in a public place, though people can request not to be photographed, and no photographer should take photographs even in public if this is likely to cause a breach of the peace. It follows that you should be very careful when, where and how you take candid pictures. Some people have no qualms about being photographed – competitors in sporting events or other competitions where the public have ready access either by payment, invitation or common consent; people acting in uninhibited ways or otherwise calling attention to themselves in public places. Examples of the above readily come to mind; footballers and spectators, buskers on street corners, and Hyde Park orators are all fair game for the photographer, and the photographic press is constantly publishing such pictures.

Low light and candid photography are not as mutually exclusive as one would first suppose. Many sporting events take place indoors under artificial light, and our national winter sports are almost always conducted in low-light, often dismal conditions. Candids of people at night do pose a special challenge but the problems are not as insoluble as they seem at first sight.

Girl with cigarette in café, photographed as described on page 173.

We find that for some candid situations it is best to keep some distance from your subject to avoid the sound of the camera shutter distracting or unduly attracting the attention of your subject. Focal lengths of 80–100 mm are excellent and very compact. We have used a 135 mm but at this focal length wide aperture lenses are very large and heavy and even a relatively modest aperture of f2.8 makes for a very heavy lens; and the same applies to zoom lenses. Also a 135 mm with a maximum aperture of f2 is

approximately twice as expensive as its 2.8 equivalent. This makes the 80 or 100 mm of f2 very good value for candids as they are often about the same price as the f2.8 135 mm. You have only to look through the pages of the Photography Year Book and see how many candids are taken with small telephoto lenses to realise how suitable these lenses are.

Choosing a film is no problem; for colour you will need a film of at least 400–800 ASA, and if it is the only way to get pictures then a film rated at 1600 ASA is justified and works very well, especially if the background is not too plain to show up the grain. We used uprated films successfully for photographing a Greek tinsmith in his Athens workshop, where we judged that flash would spoil the atmosphere (and the small flashes we had available would have failed to light both the tinsmith and his workshop adequately). We therefore used 400 ASA daylight film rated at 1000 ASA. Fortunately a little daylight was coming in from the front of his workshop, but the background was lit by unshielded electric lamps. The results using a 35 mm semi wide angle lens were quite satisfactory.

On another occasion when photographing the start of a fish auction in a small Scottish fishing port we uprated film from 200 to 800 ASA taking photographs at 1/30 at f4. The only light in the interior of the building was coming through the transparent corrugated plastic roof. This was one of the few occasions when we used a 135 mm focal length hand-held for low-light candid pictures – only one in three showed no evidence of camera shake, even though we held the camera against a tubular metal roof support.

Auctions can be great fun but do be careful. Whilst photographing dealers bidding for pens of sheep at a Welsh market, we were startled to hear ourselves referred to in the auctioneer's rapid patter; we must have caught his eye as we raised the camera to eye level, for he said 'is the man with the camera really bidding at 80?' After that we kept the camera up to eye-level until there was a pause! On that occasion we were lucky to find a roof support to lean against, and we managed to take some pictures at 1/25 at f3.5 on a 100 mm lens using a daylight film of 100 ASA at normal rating. The only light available was the natural light coming in the two open sides of the building. Even so, all the pictures were sharp – the only movement we failed to stop was the rapid movement of the hands of dealers bidding; this was unavoidable, but it somehow gives a little more life to the picture to add to the concentrated gaze of the other farmers and dealers in the picture as they watch the auctioneer. In late afternoon when the auctions were over we found several groups of shepherds and farmers relaxing in the evening sun, providing me with some excellent backlit studies of these Welsh people in their light brown smocks and cloth caps.

Photographing in the open street can be great fun especially if you can find a place where the lighting creates an effect for you.

We once sat outside a café in deep shadow on a warm spring day in Venice, watching and waiting for people to walk through the only spot of sunlight shining straight into a narrow alley. The most successful and best-timed shot was of a well-dressed lady pushing a white pram: a

spotlight effect just caught her white hat and white gloved hands, one of which she had just raised to a passing friend (see picture on page 170). A manual-only camera was used with a 180 mm lens, and the camera was placed on the café table and carefully positioned and prefocused. The picture was taken with a 2 feet cable release whilst watching for the subject to move into the required position (we used a similar technique in Nepal, firing the shutter with a cable release, when the camera was on an apparently unmanned tripod). We had very carefully metered for the sunlight using an independent meter and taking a reading from the back of a hand. Other ways to achieve a correct reading would have been to use an in-camera meter, taking a reading of just the sunlit area or back of the hand, and keeping the camera set on this exposure when retiring to your vantage point. Alternatively, with fully automatic cameras take a meter reading in the same way, note the reading, and go back to your seat – then point the camera at the subject area and adjust the compensation dial or ASA setting until it gives the noted exposure.

With some modern cameras such as the OM4 which have spot-metering, the whole process of obtaining a correct reading becomes easier, as you can just take a spot-reading of the required area without moving. Other cameras also have a shadow button for use on the auto setting which when pressed gives a 2 or 3 times decrease in exposure from the overall metered area, thus achieving the required effect. This is not to be confused with the backlight button found on some fully automatic cameras like Nikon EM which if pressed while exposing *increases* the exposure by 2–3 times, i.e. approximately $1-1\frac{1}{2}$ stops.

You do not have to go to exotic foreign countries to take worthwhile street candids. We tried a similiar technique to the above in a little English market town and took some very effective pictures – one shows a young lady smoking at the next table (see picture): light is catching her hair and shining through a cloud of tobacco smoke. Again, careful metering of the sunlit area *and* the background, which was most important to set the scene, enabled us to set a compromise exposure which, whilst it left the smoker well-exposed, also recorded detail in the background. If we had just exposed for the highlight, i.e. the well-lit cloud of smoke, the background would have been far too dark.

We have been mainly talking above of taking candid pictures of people overtly, where people were aware of us taking pictures and where it was obvious that they might be the subject of the photographs. Candid photography to many people means taking pictures surreptitiously with the subjects having no idea that they are being photographed. This is a situation that should be approached very carefully. You should never take candid pictures of people that would show them in an offensive or embarrassing way – it is neither good manners nor good photography to do so, and the resulting pictures are likely to give offence to viewers and subject alike. Perhaps the only time that such subjects can be taken without offence is candid snapshots of members of your close family – such

Farmer in southern France with his oxen, photographed in natural, but very dull, light with a 100 mm lens at full aperture. The face of the front cow was very much darker on the negative than the remainder of the picture, and had to be burnt in considerably during printing.

candids will often be opportunist and humorous and meant for family consumption only. You will have to know your subject pretty well to judge how they will be received. If you are happy with the likely reception then go ahead and take candids of the family – it must be admitted that some delightful character studies can be obtained, such as grandfather having a Sunday afternoon nap – snoring away without his teeth in. This would be a typical and well known situation within a family and providing grandfather won't mind, then go ahead and take it!

Up-town candids at night

Make sure there is plenty of film in the camera – many opportunities are missed just because you have only one or two frames left for a subject/

A hand-held photograph of an old Polish tobacco-grower photographed in poor light in light drizzle, using a standard lens at full aperture on FP4, not uprated.

situation which are quickly used up, just before an ideal shot shows up! It is much better to sacrifice the last two or three frames on an old film and put in a new one just before you set out. Nothing is better calculated to draw uninvited attention than a fumbling film-loading photographer. So, get all that done before attempting candids.

Candid photography usually calls to mind photographs of individual people or, at the most, small intimate groups, but whilst this is usually so, there is no need to restrict yourself to this type of shot. For some years now we have made it a practice always to carry a small light camera either in a briefcase or jacket pocket. The old type Rollei B 35 or similar is very good; it has a retractable slightly wide angle lens and can be kept in a pocket without a case – a captive lens cap is all that is needed, provided the pocket or briefcase is relatively dust-free. With this little camera we have taken excellent pictures of people both in groups or as scattered individuals passing through a square.

We were once attending a meeting in a tall building overlooking a square: the evening light was casting long shadows on the leafless trees and the people passing through. It took only a few moments during a tea break to take a few pictures. We waited until just the right moment when there were a few people in the right position to produce a nice pattern on the flagstones of the square.

The high viewpoint can be used to good effect in other places. Once on a dull evening in a small town in the south of France we leaned over a parapet of an old castle and caught sight of three gypsies coming up the steps towards us. Fortunately, since the light was poor, Ektachrome 200 had been put in the camera – a quick change to a 180 mm lens enabled us to get one or two pictures of a rather animated discussion that was going on as they ascended the steps carrying their loaded shopping bags. High viewpoints are excellent for candid long shots since it is surprising how rarely people look upwards; we have often exploited high view points to photograph people.

Night-time candids do pose special problems, as there is never enough light to give a good depth of field, light the background or stop the subject movement. You therefore have to uprate your film as far as possible and choose relatively well-lit public places. We have often taken night-time candids of people waiting in a relatively well-lit bus queue. Perhaps the best pictures have been of people window-shopping at night, where the light from the shop window illuminates against a background of Stygian gloom. If you are going to take this sort of picture, beware of intense highlights in the background and odd reflections in the shop windows. If necessary, you can print in reverse, i.e. turn the negative over, so that the reflected writing can be read and therefore becomes less distracting.

10 Special Effects

In addition to the more conventional approaches to low-light photography described so far, there are a number of less conventional approaches, using special films, filters, and techniques. It is possible to simulate night conditions during the day, or daylight during the night; to produce abstract pictures using zooms or out-of-focus techniques; to superimpose the moon onto ordinary pictures; create 'ghosts'; or produce strange ethereal pictures using infra-red film. We have grouped these ideas and techniques together and called them 'special effects'. You do not need much equipment for them, but you do need an open-minded experimental approach, and you have to be prepared to use a lot of film, some of which will undoubtedly be wasted!

EFFECTS WITH FILTERS

We have discussed the general use of filters in low-light work (see Chapter 2, and elsewhere), but there is also a huge range of possibilities for using filters out of context, or using some of the many 'special effects' filters now available. We cannot cover every possibility in the space available, but the suggestions made can act as starting points, limited only by your imagination. We will deal here primarily with the use of effects filters to enhance or create low-light effects; the use of these, and other, filters is also covered under specific applications later in the chapter, and elsewhere.

Graduated filters are normally square filters, with a gradation of colour from strongly marked at one end, through weakly marked, to absent at the other end. Most are clear for about half of their width. They come in various colours, such as sepia, blue, tobacco, red, grey and so on, and there are really two ways in which you can use them here: the more obviously coloured ones are simply used for an obvious visual effect, turning the sky red, or faces blue, or making the traces of fireworks change colour as they move up through the photograph. Alternatively you can use the paler ones to change the picture more subtly, without the viewer being aware of the use of the filter. The sepia or tobacco graduated filters, for example, will make a plain sky look more stormy, sometimes unreally so. Most photographers would immediately recognise the use of an effects filter, but most non-photographers would not.

The graduated filter that we have found to be most useful is the grey, or neutral density one. This produces no colour cast at all, but it progres-

sively reduces the exposure, and therefore saturates the colours of the upper half (normally) of the picture. Dark sunless landscapes often suffer from having a bright sky which is not itself casting much light on the scene, and the graduated grey filter can improve the balance by reducing the exposure of the sky by about a stop (though in some sunset pictures you may find it useful to use the filter the other way up). Similarly, in night scenes, the moonlight or a street light may be dominant in the picture but not be casting enough light on the scene to match the two exposures. A grey graduated filter will reduce the difference by one or two stops, which may be enough.

Incidentally, if you are using a square filter system, you can make use of the square black plastic front cover in a similar way during a long exposure by using it to blank out the light source completely for part of the exposure, allowing the other parts of the scene to register before removing it for just long enough to let the light source expose.

Neutral density filters are designed to cut down the amount of light over the whole picture without affecting the colour balance; their use in low-light photography might seem limited, but they can have advantages. There are times when low light forces you to use an exposure of, say, $\frac{1}{2}$ second, when an exposure of several seconds would be much more useful

False colour Ektachrome picture of the Cairngorm mountains, photographed using a deep yellow filter over the lens.

Low light reflections are always interesting; in this case the pumpkin itself is in the foreground and its reflection in a window is made into part of the same picture, showing both sides of the pumpkin at once.

since it would allow you to open flash, zoom a lens, move the subject, or adjust a masking square, as above: the use of ND filters will allow you to achieve this.

A second use might be for a picture of the interior of a busy cathedral; the normal exposure of 1 second or so would show the cathedral to be full of slightly blurred people, whereas if you can use an exposure of about 30 seconds or more by judicious use of small aperture, slow film, and ND filters, then only those people who are standing still will record, and the scene will appear almost empty.

Colour filters can be used in various ways. A blue filter, especially if combined with a graduated grey filter over the sun, can convincingly portray a night-time or dusk scene during the day. An orange or red filter can make midday look something like a sunset (though not usually as exciting as the real thing!). Some manufacturers also produce a 'sunset' filter, which is graduated orange and red, to enhance the effect.

Colour filters may be used quite unobtrusively to alter the colour of light sources in night photography, such as street lights or car headlights; since the familiar reference objects all around barely show up anyway, the colour change is only visible in the light sources. Headlights, for example, could show up as rear lights.

With multiple exposure pictures, you can create different effects by using different filters over the lens for each part of the exposure; thus a person 'flashed' into different parts of a night scene could be a different colour in each position.

You can use filters over the flashgun, when using flash for similar but more localised effects; and you can use correction filters over flashguns, too, to alter the colour balance of just the flashlit part of a picture. For example, in daylight, you could use artificial light film, put an AL correction filter over the flash, and photograph a person, rendering him correctly, but against an odd-coloured background. The possible combinations are endless.

Star filters come in various types, with names like 'star six', '8-point star' and so on. They make stars of varying sorts out of light sources, and are therefore particularly effective for night scenes, when there are often many light sources actually in the picture. There are also more complex rotating and variable types of star filters, but the effects of these often seem too exaggerated to be attractive.

NIGHT EFFECTS BY DAY, OR DAYLIGHT EFFECTS BY NIGHT

We have already touched on the possibilities for simulating night-time effects during the day, and there are possibilities for doing the opposite, too. We look in more detail at both here. To make daylight look like night is relatively easy, especially with monochrome film. Essentially, you are manipulating the exposure in such a way that the scene appears darker, without simply looking underexposed. This is simplest when photo-

Moonlit landscape. This shot was given extra exposure to give more detail in the wet areas, while the moon was blanked out of the picture for a few seconds. The marked cloud movement reveals the use of a long exposure.

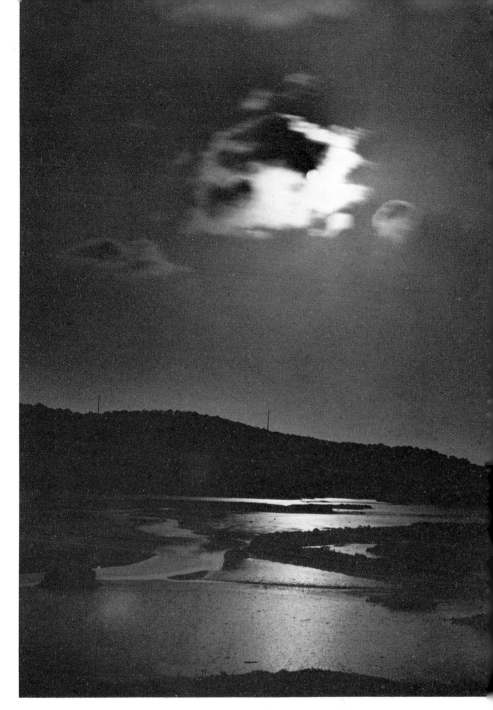

graphing objects in silhouette, when you work with the camera towards the sun, with your subjects strongly backlit, and take an exposure reading from the sky, but *not* from the sun. The sun should not normally be in the picture (although see below), and it is best to use the deepest lens hood that you can for the lens in use to prevent any flare, which would spoil the effect. Using the reading from the sky as a guide, reduce the exposure even more, perhaps by 2 stops (though some experimentation and bracketing is needed here), and take the picture at around this setting.

With monochrome film, a deep red filter will help the effect, whilst with colour film, a blue filter will heighten the effect. If you combine these methods with a graduated ND filter (grey), you can keep the sun in the picture, though it never looks quite like the moon!

You can also use flash to produce the effect of night-time; indeed, the effect is all too easy to achieve even when you do not want it! If the light from a flash falling on your subject is brighter than the ambient light falling on the background, then when your subject is correctly exposed, the background which is not lit by the flash will appear darker. To maximise the effect, you need a considerable difference in light intensity between the two sources, and you need a subject that is distinctly isolated from its background; the light from the flash falls off rapidly from the source (in relation to the square of the distance, in fact) so the closer the flash is to the subject, the more marked the effect will be. With some careful manipulation of flash-subject distance, and aperture, it is surprisingly easy to create dark backgrounds even in quite bright conditions behind a correctly exposed subject.

To produce the reverse effect, i.e. making night look like day (should you wish to), you need to expose the scene for the darker elements of it. In other words, ignore the effect of any light sources – indeed these are better excluded from the picture – and expose for the remainder of the scene with its low intensity of reflected light. If you expose for it correctly, and this may mean very long exposures, it will come to look something like daylight. With monochrome film, the effect will be very close to daylight, though with colour film you can expect colour shifts that will look unreal, and possibly unattractive. You are likely to need exposures of at least two minutes with ASA 100 film at f4 or f5.6, but it could take much more to make a moonlit scene look like daylight. The effect can be interesting, but most of the time you are better off making daytime pictures look like daytime, and night-time pictures look night-time!

USING ZOOM LENSES DURING THE EXPOSURE

The widespread use of variable focal-length zoom lenses has provided an additional opportunity for the low-light photographer working with long exposure times. By changing the focal length of a zoom lens *during the exposure*, you can produce interesting and often striking effects, especially if you plan your idea and execute it skilfully.

The technique can be achieved with a hand-held camera, but you will find it much easier and more successful if you use a tripod, since this will leave you with one less thing to do. Set the camera up facing the scene you wish to portray and focus whilst the lens is at its longest focal length. Exposure will need to be gauged so that the shutter speed is at least $\frac{1}{4}$ second and preferably longer; you will find it helpful to check what the shutter speed will be, and then practice moving the zoom through its focal

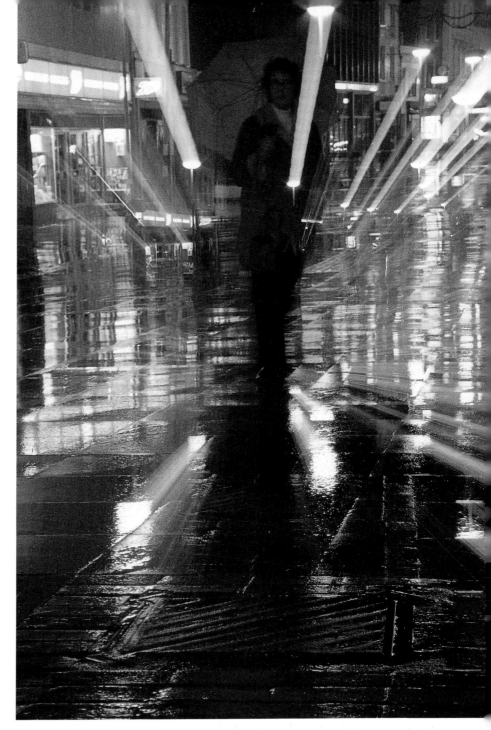

Zooming during the exposure: a Nikon 43–86 mm zoom lens was moved through the complete zoom range during part of the exposure time, leaving some time to record a normal image of the lady with the umbrella.

lengths in that time, without taking a picture; otherwise, you often find that you have zoomed too slowly, or too fast, when you actually take the picture. It is best to choose a subject with plenty of lights in, at least to start with, and then when you are ready gently release the shutter and zoom steadily back through the focal lengths whilst the shutter is open. This will produce the illusion of an 'exploding' subject, coming towards the camera.

A striking view taken in evening sunlight on Kodak Infrared Monochrome film. The growing plant material, especially the line of poplars, shows up more clearly than on conventional film. A Hoya Infrared filter, which is almost opaque, was used to enhance the effect.

This is the basic technique of zooming, but there are various other possibilities to try once the basics are sorted out. Try zooming for the first part of the exposure, then leaving the lens on one setting for half of the exposure to highlight something in the frame. This can be most effective when you zoom from short focal length to telephoto, having first decided what you are going to 'zoom in' on, and worked out what the exposure will be so that you know how fast to zoom. You can also tilt the camera during exposure, if on a tripod, at the same time as zooming. This is most easily done if you have an automatic camera with off-the-film metering, since then you do not need to worry about holding a cable release down during the exposure.

If you do need to time the exposure yourself, use a longish cable release and operate the tilt lever of the tripod with your little and ring fingers, whilst operating the cable release with your thumb and forefinger, and zooming with the other hand. You need to plan the path of your tilt and zoom in advance, with a dry run, to work out what will end up where. Again, you can leave a short period of static exposure at the end to highlight the point that you have ended up at.

For a different effect, with a long exposure, you can separate the full exposure of, say 10 seconds, into 4 or 5 exposures of 2 or 2.5 seconds, interrupting each by replacing the lens cap and changing the focal length between exposures. This gives a similar but stepped effect. Again, it works best with contrasty low-light subjects like street lights or floodlit buildings.

All these zoom effects can be very attractive if you can find something like a big name in lights, or a floodlit fountain, to end up on as a sharp centrepiece.

UNFOCUSED IMAGES

You may occasionally have noticed, whilst focusing your camera on a scene, that the picture looks rather intriguing before you have got it in focus. With normal light pictures, these unfocused pictures are usually disappointing, but the colour and contrast of night pictures, especially those with coloured lights in, make quite attractive images. There is no clear-cut way to proceed with this sort of picture, except by experimentation. We went to Blackpool, in northern England, to photograph the famous autumn display of lights, which are really something; however it rained so hard when we got there that the only thing to do was sit in the car and wait; this led to a good deal of experimentation on rainy images of coloured lights, seen through wet car windows, both out of focus and in focus, and the results were surprisingly attractive. Once the rain had eased (and, of course, only the heaviest rain should put the low-light photographer off!), the possibilities provided by wet streets with abundant reflections were endless. The more straightforward views are enhanced by the reflections, but the reflections themselves, even if out of focus, can make fascinating studies. Passers by may think you are a little odd, taking photographs of what looks simply like a wet pavement, but you just have to live with that!

USING INFRA-RED FILMS

Don't be put off by the technical sounding name of infra-red films; although they are rather unusual, and do have many scientific applications, they are also enjoyable and interesting to use without too much difficulty.

Our eyes can only perceive part of the spectrum of light, from red through to blue, but films have rather different sensitivities. Most films are sensitive to light beyond blue – ultra-violet light – hence the excessively pale skies at times, when UV filters are not used. There is also a range of radiation beyond red, known collectively as infra-red, extending eventually into heat waves and radio waves. A small part of this radiation, the part nearest to visible red, can be photographed, and the simplest way is by loading infra-red film, which is available as colour (false colour, as it is often called), or monochrome, both from Kodak.

Because we cannot see infra-red radiation, it makes it much more difficult to predict what results will be like, and it may be difficult to meter accurately. However, enough is known about the characteristics of infra-red light to allow you to predict the effects moderately well. Clear skies reflect relatively little infra-red radiation, while clouds reflect a lot. Growing vegetation reflects infra-red very strongly, especially in the spring when growth is fastest, whilst dead vegetation reflects little. Water usually behaves about the same as with normal radiation, but atmospheric haze is penetrated very effectively by infra-red film, because haze is caused predominantly by the scattering of ultra-violet light. This makes

infra-red film very useful for recording detail in hazy conditions, though it cannot penetrate dense fog.

Techniques with infra-red films

We shall be dealing here mainly with monochrome infra-red film (Kodak High Speed Infrared film 2481) since it is much easier to obtain, but we will also look at colour infra-red (Kodak Ektachrome Infrared film 2236).

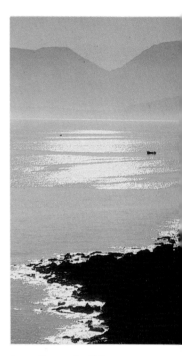

The first problem lies in the fact that infra-red film is not solely sensitive to infra-red radiation; it also responds to visible light, and since infra-red radiation makes up a relatively small proportion of the light that the film can record, its effects are likely to be swamped by the visible light, and you will simply get a rather odd almost-normal picture. To achieve more interesting results, which accurately reflect the infra-red radiation, you need to use filters. The simplest one to use is a deep red filter, such as a Wratten 25, but any deep red filter will do; this removes a great deal of the visible light, leaving only red and infra-red, and it has the advantage over the filters described below that you can still see and compose through it, though the disadvantage is that some visible light records. There are also filters more specifically designed for infrared photography, and these appear totally opaque to the eye, blocking all visible radiation but allowing infra-red through. These will create the most effective and accurate infra-red pictures, but they are more demanding to use. The filter types are Wratten 87, 87C and 88A, or Hoya's infrared filter.

An ordinary daylight scene photographed through a blue-green filter to give a moonlit effect.

Not surprisingly, there are metering difficulties with infra-red film, since camera meters are not calibrated to record it, and your eye is unable to judge it from the visible scene since we cannot perceive it at all. The films are made to a nominal speed, but these are not very relevant because of the filtration requirements and our inability to detect the 'brightness' of the radiation. However, a guide to bracket around is as follows: Monochrome infra-red film with an opaque filter should be treated as roughly ASA 25, or ASA 50 with a deep red filter. Colour infra-red film, when used with a deep yellow filter, should be rated at about 125 ASA, or lower if colour correcting filters (such as the recommended CC20C) are used as well. Although exposure *is* difficult to gauge, there is the advantage that you are working with something that does not conform to normal rules, and some tolerance is therefore possible.

Before starting, there is one other problem; infra-red radiation does not come to a point of focus at quite the same plane as visible light, and if you focus correctly for one, you will be out of focus for the other. Fortunately, the problem is readily solved on most modern cameras, especially SLR cameras, since they have an infra-red focus index. This usually takes the form of a red line or mark to the right of the normal focus index (when viewed with the camera facing away from you, but depending on the way the lens focuses). To obtain accurate focus, you focus normally, and then shift the distance you have set over to the red mark; for example, with a

landscape in focus, your normal focus mark would have 'infinity' set opposite it; you then adjust focus until the 'infinity' symbol is opposite the red infra-red mark.

All these minor problems of focus, exposure, and composition are enormously eased with the use of a tripod; indeed it is almost impossible to get good results without using one. A tripod allows you to compose accurately without filters, and then add the filters when you are ready; focus accurately and then move to the index mark; and use a small aperture to maximise depth of field. A wide-angle lens is also useful in ensuring that something will be in focus, since the effects of infra-red focusing are not totally predictable.

In addition to these photographic problems, there are two other difficulties with infra-red films. Firstly, they are inherently unstable, and should be stored in the freezer and then kept as cool as possible. This means that it is advisable to complete the use of one film during one 'shoot'. Secondly, the film should only be loaded and unloaded in complete darkness, which means, if you reckon to use more than one film in a day, that you either need a changing bag or a second body loaded up in advance to take with you.

Taking the picture

This may all seem a little daunting, but it is not too difficult in practice if you are well prepared in advance, and in a tolerant frame of mind. The choice of pictures is as endless as with any other film, but we suggest you try the techniques first on a bright sunny day in spring, with plenty of clouds about. Landscapes are particularly rewarding and revealing, and it is worth investigating the haze-penetrating properties of the film, if you can. Use a standard lens or wide-angle to begin with, and start out with a deep red filter for monochrome work, graduating to one of the opaque filters (see above), if you can get hold of one, and you are using a tripod. In either event, bracket the exposures around your estimated reading. With colour infra-red film, best results are usually obtained with a deep yellow filter, though you can also try orange and red for different effects. The colour film, in particular, is inherently contrasty, and it is wise not to shoot against the light too much.

You can also, of course, try exposing infra-red film in conditions where there is hardly any visible light, focusing by torchlight if necessary, and the results are unpredictable, to say the least.

Processing the film

Get the films processed as quickly as possible. Monochrome infra-red is processed normally in a developer such as D.76 or IDII, but we have found it is preferable to increase the development time slightly over that recommended, to increase the contrast. Colour infra-red film needs to be processed by the old E-4 process, used for ordinary Ektachrome before E-6 processing was introduced. Although Kodak offer a service in their leaflet,

in most countries this has been discontinued through lack of demand. In the UK, you can still find a few laboratories dealing with E-4 films, and we suggest you try Argentum, of 6 Upper Harley Street, London NW1; or Medical Illustration supply services, Unit 165 Cannon Workshop, London Enterprise Zone, West India Dock, London E14. Alternatively, you can still buy E-4 chemicals occasionally to process your own, though it is best to track down the chemicals first, if you intend to do this, to avoid having the films waiting about for processing.

PHOTOGRAPHING TELEVISION AND VIDEO SCREENS

A rather different branch of low-light photography is that of taking images from existing pictures on television or video. There are frequently events or features of interest on television which you might wish to record as a still picture, and this is easy enough if you know what you are doing. There may, of course, be copyright problems in so doing, though there is unlikely to be a problem if the pictures are solely for your own home use.

Many people attempt to take pictures from TV screens, often on the spur of the moment when something of interest attracts attention, but are disappointed with the results for one reason or another. Whatever you do, the quality is not going to be perfect, but by following some simple guidelines you can at least get the best out of the situation. The same guidelines apply basically to computer screens as to television and video screens, should you wish to photograph something from a computer screen.

First, it is best to adjust the controls of the set to give a picture that is not strongly contrasty, and which has detail in both shadow and highlight areas. This may be slightly different to your normal viewing preference. The camera should be loaded with medium or fast speed daylight-balanced film (or monochrome film), and you will find it much easier if you use a tripod. Darken the room as far as practical to prevent flare and reflections from the screen, and set up your camera on the tripod in such a position that the screen fills the frame as exactly as possible. You should work with the camera exactly opposite to the centre of the screen, to avoid focus problems and distortion. Do *not* use flash or floodlights to light the screen.

The images on the screen are formed in a cathode ray tube by a rapidly-scanning electron-beam that covers the screen line-by-line. This means that, contrary to the way it may appear, it takes a finite time for each distinct image to appear, and this is usually in the region of 1/30th second. To prevent loss of part of the image, you therefore need to use a slower shutter speed than this, and in practice, with a typical focal plane shutter, you will need to use 1/15th or 1/8th second to be sure of results. The aperture will be determined by the need for this shutter speed, and it is best if it is f8 or smaller, since the screen curves slightly and will not all be in sharp focus at a wide aperture.

Gauging exposure is not easy. Some meters react inadequately to television pictures whilst others fluctuate wildly. Off-the-film metering seems to work accurately, but in other situations there has to be a degree of trial and error, with some bracketing of exposures if possible. The following table gives some guidance for starting points:

	COLOUR SCREEN	*MONOCHROME SCREEN*
100 ASA film	1/8th at f5.6	1/8 at f4
200 ASA film	1/8th at f8	1/8th at f5.6

You can try faster shutter speeds for active situations, but the image will probably degrade beyond 1/15th second.

PUTTING THE MOON INTO YOUR PICTURES

We have discussed various ways of photographing the moon (e.g. Chapter 6 and 7), and of producing double-exposures (Chapter 3), but if you have a particular interest in pictures with the moon in them, then you may find the following technique of interest.

Load the camera with a medium-fast speed film, about 1–200 ASA. As you load it, mark a clear starting point on the film that you can easily relocate; this can be a scratch, a small cut, or a spirit-pen mark, but you must note what you have lined it up with, and what the frame counter of the camera reads at that point. One simple way is to engage the film as normal until it has been taken up by the sprockets, then draw a line down the edge of the cassette, on the film, with a fast-drying pen. Then close the back before winding on any more.

Use this film to take a complete set of pictures of the moon in as many shapes and positions as you require. You can use telephotos to make large images, or just have small new moons; if you are in no hurry, you can photograph the moon at various stages. The two important things to remember, though, are 1) that you want the moon in such a position that it allows another picture to be exposed over or round it, and this normally requires that you put the moon in the upper half of the picture; and 2) unless you want them all in the same place, you must note down where in the frame each moon appears, and what form it takes. It is easiest to draw out a series of frames beforehand, and simply sketch in where the moon appears, and what shape it is.

Expose as accurately as you can for the moon itself (see Chapter 7) not the scene, and make sure you know whether the number of the frame indicated each time was before or after winding on.

When the film is completed (and it is advisable to start out with a shorter film), wind it back as normal, but stop when you hear it disen-

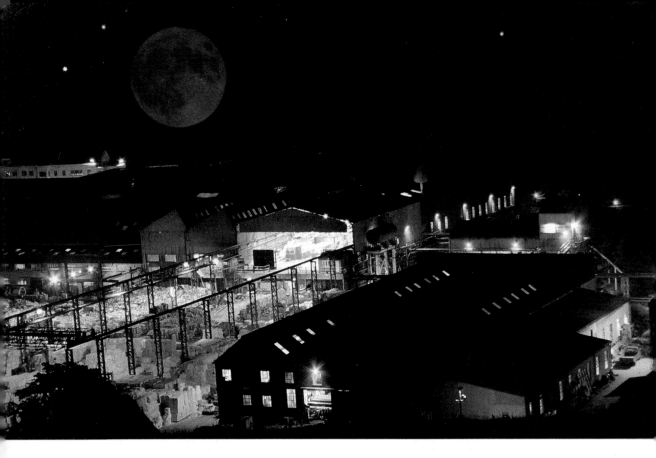

gaging from the sprockets, to make sure that the leader does not disappear into the cassette. Then reload the film, lining it up exactly as you did the first time, and go out and shoot all the frames again with whatever scene you wish, making sure that the moon is correctly aligned in each. It is wise to choose pictures with dark areas to put the moon into, but it depends partly on whether you want faked realism or simply effect. Either way, it is worth a try, and can produce some interesting and attractive 'moonlit' images (see picture).

Factory at night. The factory was photographed on film that had already had moon pictures photographed onto it, giving an interesting effect.

Index

Illustrations are shown in *italics*.

PICTURE CREDITS

All pictures by Bob Gibbons and Peter Wilson except the following: p. 28, courtesy of Kodak Ltd; pp. 81 and 154, courtesy of T. Sandal-Codd; pp. 129, 132 and 136, courtesy of W. Pennell; p. 131, courtesy of Neil Vernon; p. 149, courtesy of Roy Saxby.